RADICAL
LIVING

RADICAL LIVING

HOMES AT THE EDGE OF ARCHITECTURE

CONTENTS

7 Foreword

HOMES

10 ⅓ House || Norway

18 Acute House || Australia

26 Bumpers Oast House || United Kingdom

32 Cabin at Trolls Peak || Norway

42 Carroll House || United States

52 Casa 3000 || Portugal

60 Cocoon House || United States

72 Connected House || France

80 Cork House || United Kingdom

88 Croft Lodge || United Kingdom

98 Domic House || Australia

107 Green Line House || Poland

113 House in Hokusetsu || Japan

121 House in Takatsuki || Japan

129 House in Usuki || Japan

136 House on an Island || Norway

145 Love2 House || Japan

150 Montebar Villa || Switzerland

155 Parchment Works House || United Kingdom

162 Quadrant House || Poland

171 Rode House || Chile

176 Shkrub || Ukraine

185 Sustainable House || Brazil

190 Tri House || Ireland

198 Villa F || Germany

205 Villa Ypsilon || Greece

DREAMS

215 Cliff Retreat || Iceland

220 Dune House || United States

227 House Cylinder || France

232 Skýli Cabin || Iceland

238 Project Credits

RADICAL LIVING: HOMES AT THE EDGE OF ARCHITECTURE

Foreword by
Dr Avi Friedman

The twentieth century witnessed the introduction of several dwellings that were considered "radical" at first. Years later, these homes went on to become pivotal in charting a new course in the philosophy and form of residential design.

In 1929, Mies van der Rohe's Barcelona Pavilion stripped a dwelling of its excessive exterior ornamentation and displayed an open-plan concept with interior partitions that could be placed according to the occupant's choice or need. The design went on to influence generations of architects who combined all the home's living spaces. Similarly, Le Corbusier's 1931 Villa Savoye, in France, set both a design and a stylistic statement that years later was regarded as the dawn of the Modern Movement and the International Style. Gerrit Rietveld's 1924 Rietveld Schröder House in the Netherlands marked a radical departure from any interior and exterior work seen before to inspire new forms. Frank Lloyd Wright's 1939 Fallingwater home in Pennsylvania, United States, stands among other contributions as a prime example of the integration of architecture and nature. Paolo Soleri's 1950s Woods residence in Arizona demonstrated that dwellings could minimize their bearing on their surroundings, thereby planting the seed for the Net-Zero concept. Decades later, award-winning Australian architect Glen Murcutt's 1974 House for Marie Short, in New South Wales, sensitised designers and the public about the need to explore vernacular practices to avoid incorporating mechanical means and to promote the use of locally sourced materials.

What led to the introduction of these ground-breaking concepts? For some designers, it was a need to make a statement about the functions of a home and lay out a vision of how people should live.

Other architects were taken by a need to unveil a new aesthetic. Forging better relations between the built and the natural environments propelled other architects' ideas. Those motives were aligned with the spirit of the time of their introduction, but they nonetheless have cast a long shadow and left an imprint on generations of designers' ideas.

Time has passed since these landmark prototypes were unveiled, yet contemporary planning and design modes of dwellings are facing a mounting number of new social challenges, and thus, the call for innovative thinking is evident. The depletion of non-renewable natural resources, elevated levels of greenhouse gas emissions, and climate change are a few of the environmental aspects that are forcing designers to reconsider conceptual approaches in favor of ones that promote a lower carbon footprint and a better suitability between dwelling and nature.

Increasing costs of material, labor, land, and infrastructure have posed economic challenges, with affordability being paramount among them. The need to do more with less brings about concepts that include adaptable and expandable dwellings, and smaller sized yet quality designed residences. Designers are also exploring new means of production such as prefabrication and are incorporating innovative materials. Lifestyle and demographic transformations are leading the introduction of new interior design concepts and functions.

The projects assembled in *Radical Living: Homes at the Edge of Architecture* offer a response to these challenges. At the center of the beautifully illustrated homes are not only distinctively attractive architecture but intriguing ideas. The book is a voyage through the minds of designers who felt compelled to offer an "out of the box" approach to a unique situation, be it due to constraint or opportunity. I was captivated by what prompted architects to shape the homes the way they did to make them thought-provoking. The wide international range of the designs further enriches the offering by drawing from different geographical contexts and cultural backgrounds.

All the chosen homes have something to offer in philosophy and form. In some, the designers pay special attention to the integration of the home with the site's natural environment. The designers of the Green Line House in Warmia, Poland, respected the secluded wild location and embedded it into the landscape. The inclusion of a sloped green roof that borrows from local tradition further creates a seamless combination of nature and building.

The design of Cork House in Berkshire, United Kingdom, is a thoughtful response to the challenge of depleting natural resources by using

sustainably sourced cork blocks supported by timber components. Circular economy is practiced throughout the structure, which was designed to be dismantled, reused, or even recycled in the future. The attractive cone-like structure makes it resemble beehives with an envelop that lets in ample natural light.

When an eighteenth-century heritage cottage existed on an English countryside site, rather than demolish it, designers David Connor and Kate Darby built their award-winning Croft Lodge over it. They preserved everything inside, from the 300-year-old timber frame with original carpenters' marks, peeling lime plaster, birds' nests, rotten timbers—even the dead ivy. Looking at the outcome, the interior reads more like poetry than architecture to tell a story of past and present.

The architects of Love2 House in Tokyo, fitted a home on a 300-square-foot (31-square-meter) lot. The occupants were inspired by a story set in the Edo period (1603-1868) of Japan, which discussed a family of four who lived in a 100-square-foot (9.6-square-meter) house. The floor plan of the land was, in comparison, a generous 194 square feet (18 square meters). The creative design of the concrete-poured home draws light from a top opening and exterior windows to make the small space seem larger.

A combination of unique design and integration with the natural setting was the outcome of Alex Hogrefe's Cliff Retreat in Iceland. The architect employed techniques derived from his background in painting and drawing, such as focusing on light and shadows, texture, and atmosphere. Here, too, the design draws from the environment that surrounds the site. The cliff's edge and the waves below inspired an expression of forms, sounds, and light.

A dynamic approach to architecture was the mark of the Quadrant House in Poland. The home includes a moving outdoor living space that pivots and docks with rooms on either side of a garden. The moving terrace with its kinetic architecture follows the sun's movement. The outcome is not only a passive solar gain but a range of interior designs that suit the occupants' needs according to their domestic activities and time of the day.

Radical Living offers a collection of dwellings with outstanding imagery and ideas for readers to enjoy and reflect upon. The book also serves as a podium for talented architects to voice their thoughts and creativity. As time passes, these projects will no doubt inspire designers and dwellers worldwide.

⅓ HOUSE

Rever & Drage Architects
Øksendal, Norway

Seeking to resolve the markedly different ideas of a young couple into one cohesive design, this simple and economical house succeeds in providing a romantic and cozy building while at the same time being eminently practical, and also allowing room for expansion in the future as required.

Because of the simplistic design, the building appears a little abstract. Yet, the clients have built the part of the house they could afford, while planning for additional expansion when needed. The double-story living section is insulated, and organized around a warm core on both floors. The roof over the utility space, or veranda, provides an indoor-outdoor setting, while the openings provide varying views of the magnificent surrounds. The windows in the main residence are deliberately placed in a traditional way, albeit with a somewhat larger format than usual in such buildings, while the veranda has a more industrial and temporary design.

The main residence is comfortable and snug, and caters for the living needs required by the couple, and will also be able to accommodate any modest increase in family numbers. The uninsulated outdoor space is about twice the area of the main residence, and it is here that contains the potential for expansion. In the meantime, the veranda functions as a storage room, garage, workshop, banquet hall (why not indeed, in this Viking-esque landscape!) and, not least, as space for butchering deer.

By sticking to their budget, the clients have been able to obtain a cozy residence, while also taking the opportunity to plan for future expansion and enjoying the benefit of a dramatic veranda. In time, the building will more closely resemble a traditional farmhouse. And so what started as a striking and unusual building, and one-third of a residence, will gradually develop to become more traditional in form and function.

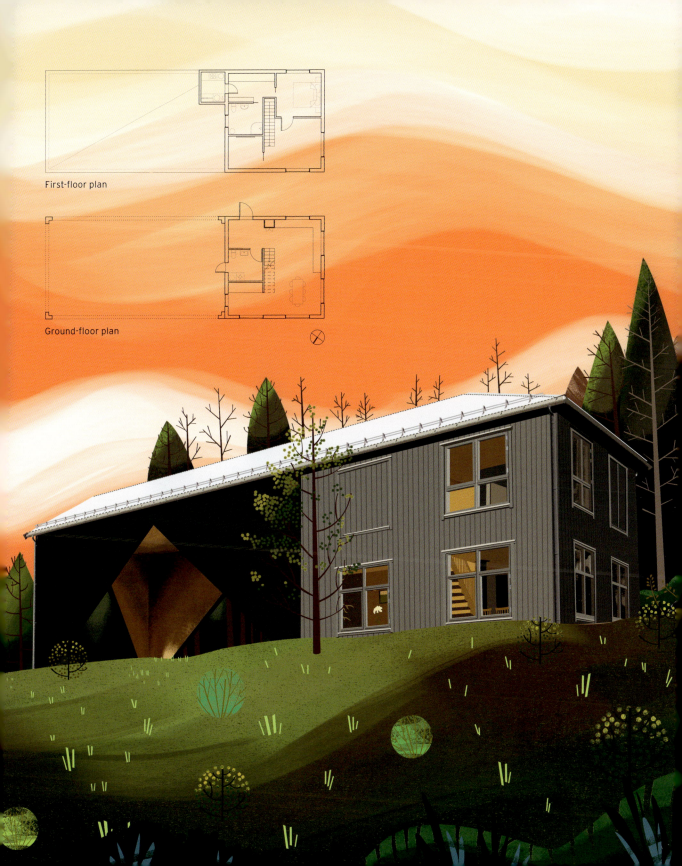

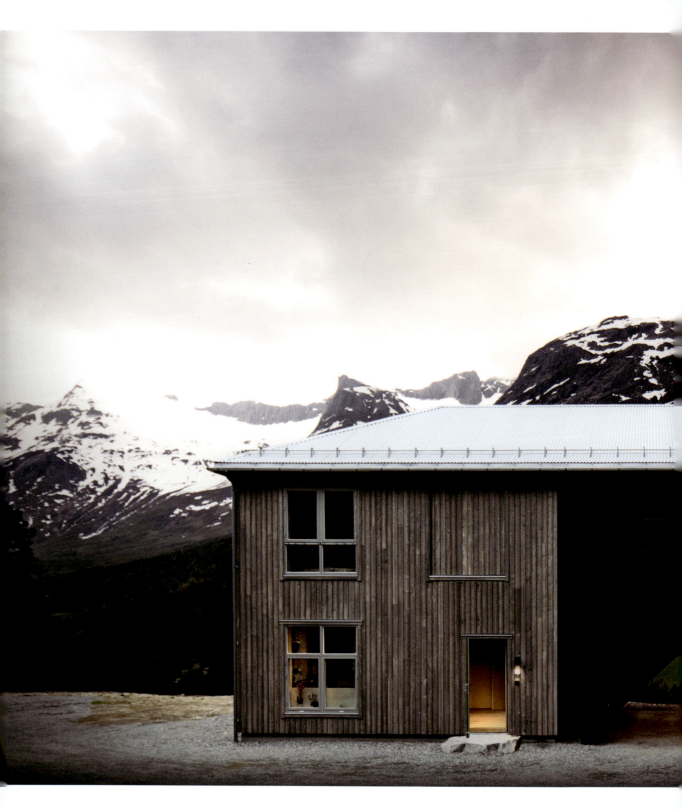

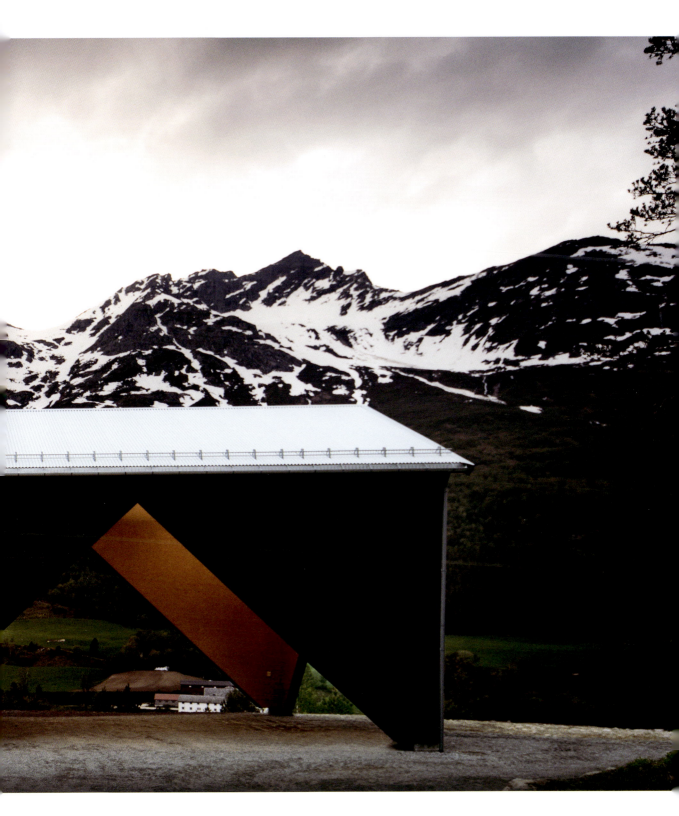

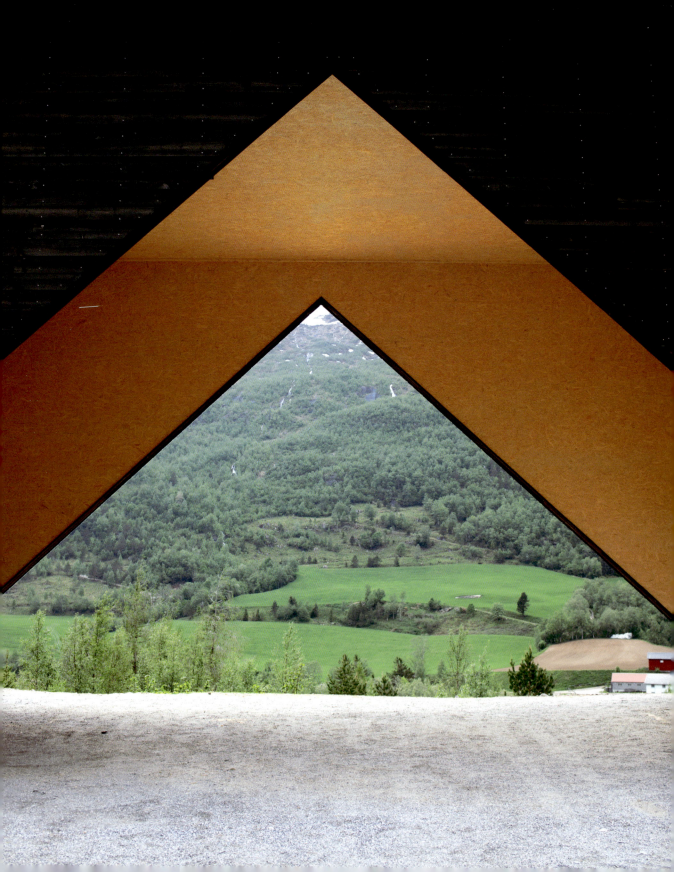

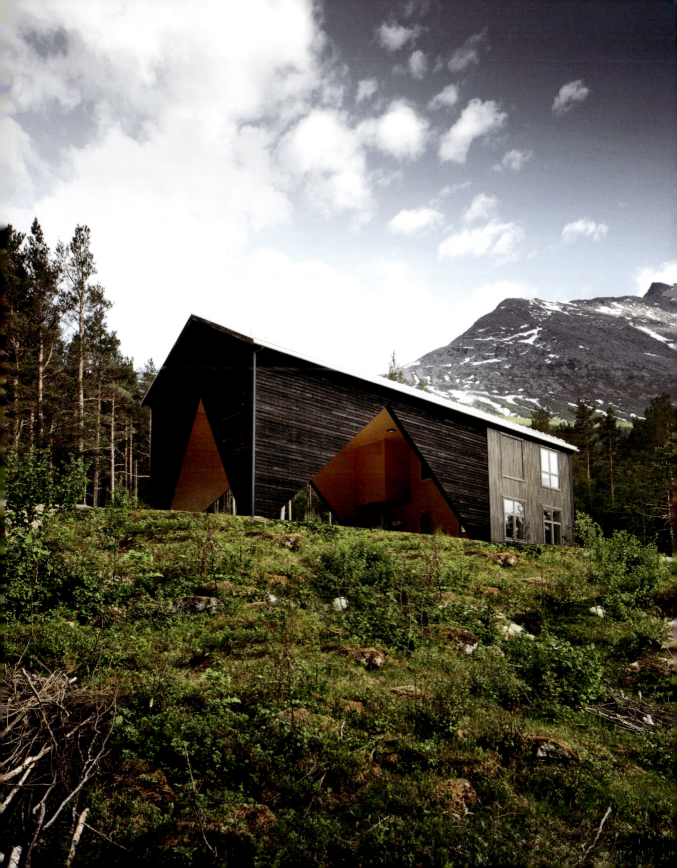

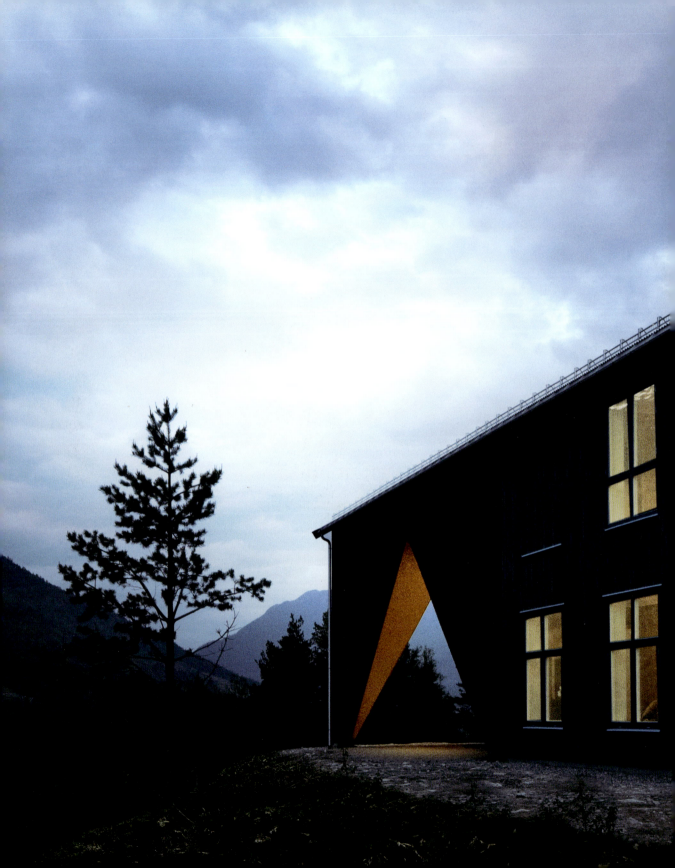

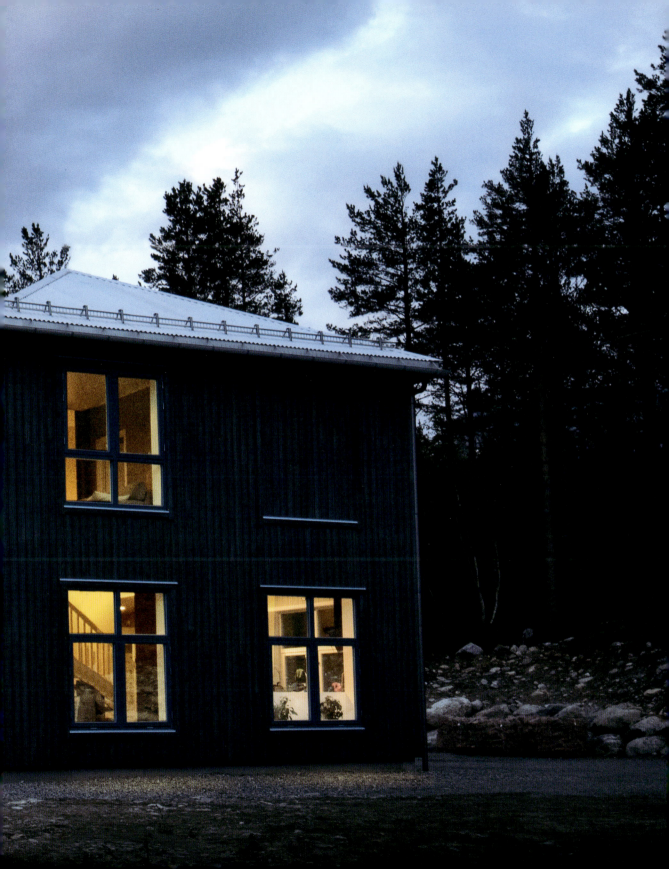

ACUTE HOUSE

OOF! architecture
Melbourne, Australia

Available options are limited when presented with a challenging, narrow, and very triangular site, coupled with a demanding heritage context. In this case, the designers used all their ingenuity to exploit the difficulties and transform this "renovator's nightmare" into a compact twenty-first-century family home.

The original and decrepit Victorian weatherboard house had come to the end of its life, but the unusual home had become a valued feature of the neighborhood. Thus, the architects endeavored to salvage what they could to produce a new home that retained the character of the original building, fitting in with its surrounds while at the same time remaining resolutely contemporary in its expression and articulation.

The complexities of such an unusual site required an adjustment to the layout and lifestyle expectations of a conventional family house. Multiple levels were required to accommodate the basic space needs of a family home and these were distributed over split levels with the vertical space of the stairwell providing visual privacy and a sense of definition without wasting precious space on internal walls, corridors, or doors.

The metal cladding provides a sharp, smooth, and precise contrast to the fragile weathered-timber cladding, carefully salvaged from the original building. The raw, weather-beaten boards and barely-there flaking paint demonstrate a different sort of timber beauty: a unique record of the life and times of a 100-year-old house.

The resulting new wedge of house is an unusual but highly responsive approach to the character of the surrounding neighborhood, and to the challenges and opportunities for responsive architecture presented by the site and its immediate context.

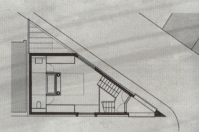
Second-floor plan

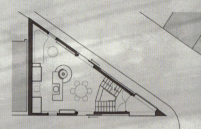
First-floor plan

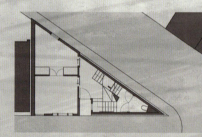
Ground-floor plan

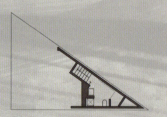
Basement plan

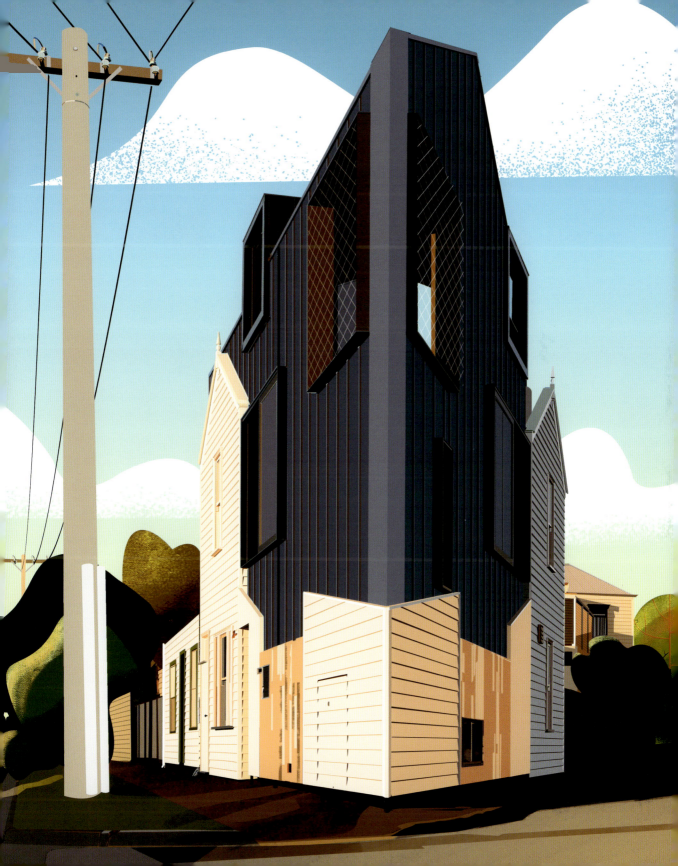

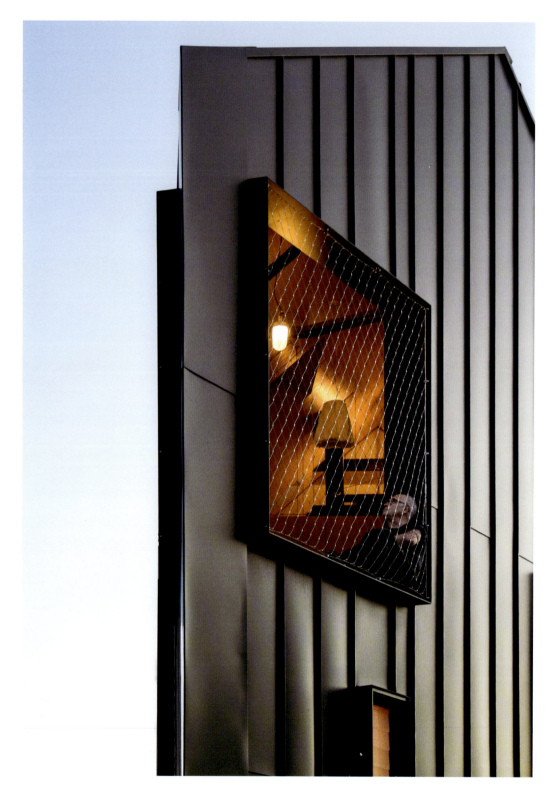

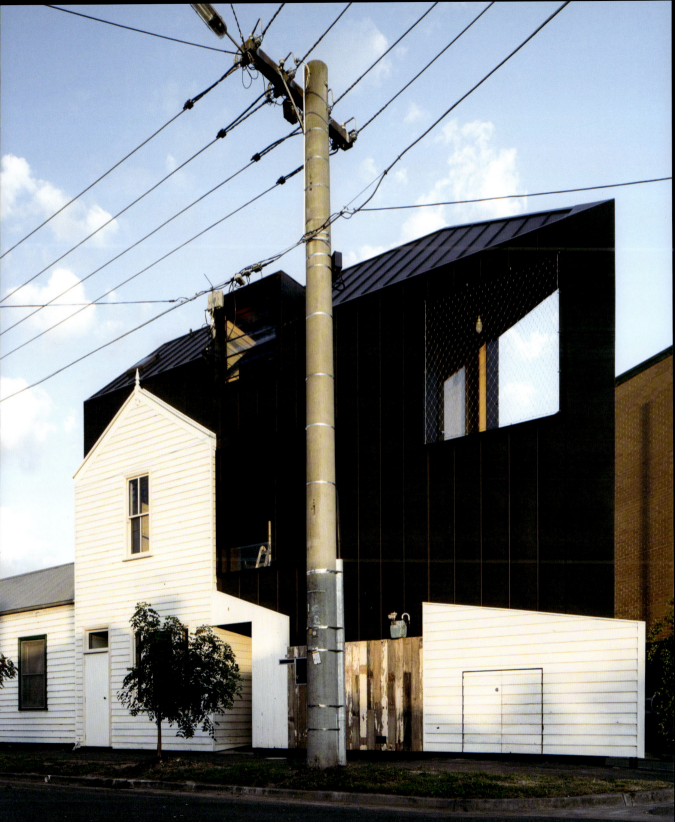

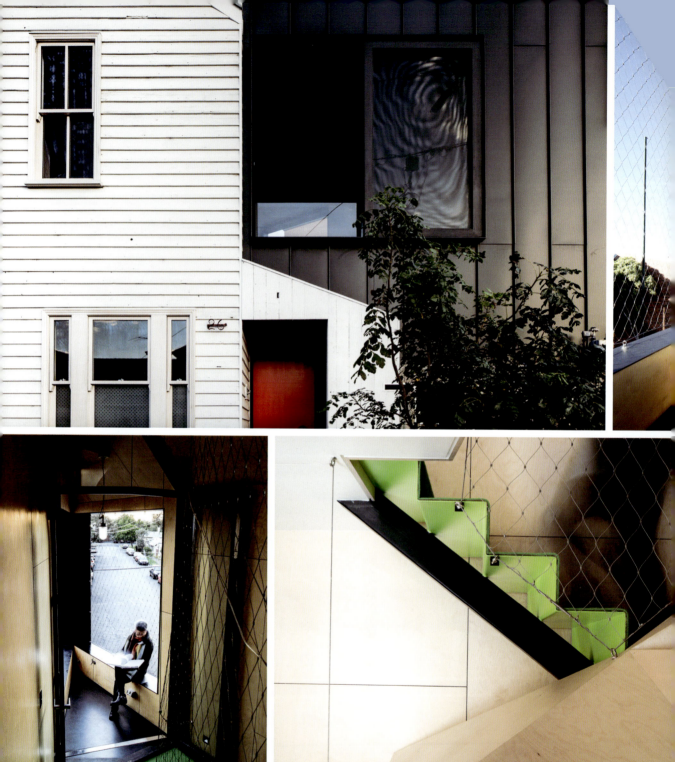

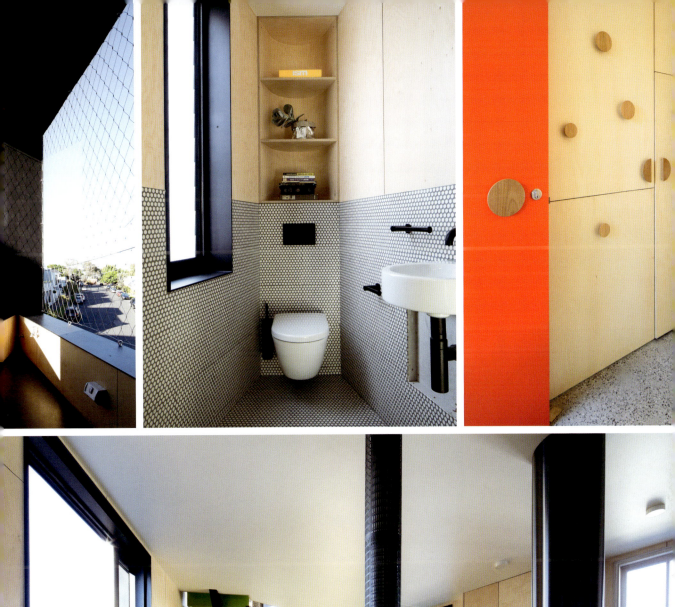
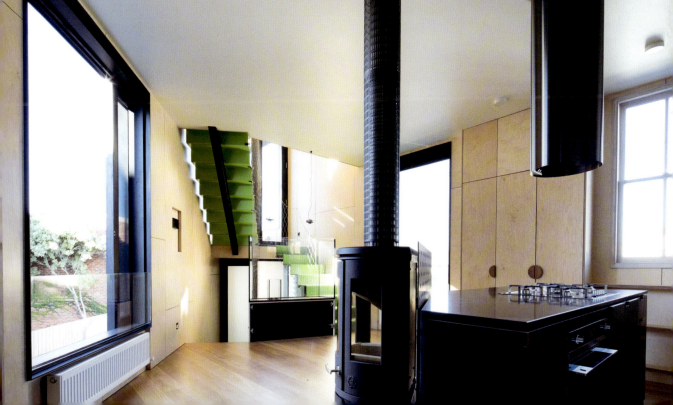

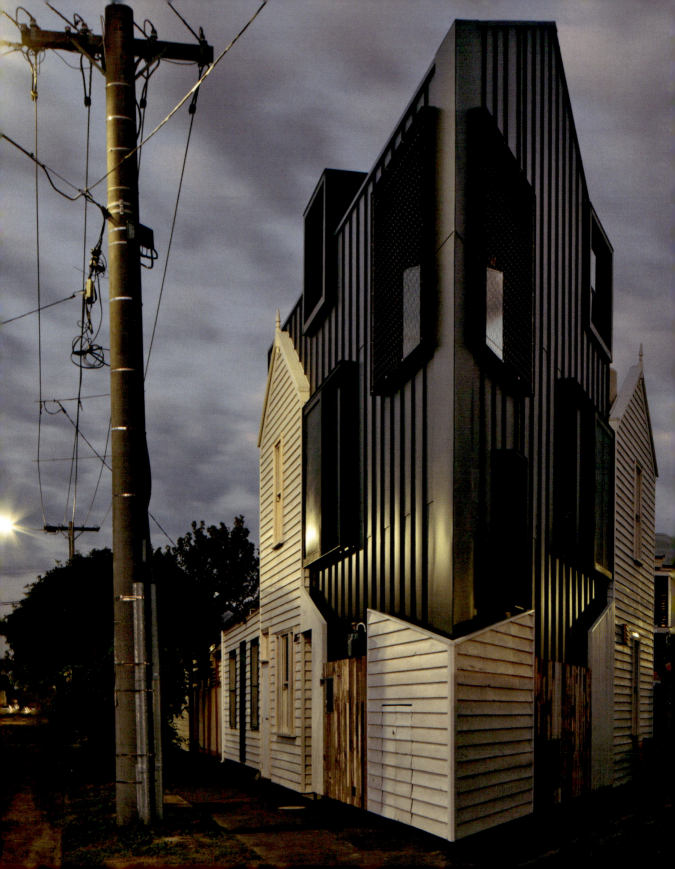

BUMPERS OAST HOUSE

ACME
Kent, United Kingdom

This award-winning house is a striking, contemporary reinterpretation of a traditional oast house, a structure used to dry hops as part of the beer-brewing process. Four shingle-clad towers rise up from the natural rolling landscape and apple orchards of Kent, creating an extremely low-energy home with a bold contemporary aesthetic.

The home was created for a family who held a fondness for oast houses, and enjoyed the intimacy and idiosyncrasies of living in circular spaces, and were happy for the architects to explore a modern interpretation of the traditional vernacular.

The tower roundels are based on a traditional oast house and stand slightly apart from one another, creating views inwards and outwards. The towers are all connected to a triple-height central space that opens out to an orchard setting and forms the heart of the house. Kent-style tiles, produced by local craftsmen, are used to create the exterior skin in six shades, slowly facing from dark red at the base to light orange at the tip. Each tile above the eaves level has been individually cut, with 41,000 used across the whole façade in a process that was a huge technical challenge, but creates a stunning effect.

Curved furniture is built into the rooms where possible to make the best use of the space. Timber was employed in the kitchen to create a warm space in this important gathering space and also used to create bespoke curved units and fronts to follow the line of the wall.

All bedrooms are on the second floor, and each one has its own private staircase to an upper level in the roof cone, creating a building that is entirely communal on the ground, shared on the first, and full of secluded treehouse-like retreats on the second floor. Friedrich Ludewig, director at ACME, proudly sums up the project: "This house can be both contemporary and proud of its Kent identity."

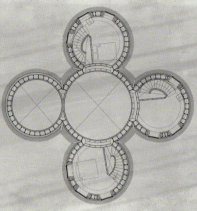

Second-floor plan

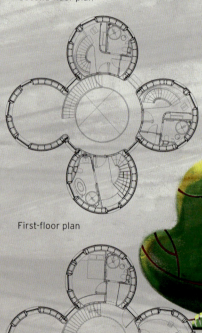

First-floor plan

Ground-floor plan

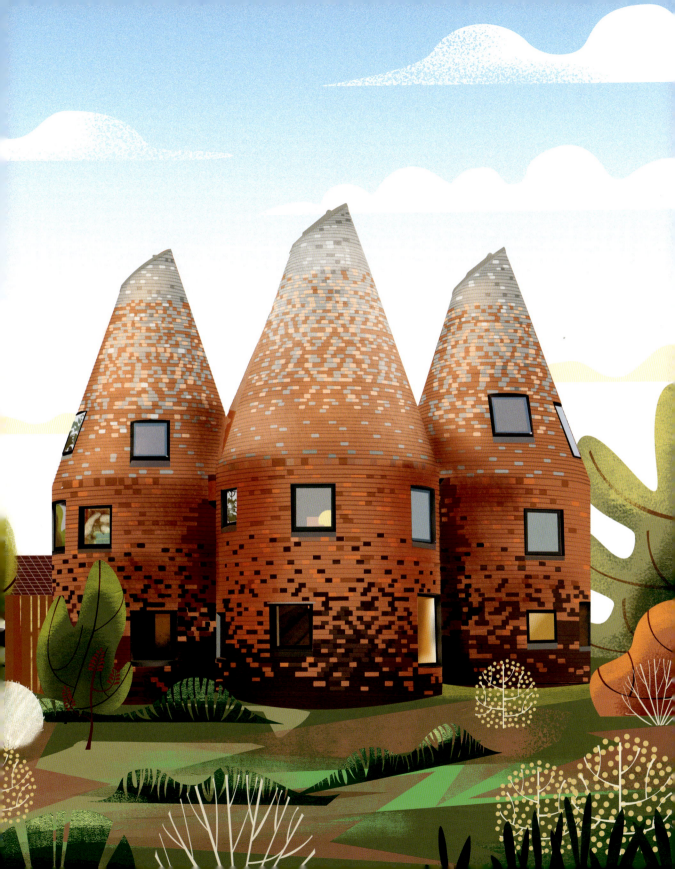

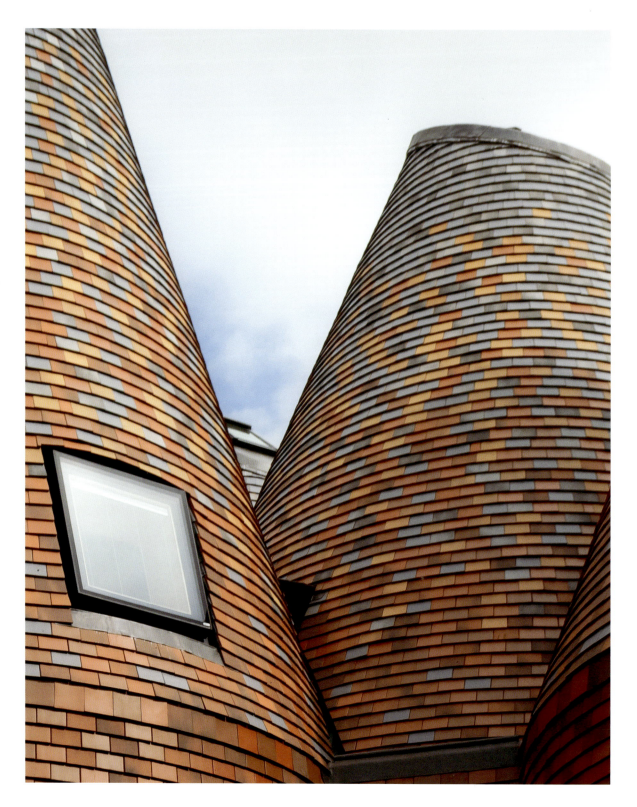

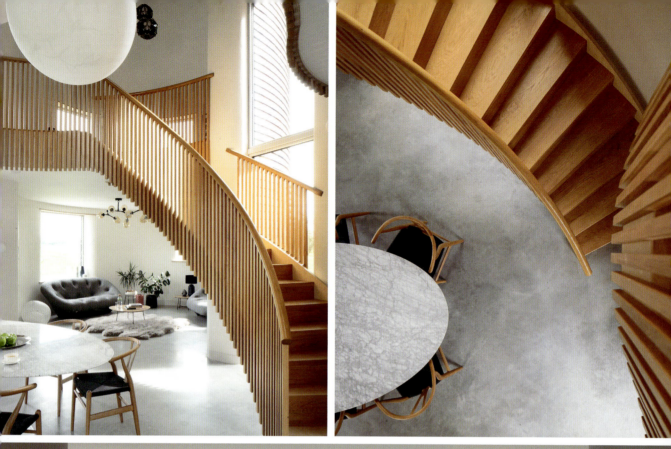
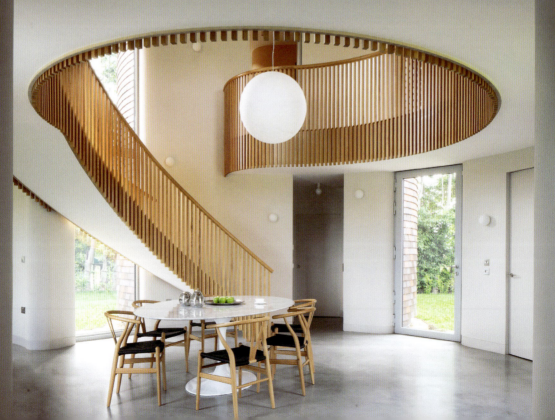

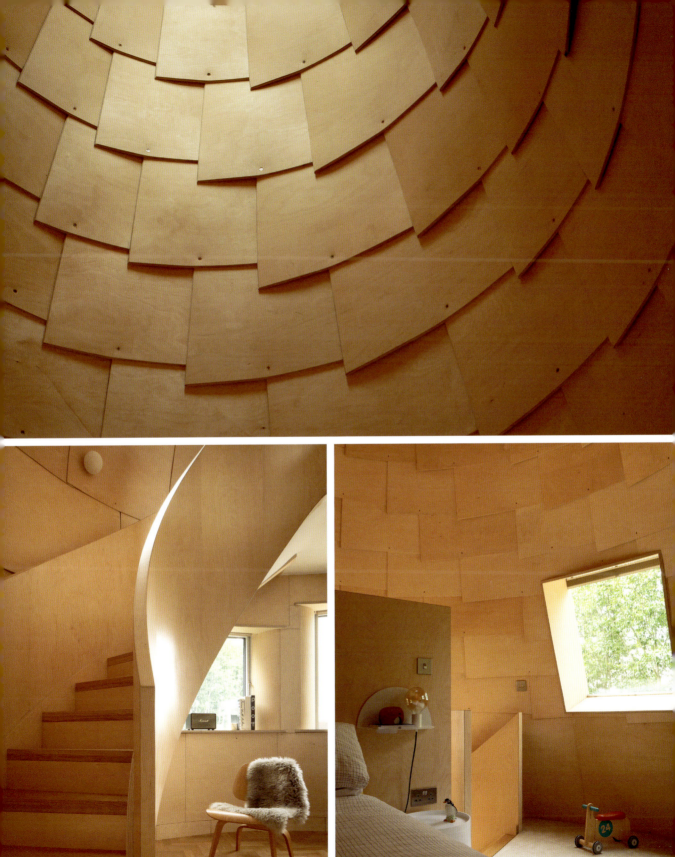

CABIN AT TROLLS PEAK

Rever & Drage Architects
Trolltind, Norway

The inspired decision to include four different types of roofs makes this cabin unique and also bestows upon it its charming character. This is first and foremost a robust heavy-duty cabin with high-quality traditional craftmanship and local timber used throughout. It uses a traditional layout with a connecting row of different building styles and with materials and techniques corresponding with the different indoor functions, the weather conditions they must handle as well as their representative status.

The choice of durable materials and a construction to fit the terrain will give the cabin a long life, even in the harsh weather conditions of this high mountain valley. The cabin is practically designed for an active outdoor family with a lot of equipment and the need for a comfortable place to change before and after hiking and skiing trips and, not the least, to provide a drying area for wet clothes.

The outside composition is that of a traditional row farm (cluster farm) where buildings with different functions and different construction techniques are arranged in a line corresponding to the dominant direction of wind. Each of the units has its own character as presented by their building technique, roof, and window type. Furthest north the notching technique is late medieval with large, narrowing logs. The living room is built with more elegant nineteenth-century notched logs, while the kitchen has slim, more modern, square logs with dovetail notches. Furthest south is the garage, built in a local timber frame technique and clad with transparent polycarbonate. In this room all the traditional wooden joints are exposed and well lit. From the conservatory the nearby scenic peak of Ryssdalsnebba can be observed to the south.

In the western façade of the building the individual characters of the different units are most obvious, while in the eastern façade their coherence and the cabin as a whole is more prominent. The cabin in this respect can be seen as both a single unit and four separate buildings.

Floor plan

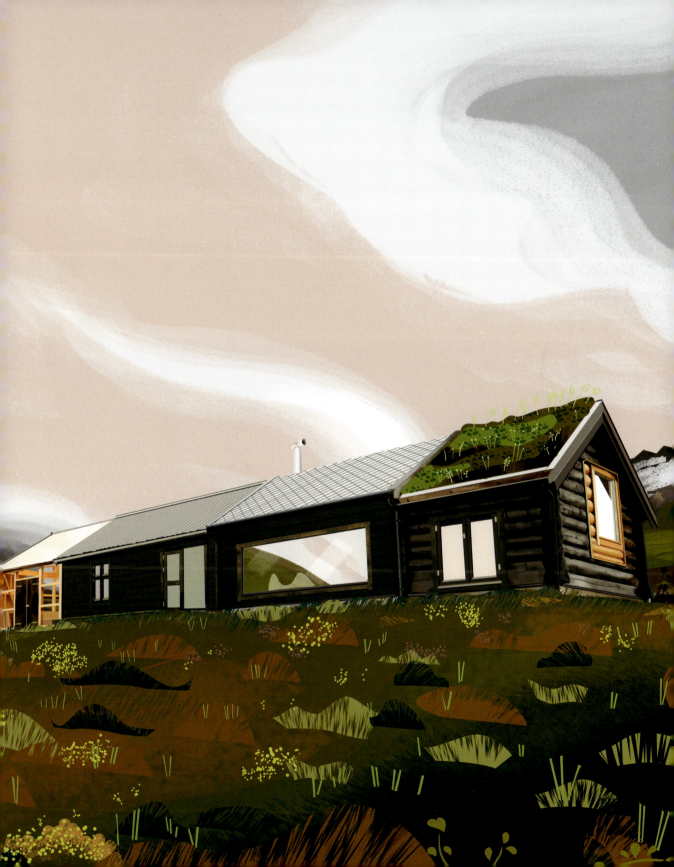

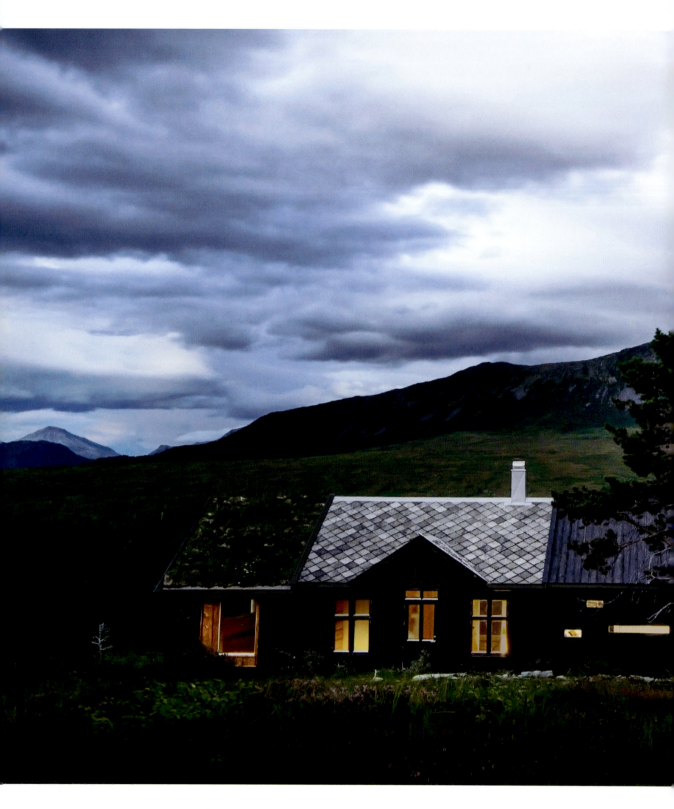

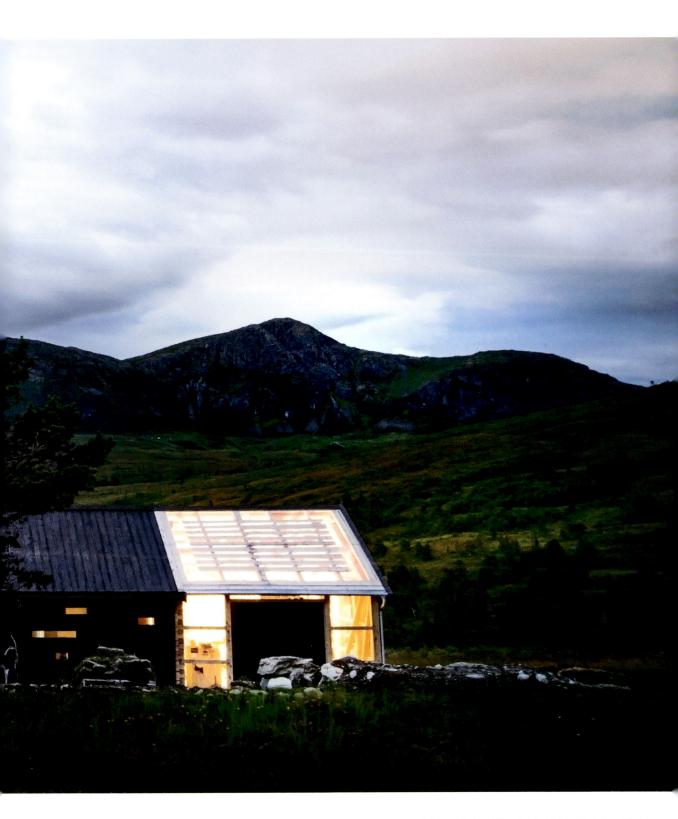

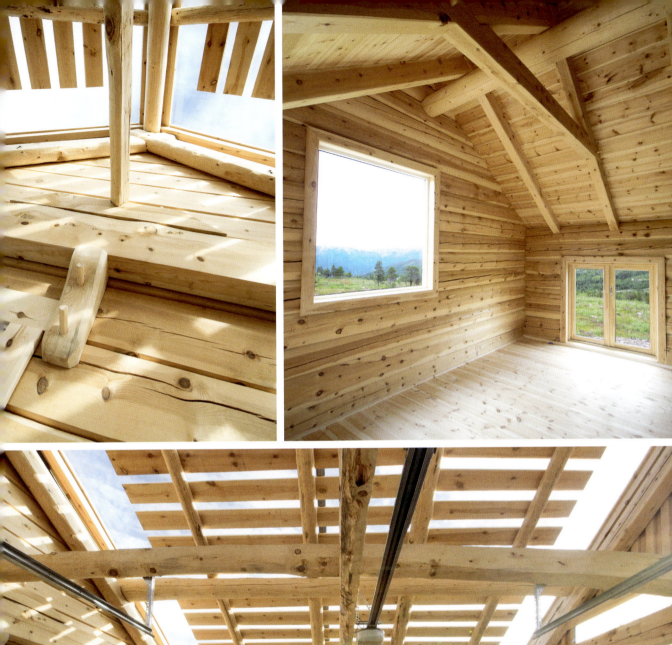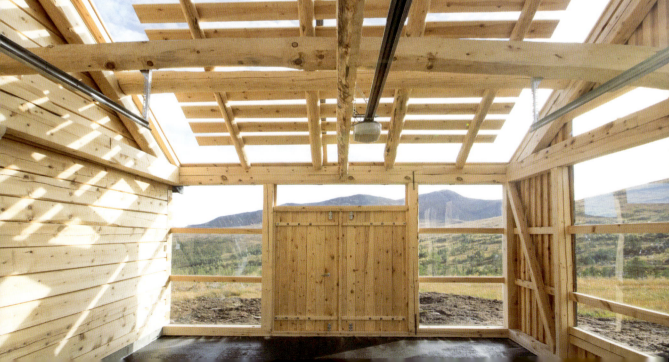

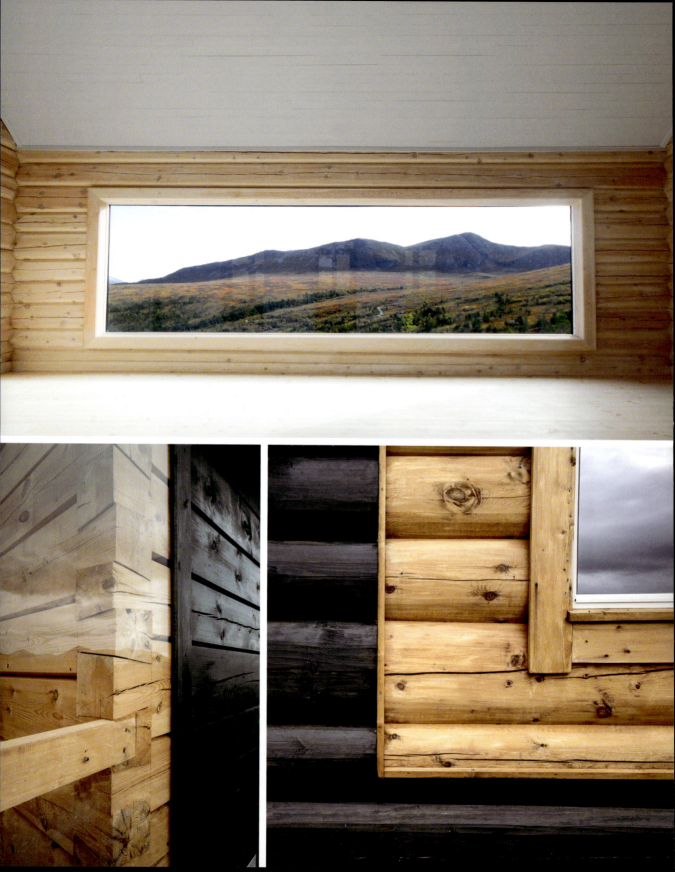

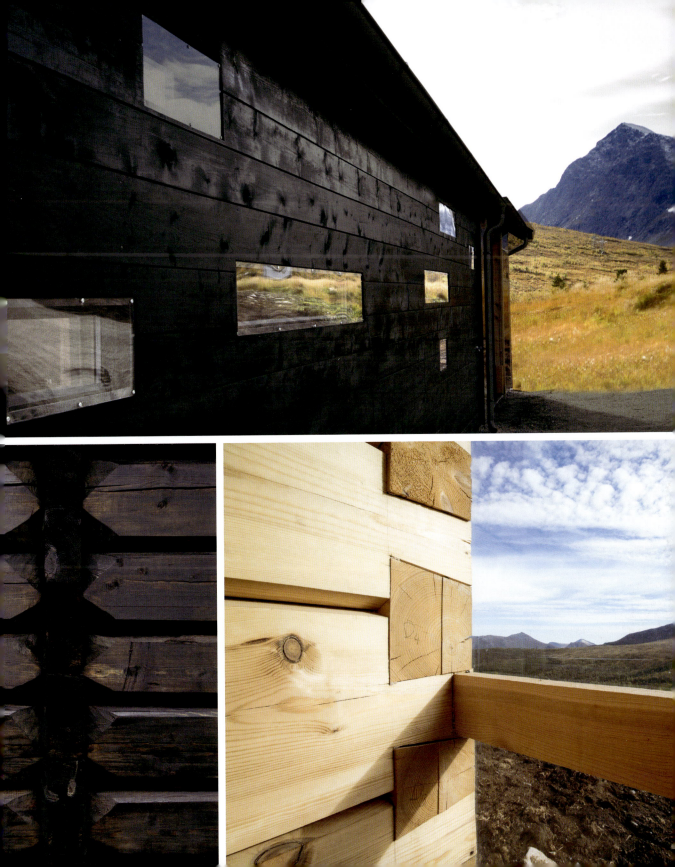

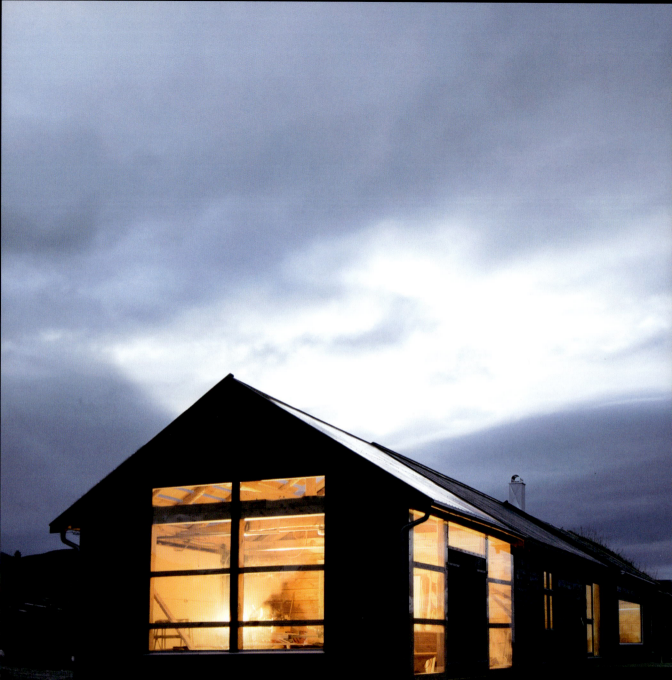

CARROLL HOUSE

LOT-EK
New York, United States

When a block in Brooklyn becomes available, in one of the world's most highly populated cities, a rare opportunity presents itself. This imposing edifice is actually a clever repurposing of shipping containers, in an imaginative and entirely successful build.

The monolithic size of the home can be explained by the use of eighteen shipping containers, stacked and cut diagonally to create a monolithic space, all within the urbanized area.

The diagonal cut modifies the conventional ground-floor rear yard type and uses, allocating outdoor space at each level, a welcome bonus in the busy city. At the same time, the container walls along the diagonal cut shield the outdoor space from passers-by. Large sliding glass walls create continuity between indoor space and outdoor private enclosed decks.

At ground level, the diagonal cut provides entry to the cellar and garage. Kitchen, dining, and living room occupy the first floor above ground, while the area right above the garage ramp forms a media room with bleacher seating and projector. The kids' level is right above, with the intimate space of single containers providing privacy to the bedrooms and a large open area dedicated to playing. At the top, the parents' bedroom is split into an open space with a bed and a large bathtub and a large dressing area with powder rooms.

Ingenious design has resulted in the reuse of shipping containers while creating a visual landmark within a city already full to the brim with buildings of character.

Longitudinal section

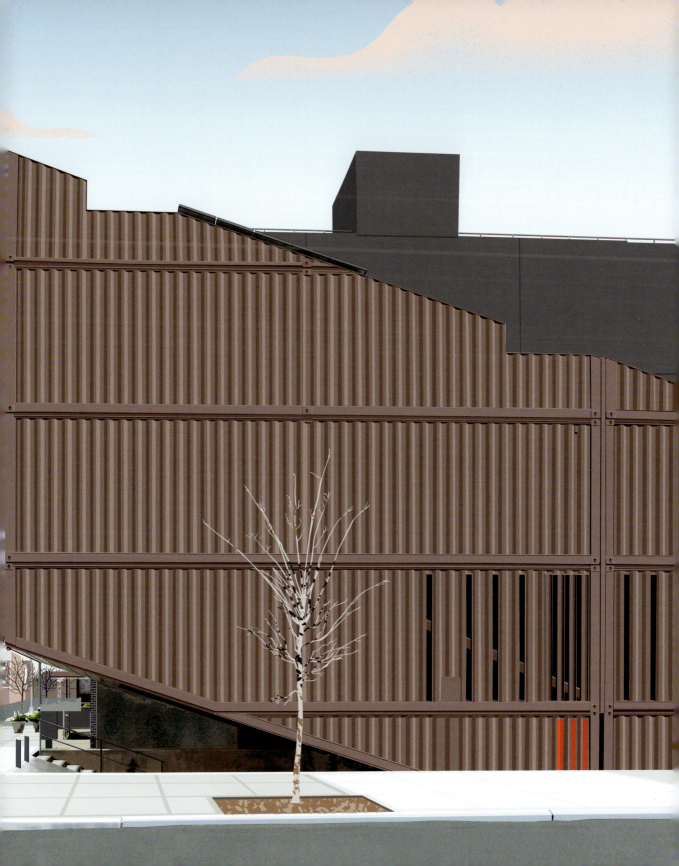

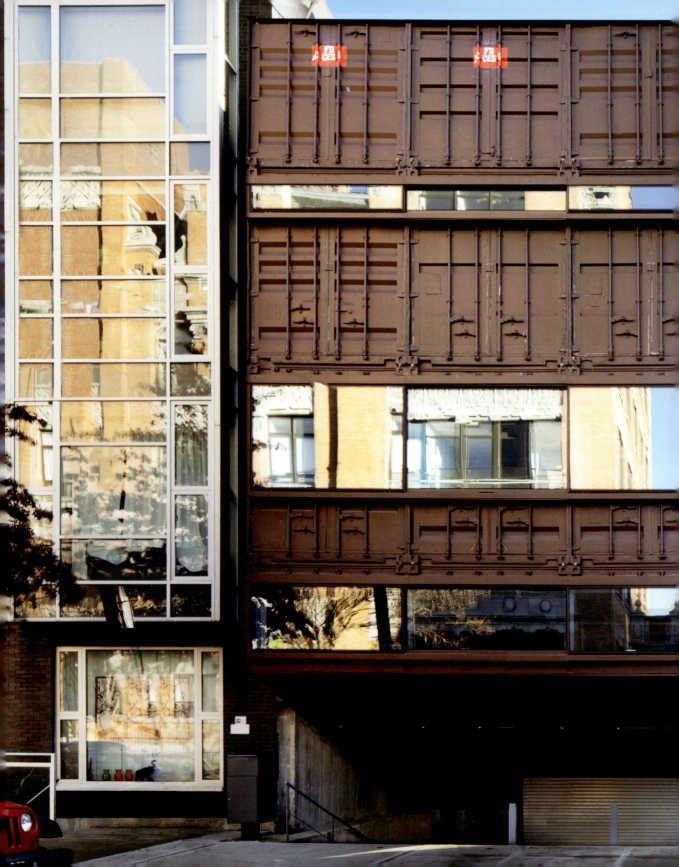

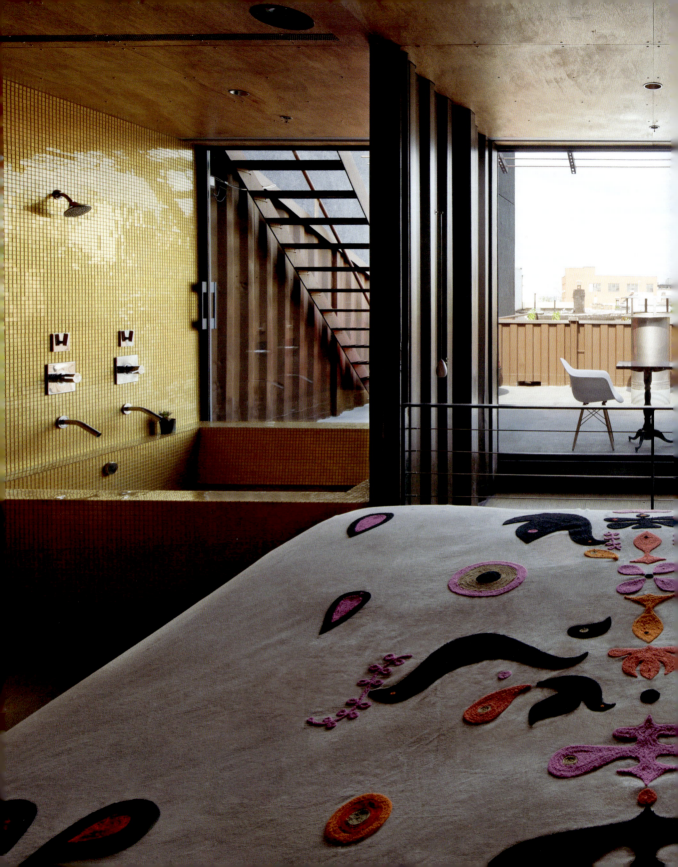

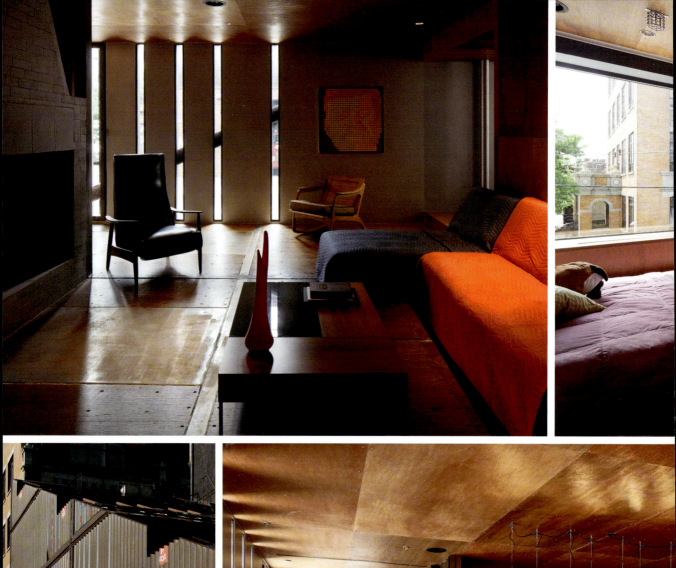
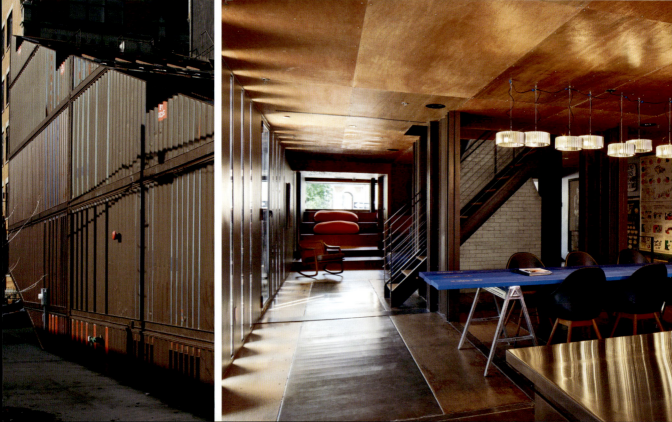

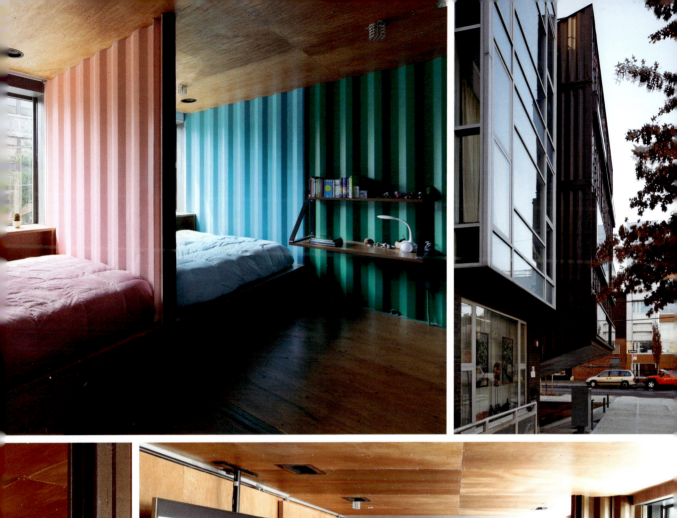
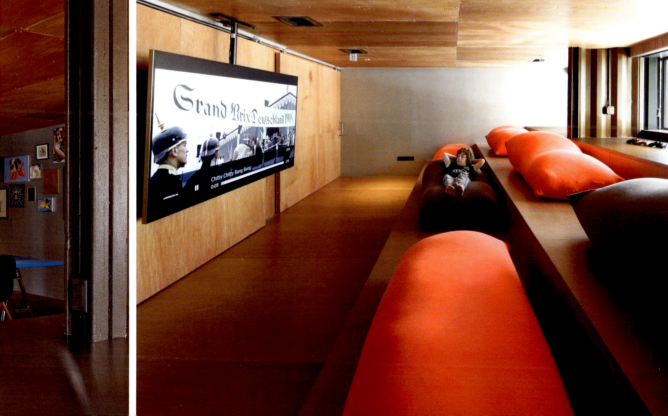

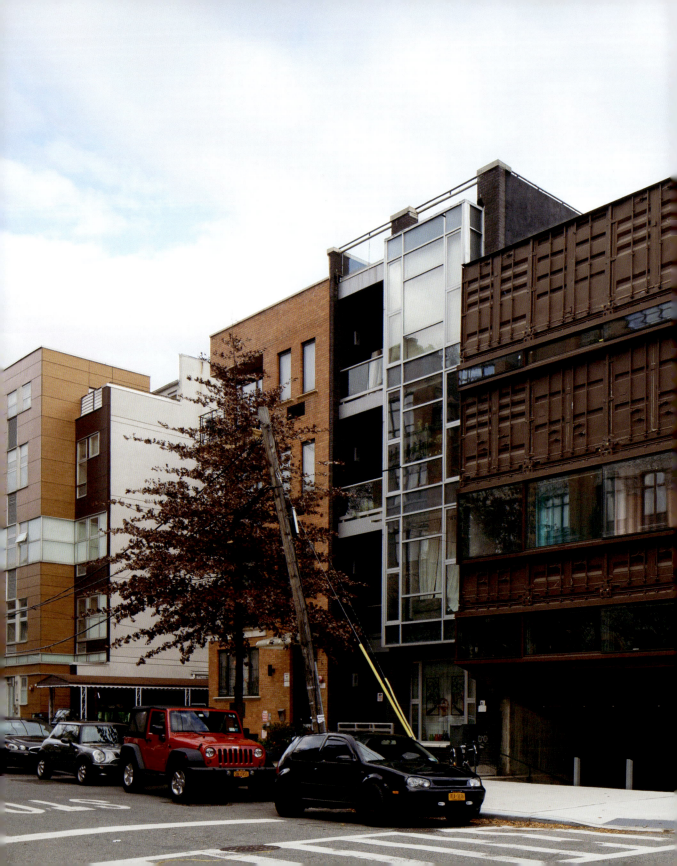

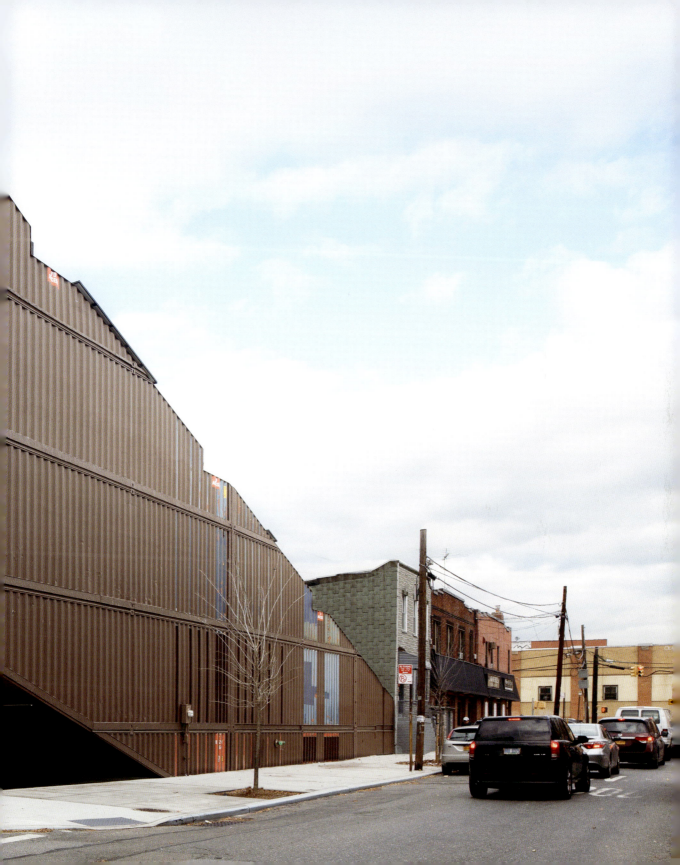

CASA 3000

Rebelo Andrade Studio
Alcácer do Sal, Portugal

What happens when a location is devoid of geographical markers? In this case, architecture (big, bold, and unmissably red) takes the place of the reference points that from time immemorial have guided humans. This is not a house designed to sit gently in its landscape, but one that shouts out its presence.

Located in a rural site, dotted with cork oaks and umbrella pines, the landscape of Herdade da Considerada is overwhelmingly uniform. In fact, as the architect Luís Rebelo de Andrade found on a preliminary visit, it is easier to lose your car in this landscape than in a supermarket carpark. This experience led to a key idea that informed the entire project: in the absence of geodesic markers, let the architecture itself become the reference point, complementing the landscape with a building that you simply can't miss.

Monochrome colors have been used in many different traditional architectural typologies, including the preference for bright red in many Scandinavian structures. The brightness of a single color is also increasingly popular with contemporary designers who use it to create a visible reference point on the landscape.

Not only is this a house determined to stand out against its surrounds, but the architect also sought to create an energy sustainable residence. Indeed, the solar panels and thermal collectors produce more energy than the house consumes. With its steep gable roof, doors, windows, and the primary red, the exterior design of the house echoes the typical child's drawing of a house. The interior is a delightful mix of wood floors and paneling, with a cream-colored palette used throughout.

Casa 3000 successfully uses the concept of a monochrome exterior to create a visual focus point that stands proudly and boldly against the blue sky and amid the green trees. As a bonus, one will never lose your way home to this particular house.

Floor plan

52

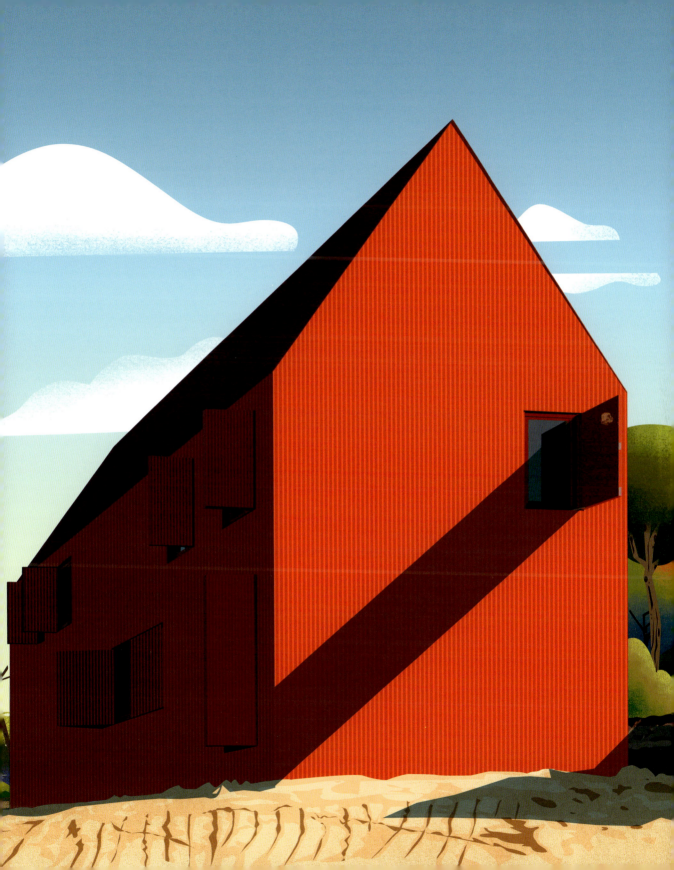

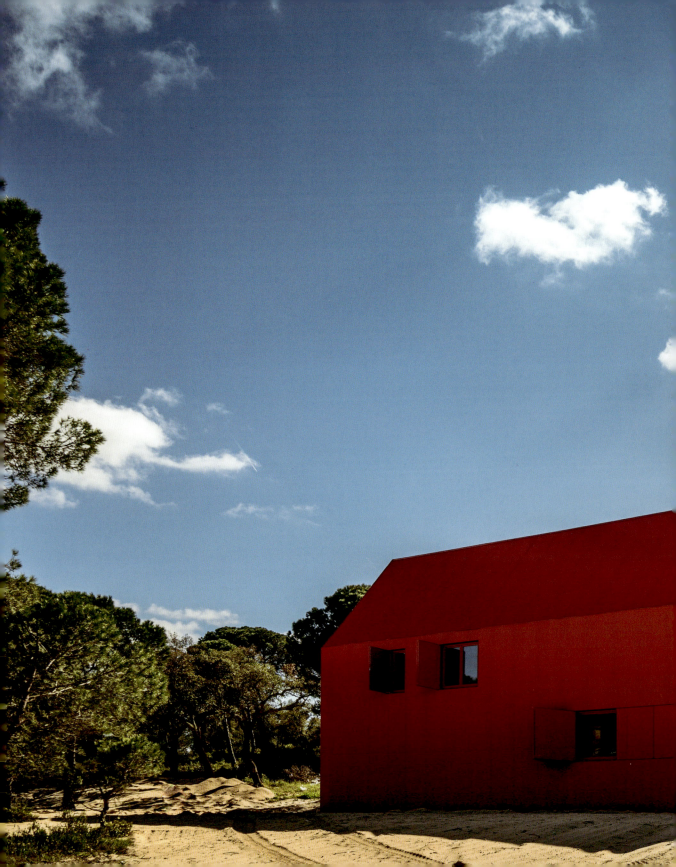

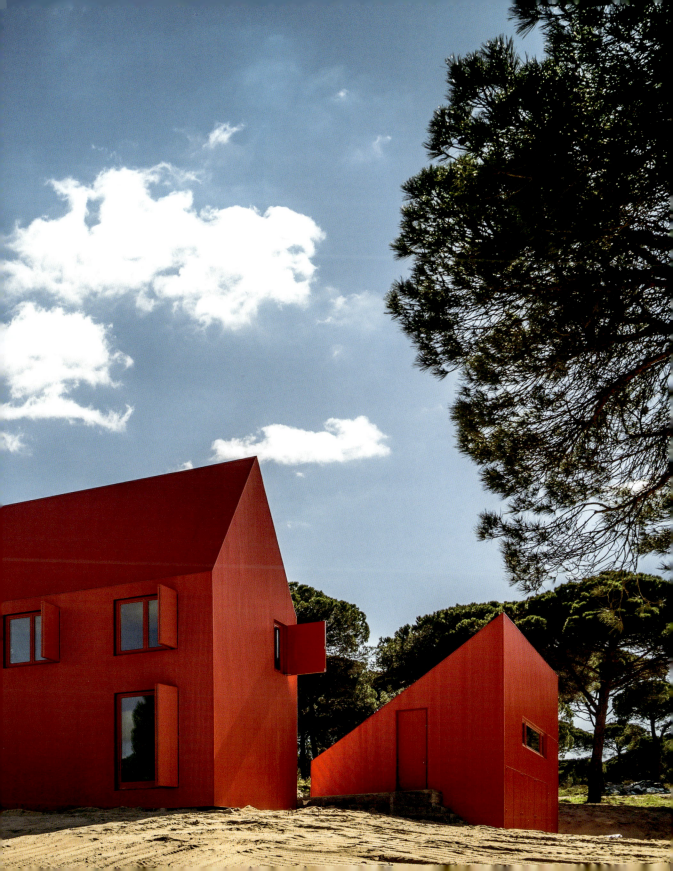

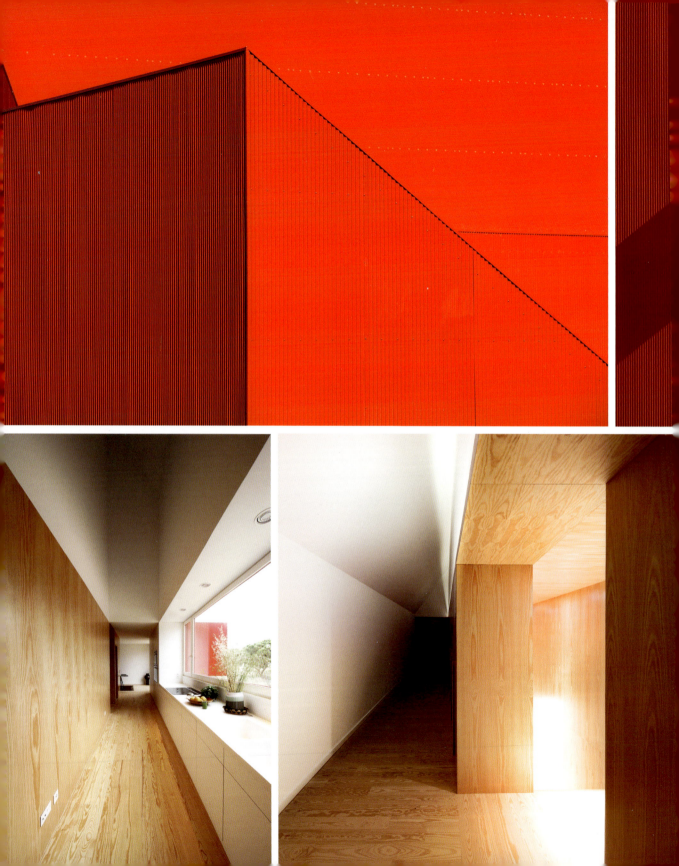

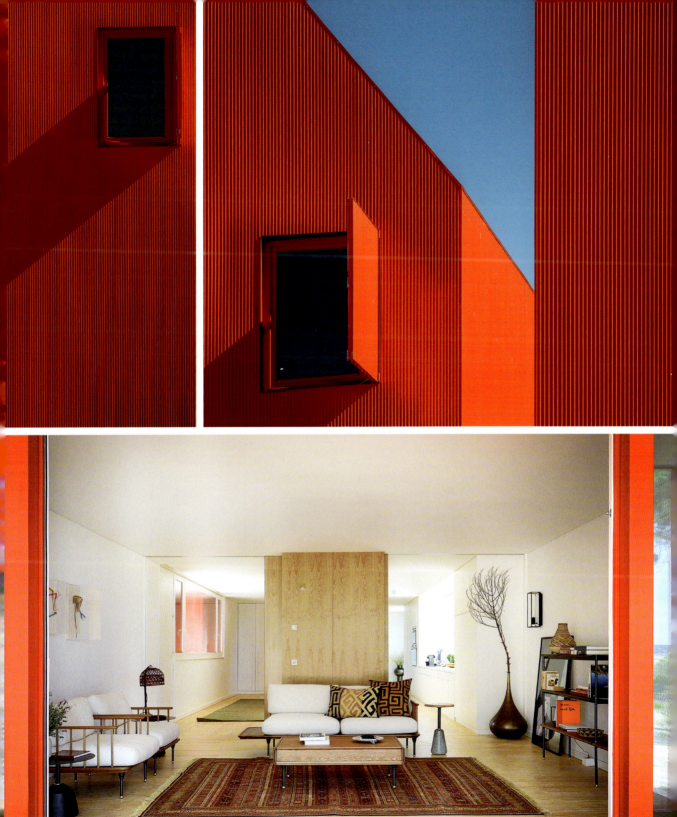

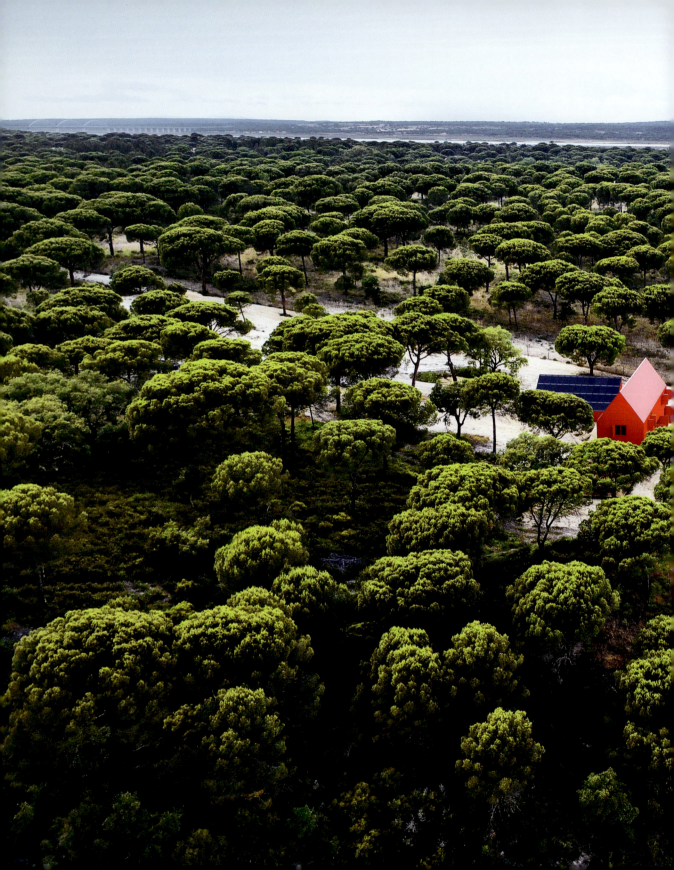

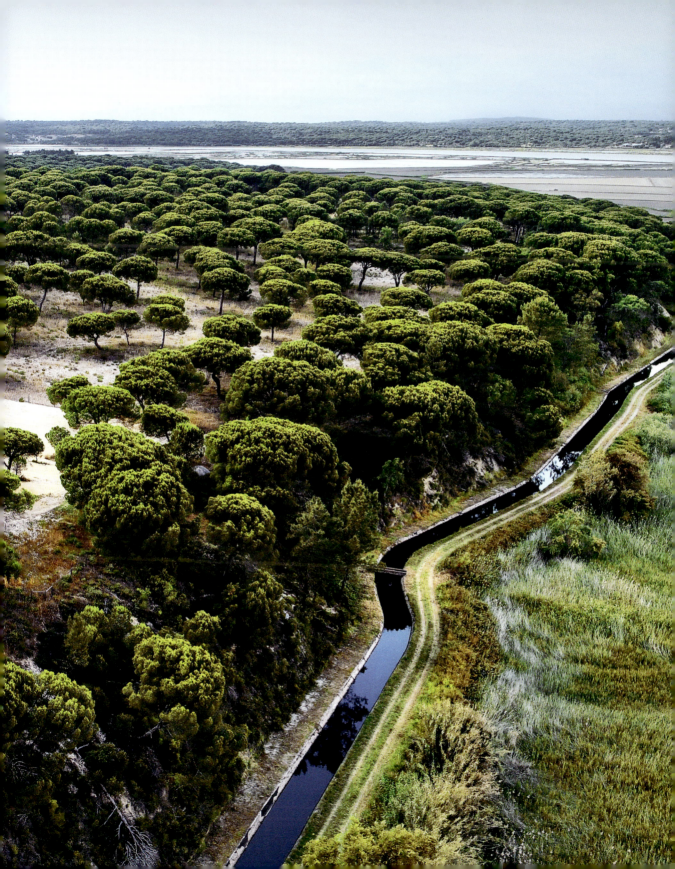

COCOON HOUSE

nea studio
Long Island, United States

A residence with an apt if somewhat whimsical nomenclature, Cocoon House is a wonderful example of a design that delights in the unusual, but adheres to the science of sustainability and through careful consideration of the site conditions.

The uniquely characterized rounded walls form a cocoon shape toward the northern and western neighbors, providing not only shelter but also a measure of privacy. The other side, consisting largely of glass, is in stark contrast more open, and faces south, taking in the ocean breezes as well as the beautiful views. And when the sun is shining, there is the added bonus of passive heat gain.

Indeed, this Gold LEED certified residence achieves a comfortable temperature through passive strategies: the open door to catch the prevailing breezes, or the glass façade that collects heat during winter. The thermal mass of the thick cocoon-like walls keeps away humidity and helps to retain heat.

The cedar shingle cladding on the rounded walls blends in with the architectural material palette of the surrounding neighborhood, and offers no clues as to what will be found on the interior. The soft, undulating yet rather closed appearance of Cocoon House belies its inner colorful true self.

Along the transparent and crystalline hallway, sunlight passes through translucent colored skylights, resulting in changing colors throughout the day. You may imagine that this signals the start of the chrysalis of the cocoon's butterfly, but these colors are actually based on the color theory proposed by Goethe, and employed by J. M. William Turner in his paintings of sunlight above the water. Vermilion red signals sunset and rest, and is located above the master bedroom, while yellow signals zenith and activity, and is found by the living room. At any rate, these panels certainly bestow a colorful brightness to the home, even more so when reflected off the surrounding water reserve.

The interior is light, bathed in natural sunlight, while the décor is minimalist, resulting in a cool, relaxed ambience. Large glazed sliding doors connect the inhabitants with the sounds and smells of the garden and, in the distance, the ocean. The perfect residence to cocoon yourself away in.

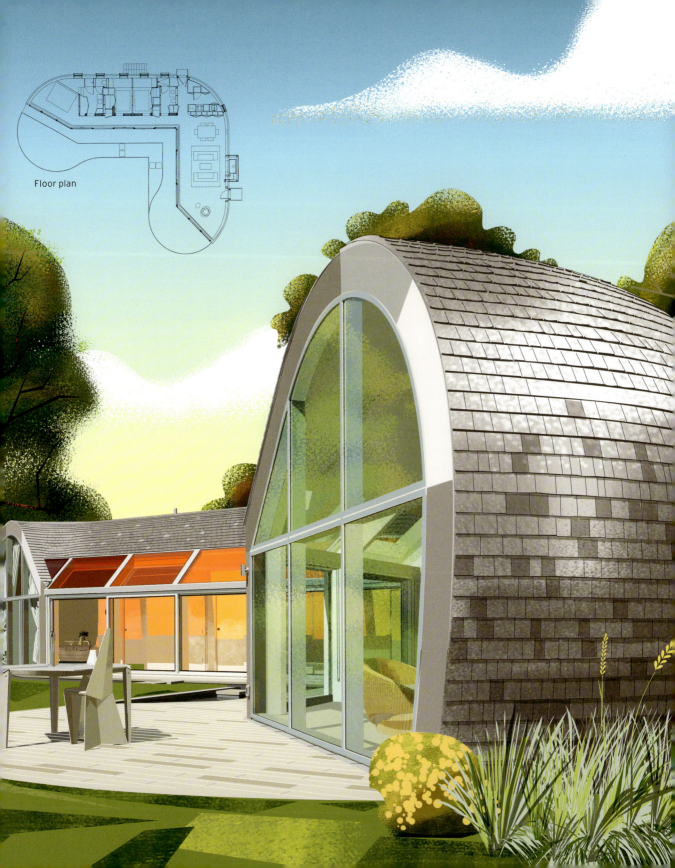

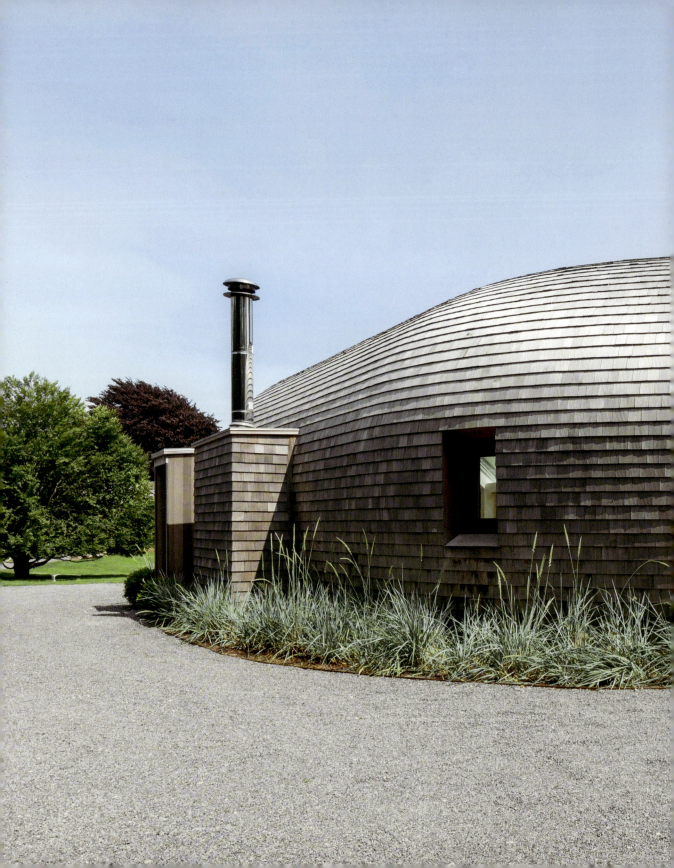

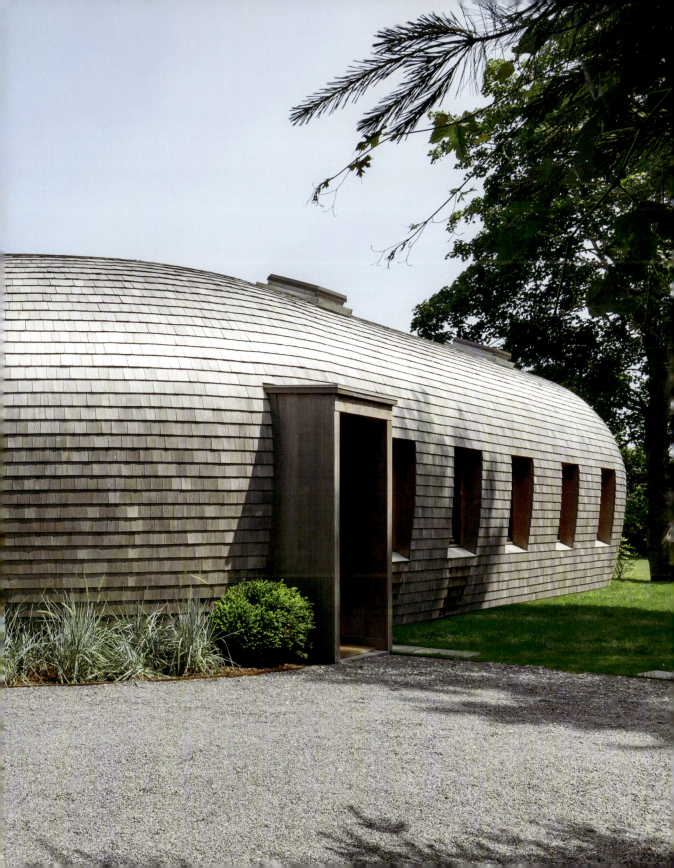

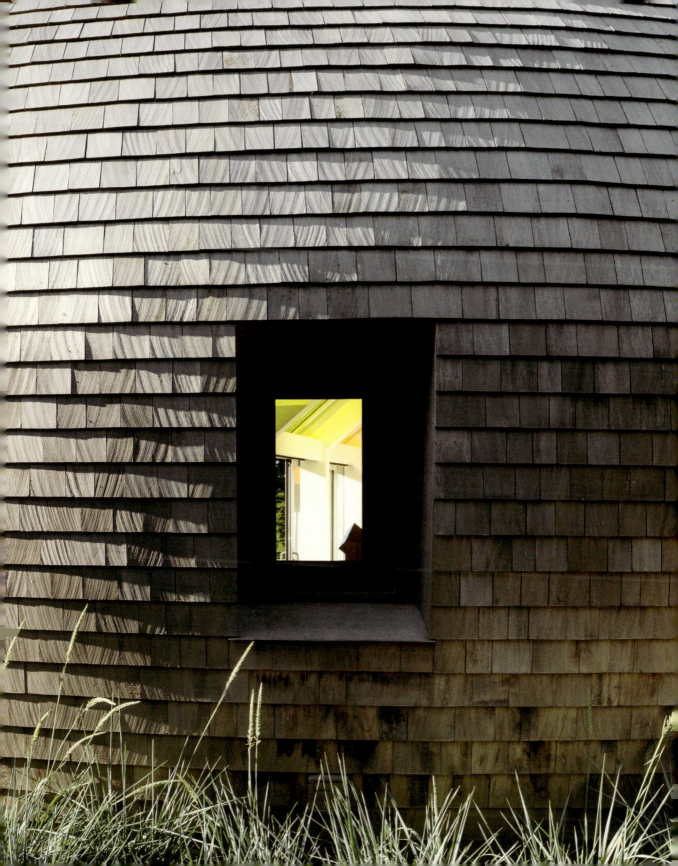

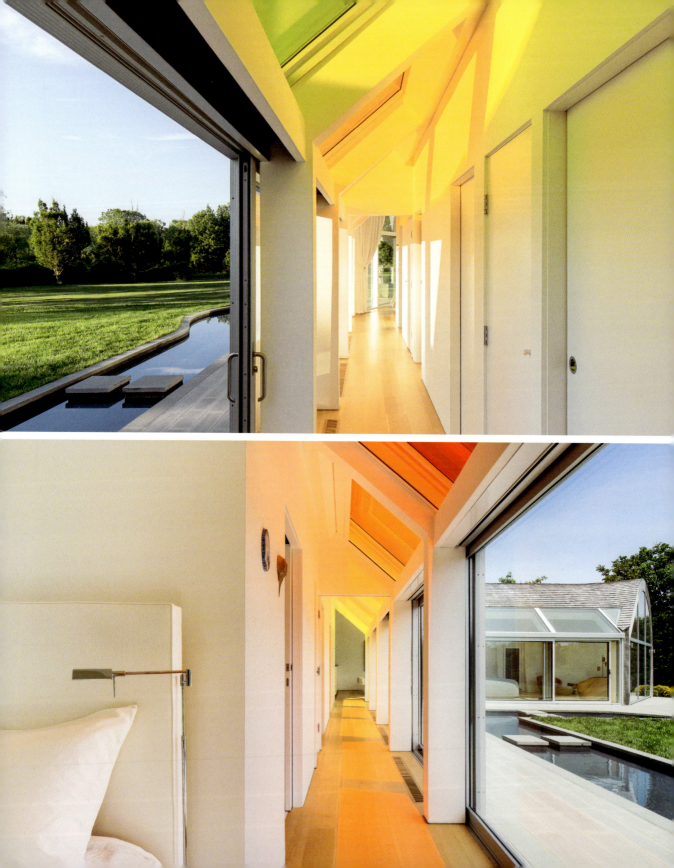

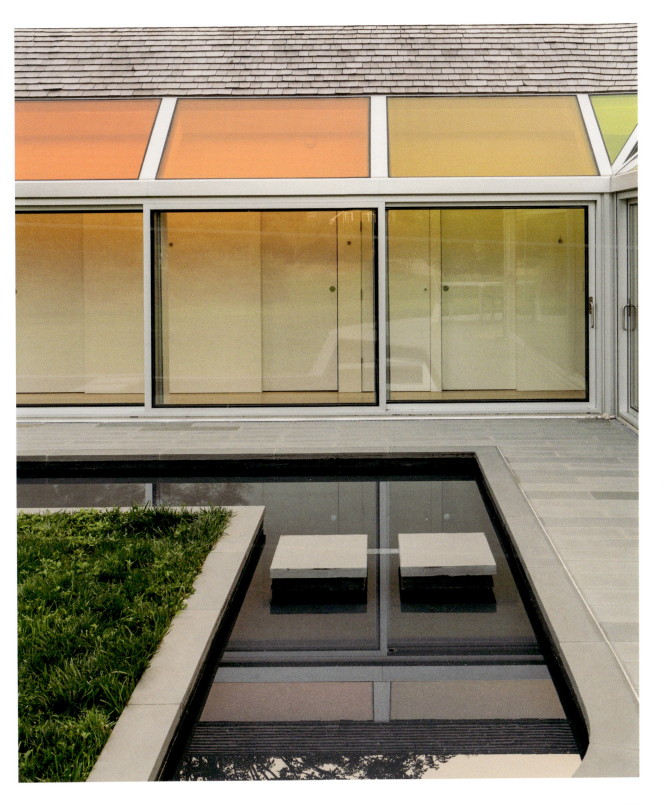

COCOON HOUSE 67

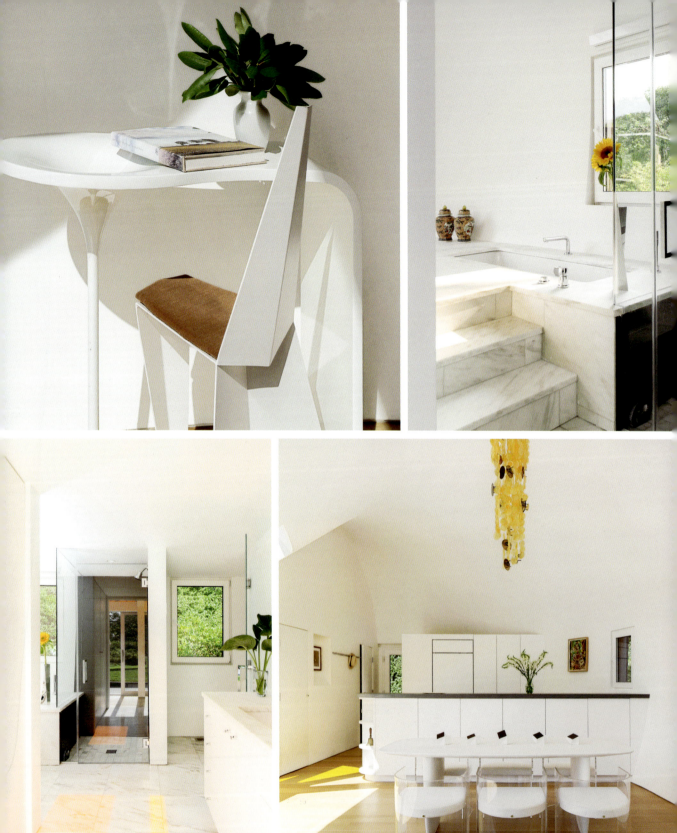

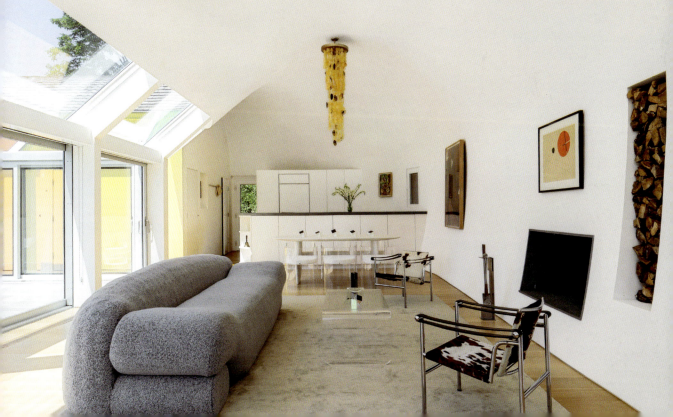

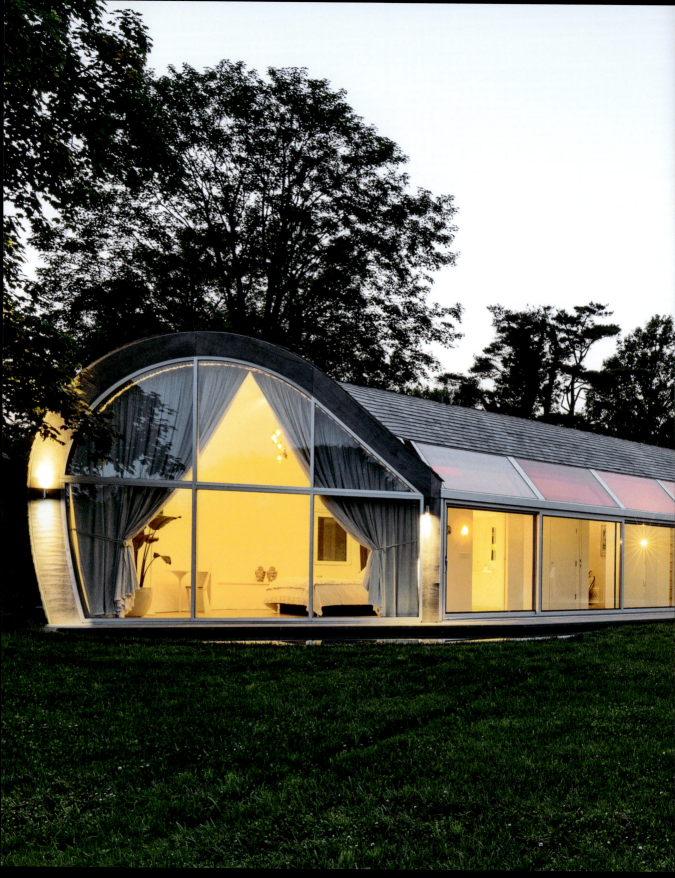

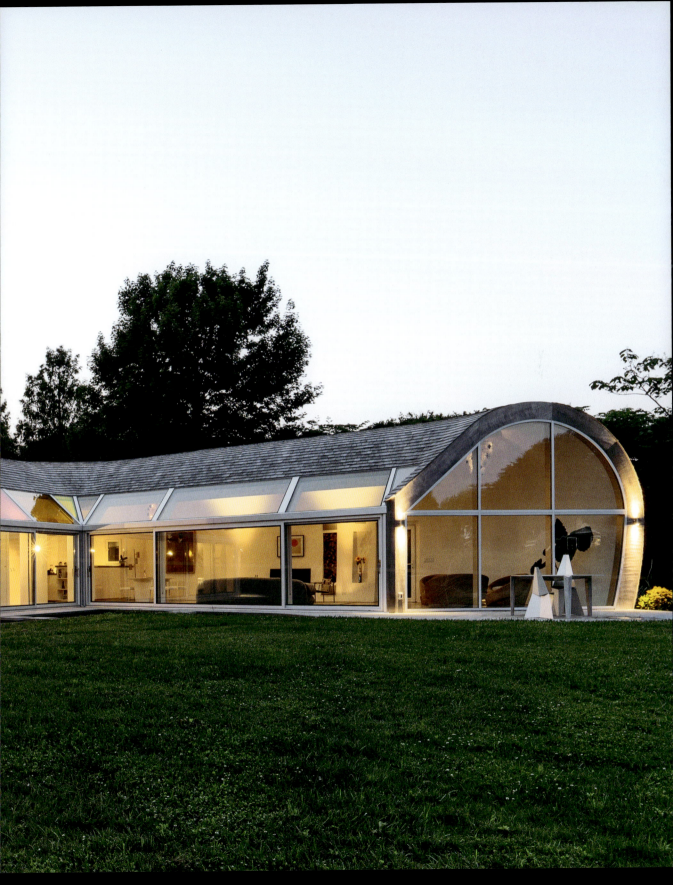

CONNECTED HOUSE

Jacob + Macfarlane
Paris, France

Befitting its location near the famous Bois du Boulogne in western Paris, this striking house certainly makes a dramatic and unusual statement in its setting, surrounded by trees. And in fact, the house was conceptually based on the natural growth system of a tree, inspired by the notion of concentric tree rings around a central vertical circulation core. Continuing this theme, the main structure of the house acts as a trunk, while the steel skeleton branches out to support the floors, and the outer skin of white panels represents bark (or foliage).

The name Connected House refers not only to its technological advances, but to its subterranean connection to the nineteenth-century villa that inhabits the same block of land.

Boasting a tubular exoskeleton, this four-story home continues its theme of connections through its angular windows and openings between the spaces inside, creating interesting and everchanging sightlines. From the dining room, for instance, you can look down through a glazed aperture on the swimming pool below. Or look down on the double-height salon from the staircase. This fractured geometry is echoed in the paving that surrounds the house.

The interior continues the unusual angular shapes as a design motif, from the bookshelves to the fireplace mantel. The inside is light and bright, with plenty of natural light streaming through the oddly shaped windows. The cabinetry is made from oak, as is the large staircase that traverses the levels.

This experimental house sits in excellent company as it continues in the architectural traditional of challenging the limits of housing design, with one of its famous neighbor's being Le Corbusier's own home and apartment building, Immeuble Porte Molitor. The architectural experimentalism begun in the 1920s continues with this bold new design.

Section

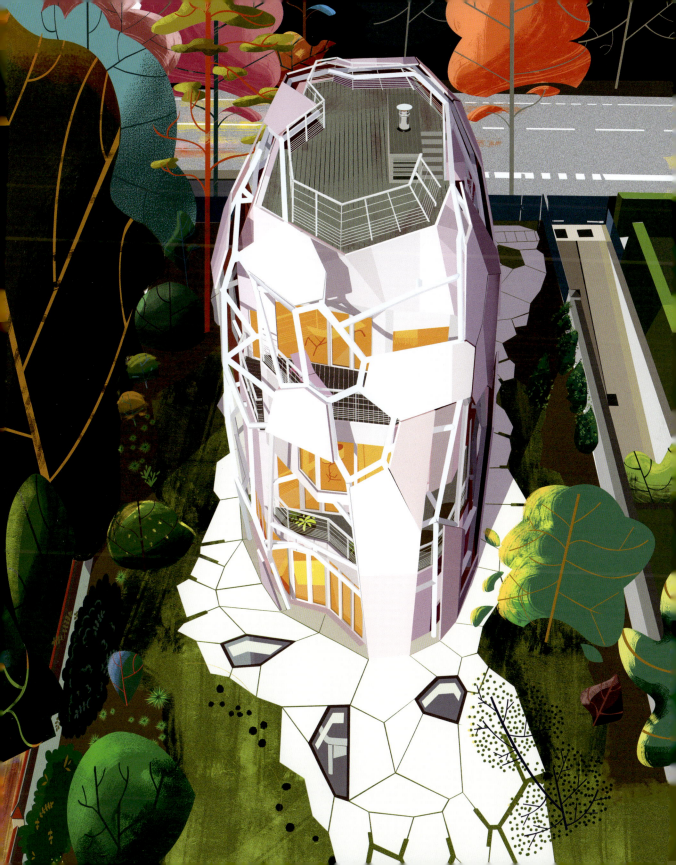

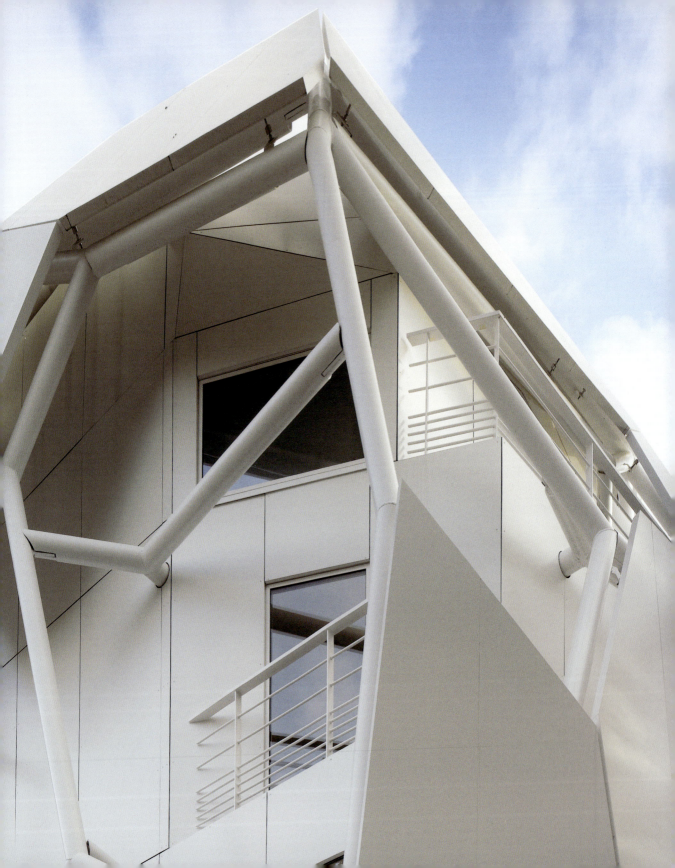

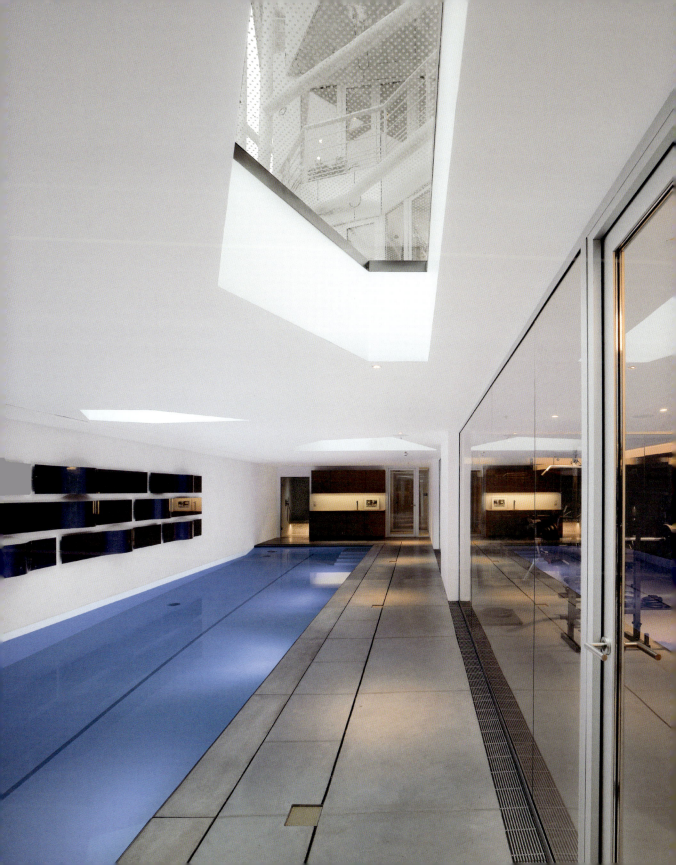

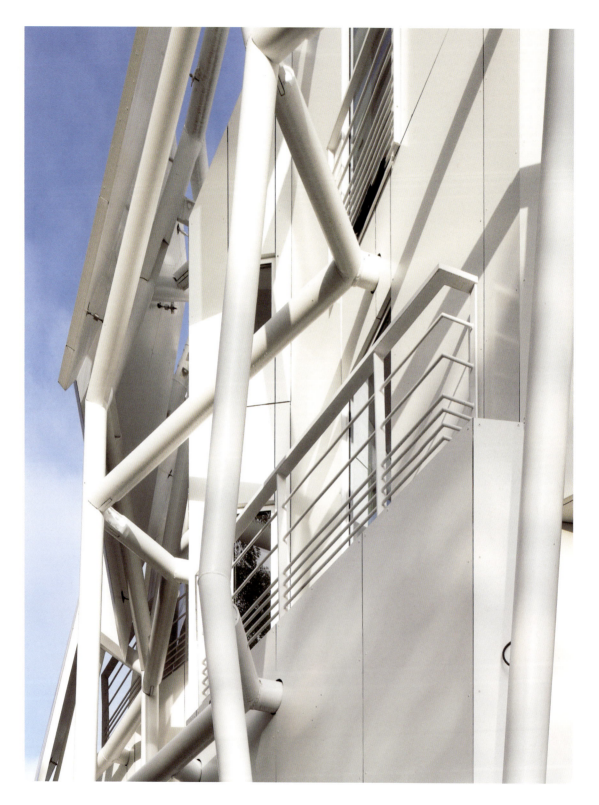

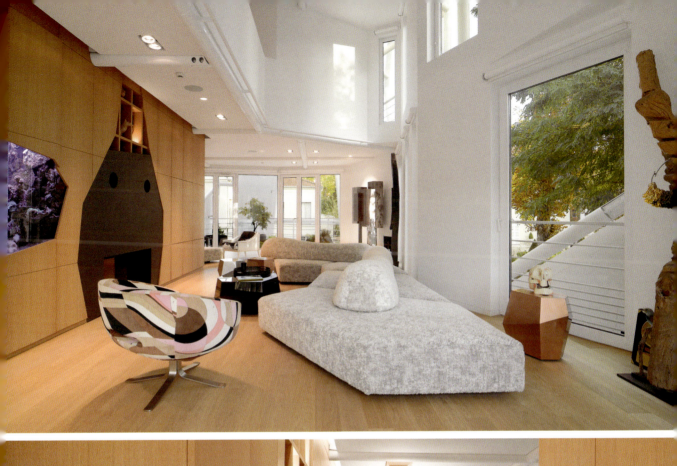
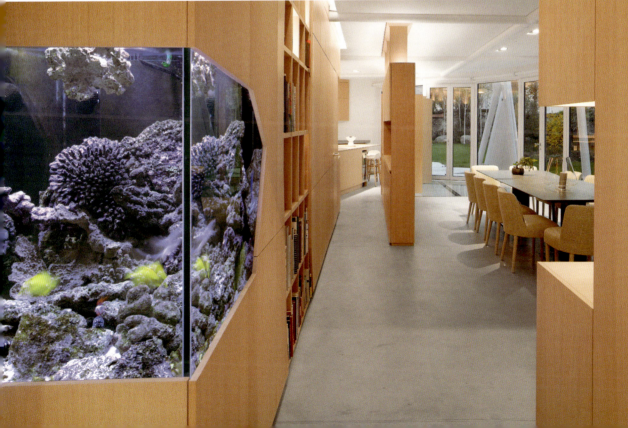

CORK HOUSE

**Matthew Barnett Howland
with Dido Milne and
Oliver Wilton
Berkshire, United Kingdom**

Peeking out from behind the shrubbery in rural Berkshire, Cork House at first glance resembles giant, old-fashioned beehives. And when seen looking into the distance toward the cathedral with its flying buttresses and spires, you could be forgiven for thinking this might be a modern if humble reinterpretation of the dreaming spires of England.

But aside from its almost Hobbit-like character, Cork House is a thoughtful response to the architecture industry's impact on the planet. The house is constructed from sustainably sourced load-bearing cork blocks combined with timber components, and the structure is designed so that it can be dismantled, reused, or even recycled in the future.

Squatting fixedly and determinedly in place along the banks of the River Thames, the home comprises five volumes, each topped by pyramid-like skylights, optimistically angling toward the sunshine. The skylights at the apex can be opened to increase ventilation. The interior is modest in size, but boasts an open-plan kitchen and dining area. The interior is warm and cozy during winter, with light emanating from the light wells.

The cork blocks are made from cork granules, heated to form a solid building material. These blocks are then cut with interlocking joints to form a "Lego-like" kit of parts, which link together to form the solid walls. With lateral stability provided by engineered timber, there is no need for mortar or glue, and the cork material simultaneously provides not only structure, but insulation, external surface and internal finish. The exposed cork creates a rich sensory environment, capturing light and shadows.

This is not the first experiment by designers using cork, but it is the first full-scale building to use the material as a structure rather than as a cladding material. Cork House certainly shows the way to a cozy and sustainable future.

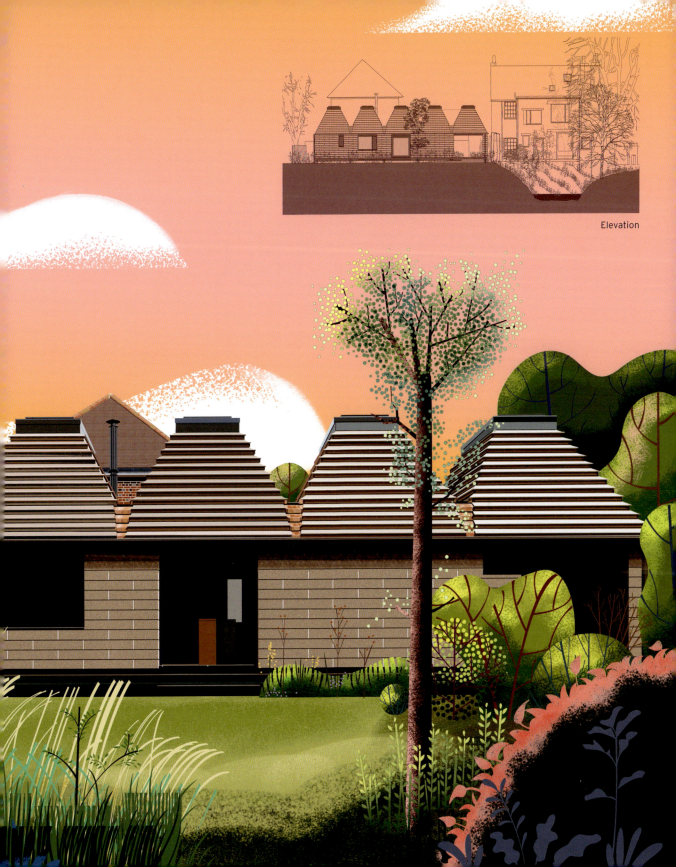

Elevation

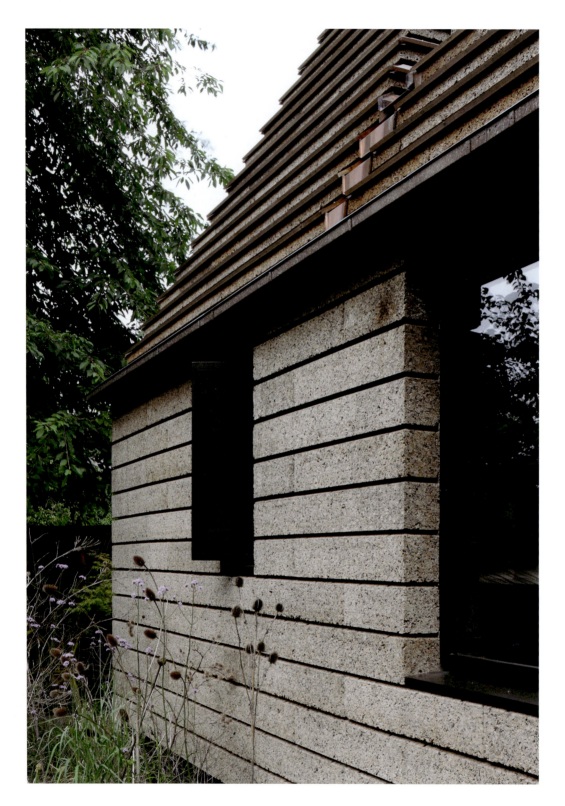

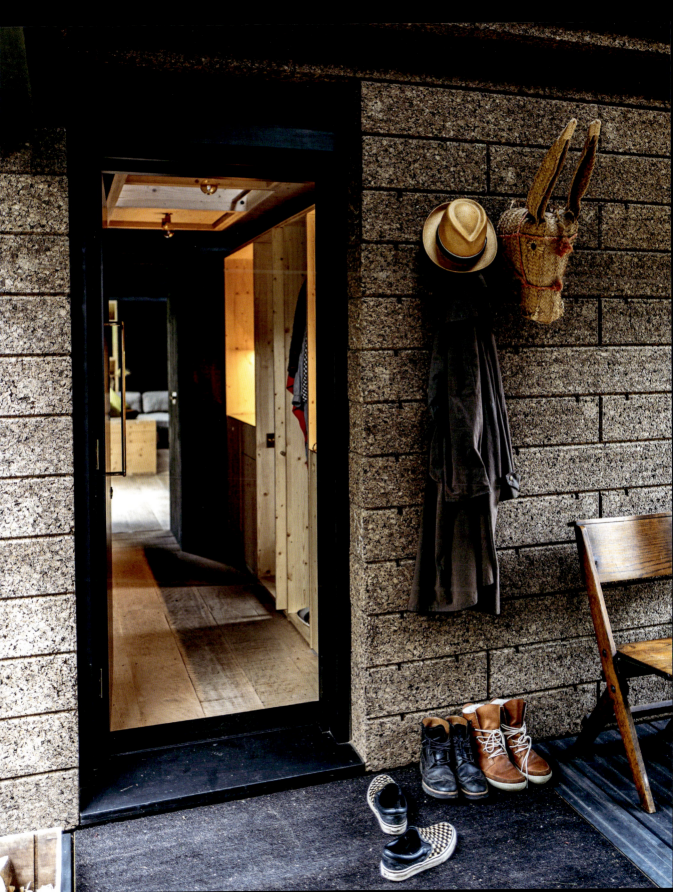

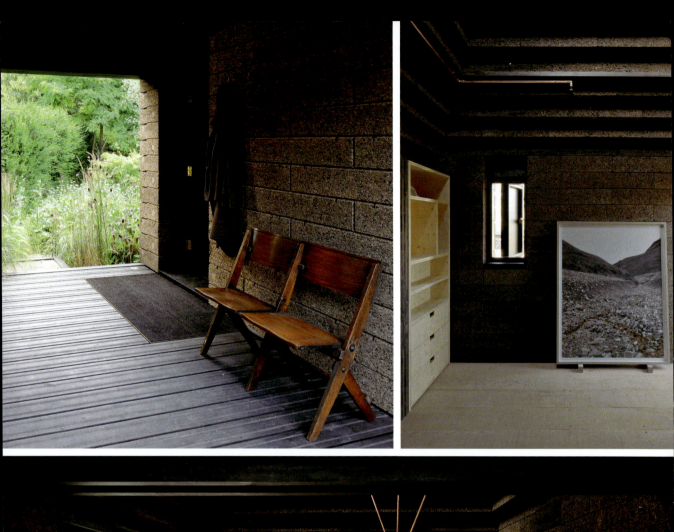
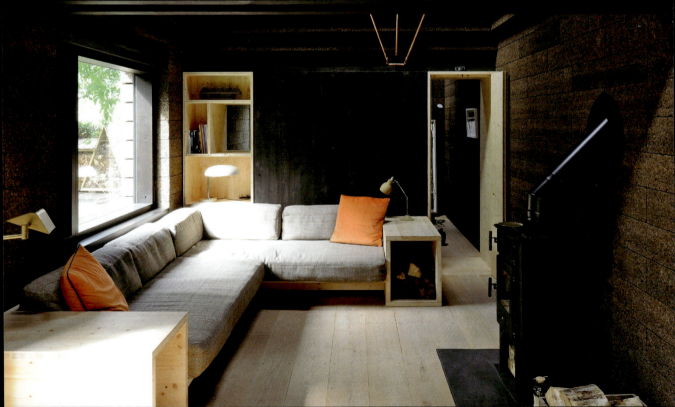

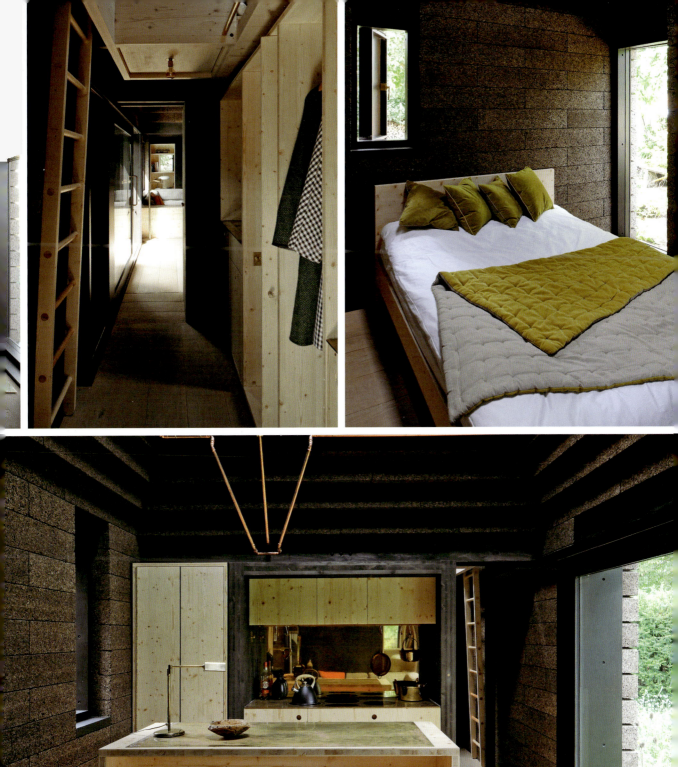

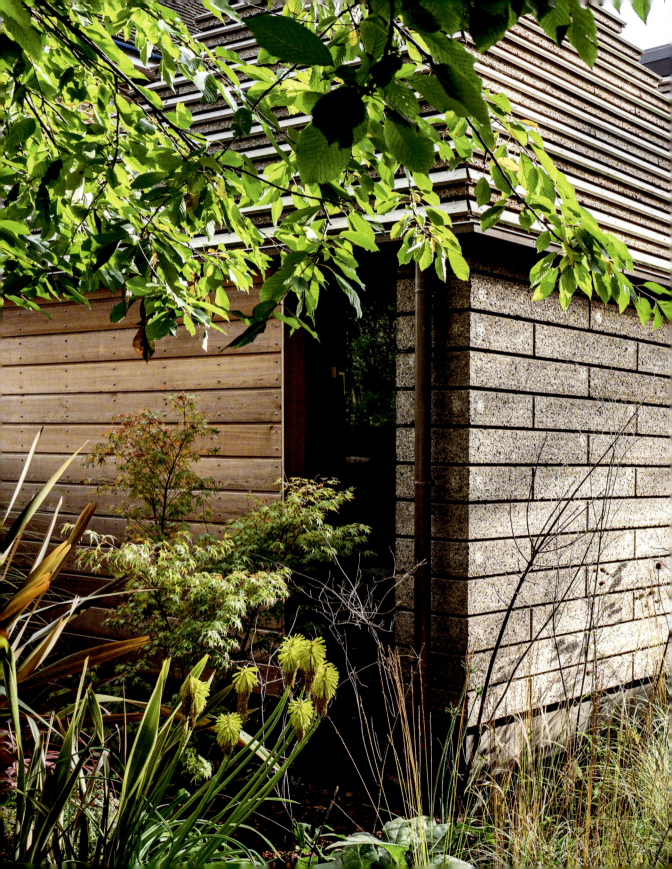

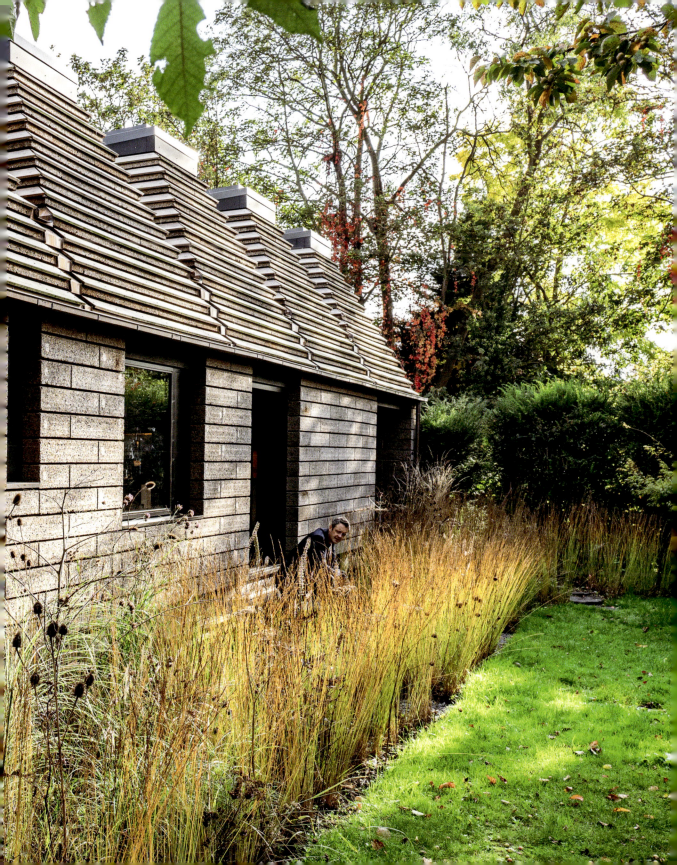

CROFT LODGE

Kate Darby Architects and David Connor Design
Herefordshire, United Kingdom

When designers David Connor and Kate Darby were asked to conserve a heritage-listed overgrown ruin, it raised two questions: firstly how to afford it and secondly which parts were worth conserving?

Their striking and imaginative strategy provided the answer to both these questions. The eighteenth-century cottage was encapsulated within a new building that provided both thermal comfort and structural support, enveloping the ruined structure in a shell of black corrugated metal.

Everything inside is preserved, from the 300-year-old timber frame with original carpenters' marks, peeling lime plaster, birds nests, rotten timbers—even the dead ivy. The old elements bestow an element of theater to the interior.

The new building surrounds and protects the old, warped timber structure, but provides a modern accommodation within. The ground floor has been transformed into a double-height studio for the designers with an entrance hall doubling as a dining room that links with a kitchen and lounge, while a bedroom and bathroom are set overhead.

The smooth, white plastered walls of the new interior provide a neutral backdrop allowing the delipidated timbers to take center stage. With a modern eco-friendly flourish, the new structure boasts triple-glazed windows, to keep the building insulated and airtight, and solar panels on the roof provide energy.

The award-winning project received recognition from the RIBA, who described it as "both bold and brave" while further commending the designers for displaying architectural confidence and maturity. While admittedly not to everyone's taste, the project nevertheless provides an intriguing and stimulating example of a different way of thinking about preservation.

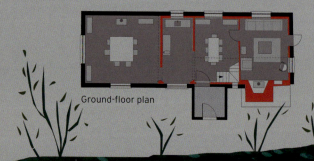
Ground-floor plan

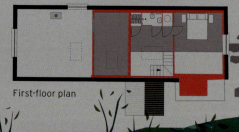
First-floor plan

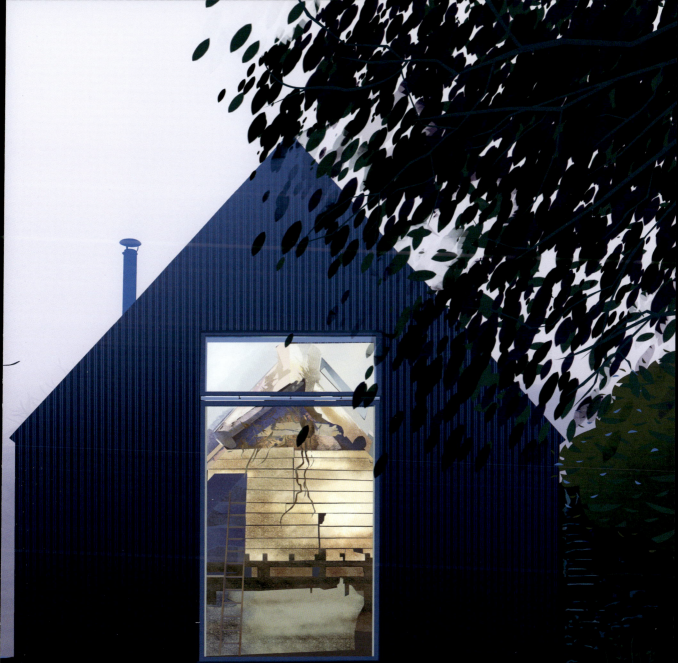

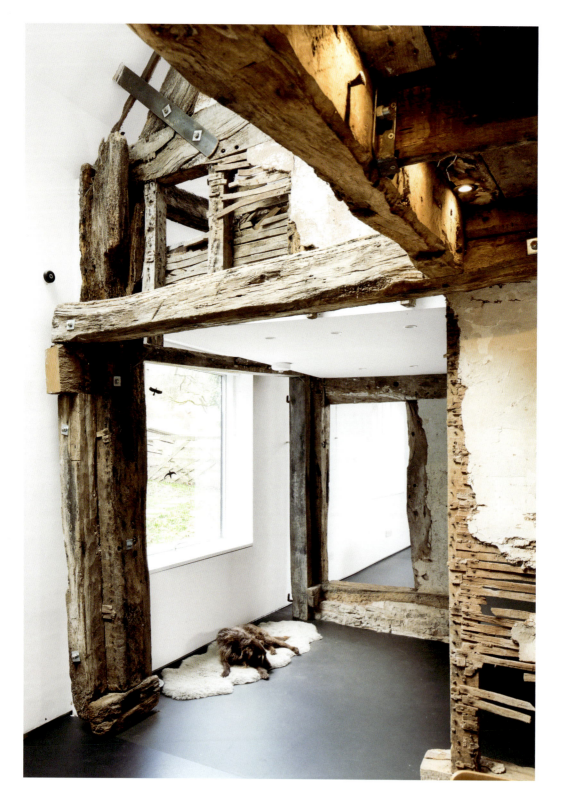

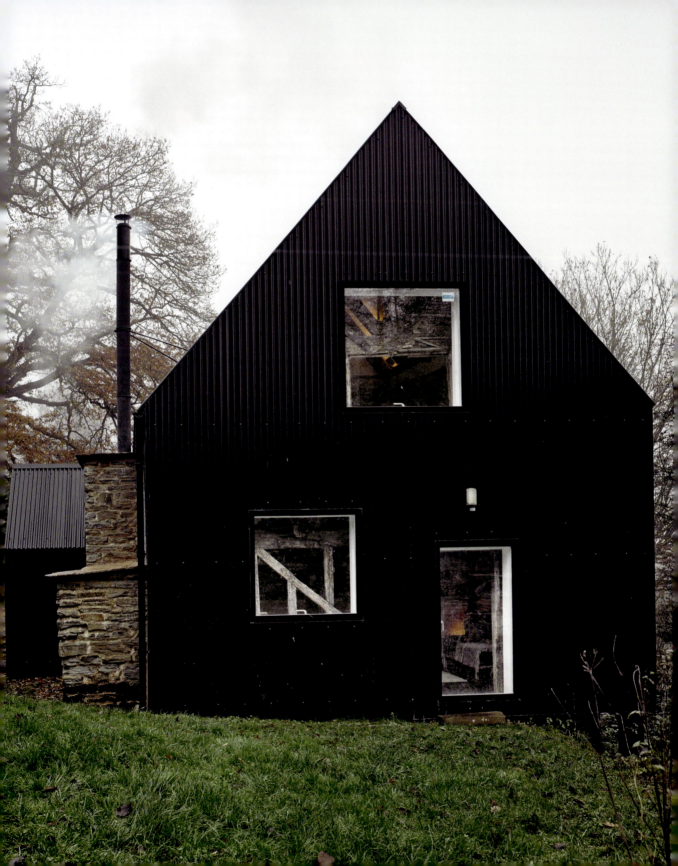

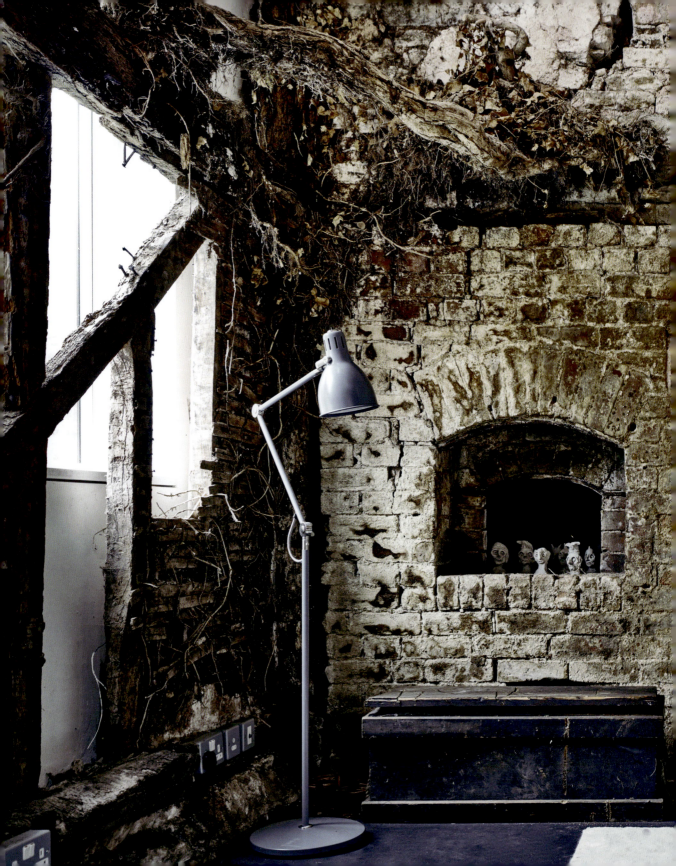

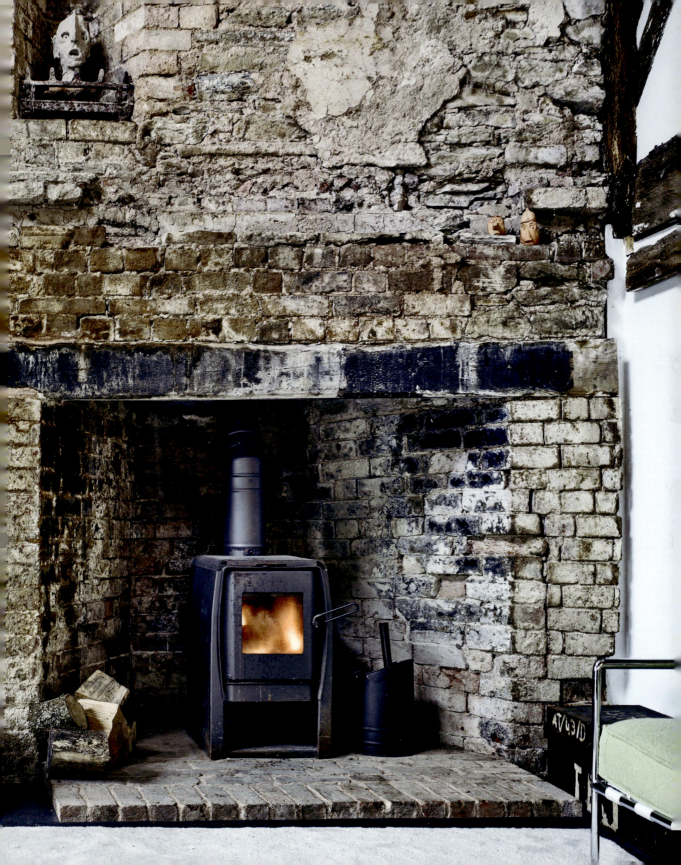

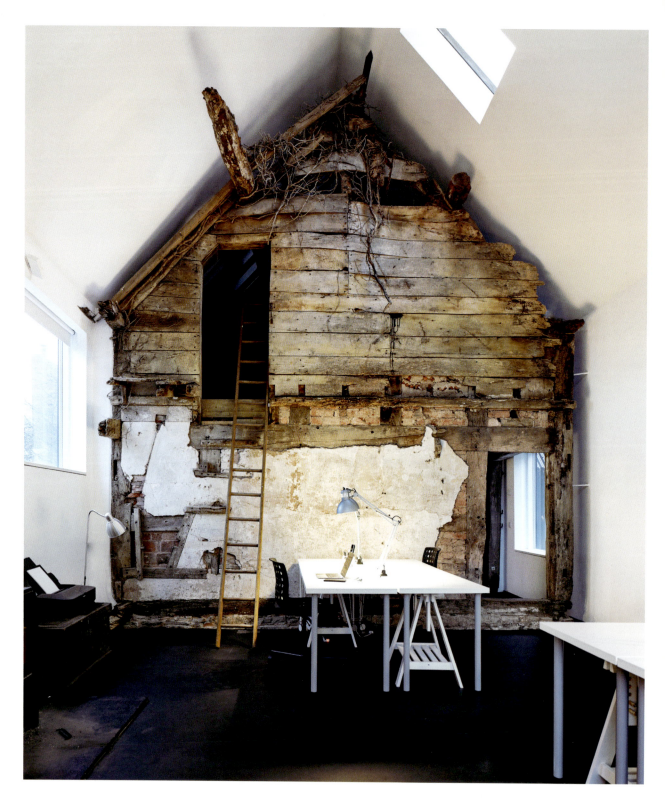

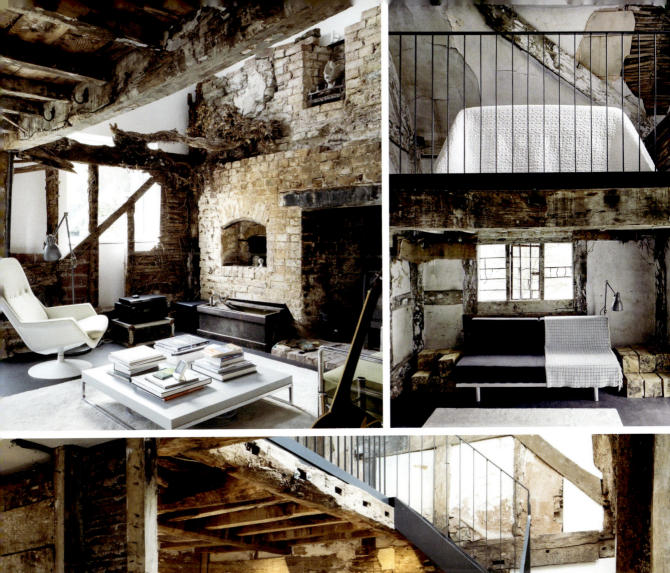
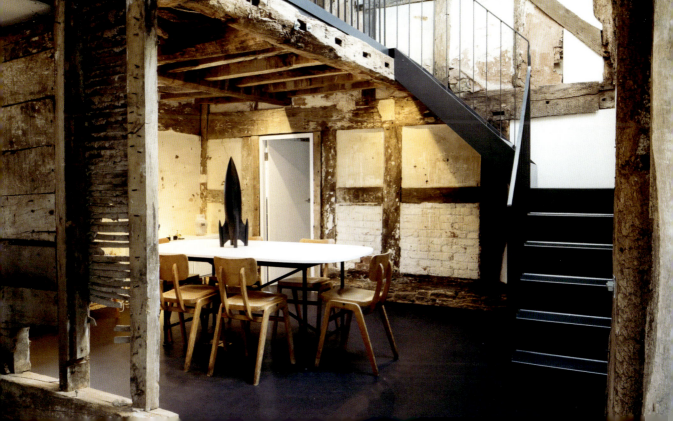

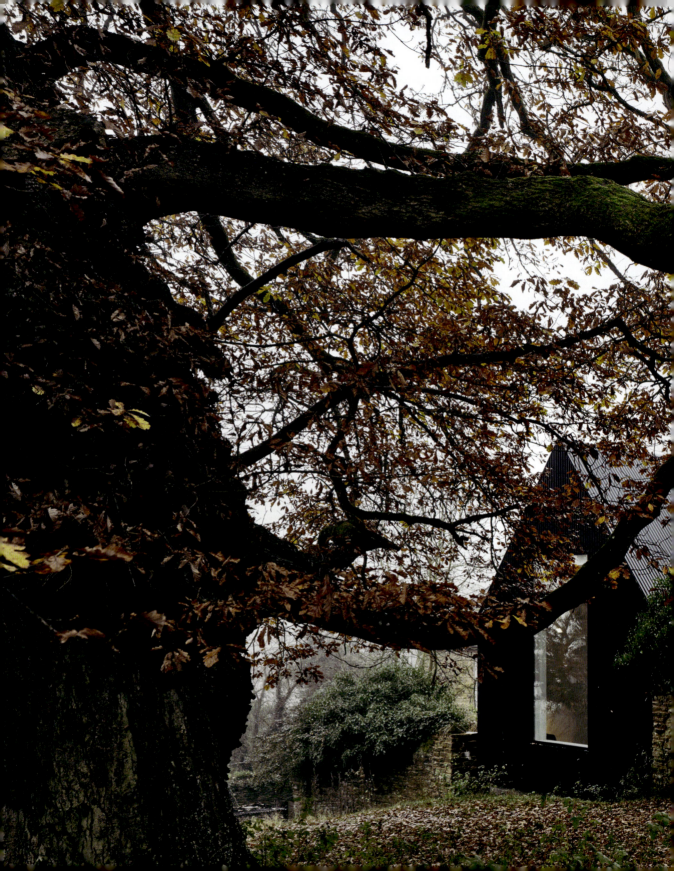

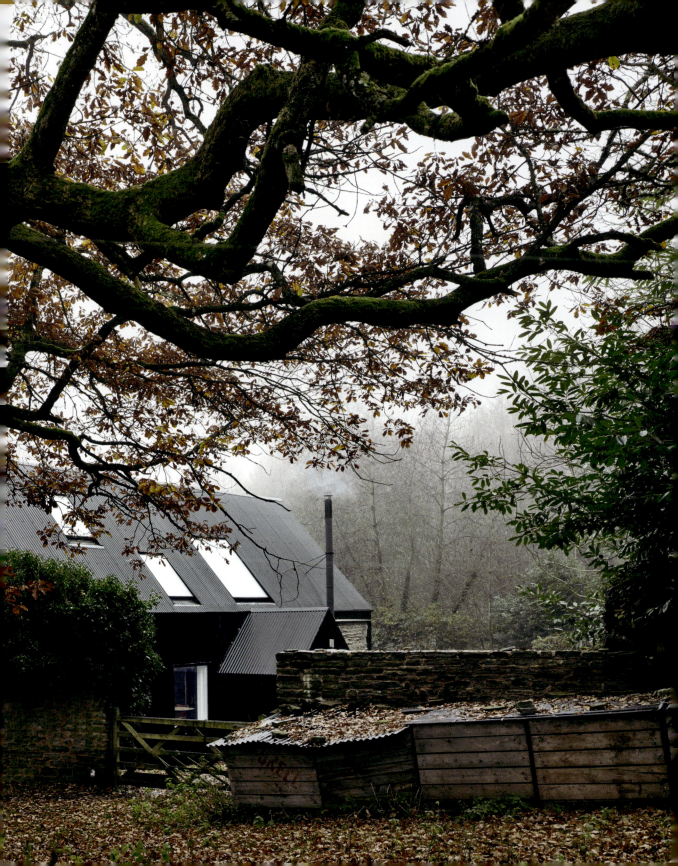

DOMIC HOUSE

Noel Robinson Architects
Noosa, Australia

This expansive private residence burrows into the sand hills to the south of the Noosa National Park and enjoys a stunning easterly aspect with views over the Pacific Ocean. But it is the manner in which the architects cleverly faced the challenges of the site that makes it exceptional. The brief called for a timeless, practical holiday home, with high ceilings, minimal internal columns, use of natural materials, and a strong connection to greenspace and local landscape.

The site was a challenging proposition, being composed of sandy soils, having a steep gradient, being in a bushfire prone area, fronting a conservation zone, being exposed to salt air, and having restricted street access.

The house's sculptural forms and the burrowed nature of its siting was a response to the site's challenges and the client brief. Concrete arches as a structural form minimized the need for internal columns and maximized the open spans for windows. They also produced complex shapes, high ceilings, and the opportunity to create interestingly shaped organic internal bedroom and living spaces.

The continuation of the landscape up and over the house, the use of lightweight timber "eyelids" to the concrete arches and the burrowing of the house into the ground all serve to re-green the hillside and break down the building's bulk. When viewed from the beachside, the national park, and from neighboring houses the residence is largely camouflaged into the landscape. In this sense the residence contributes positively to the visual amenity of the coastal environment.

The client had clear sustainability aspirations, which included the desire for on-site power generation, and incorporation of sustainable and renewable building products. The house has an expansive rooftop solar array supported by a battery storage system and rainwater harvested from the roof is collected for reuse on-site. Internal non-load-bearing walls are composed of hempcrete, which provides for acoustic and thermal insulation, has high carbon sequestration, and is a fully recyclable product.

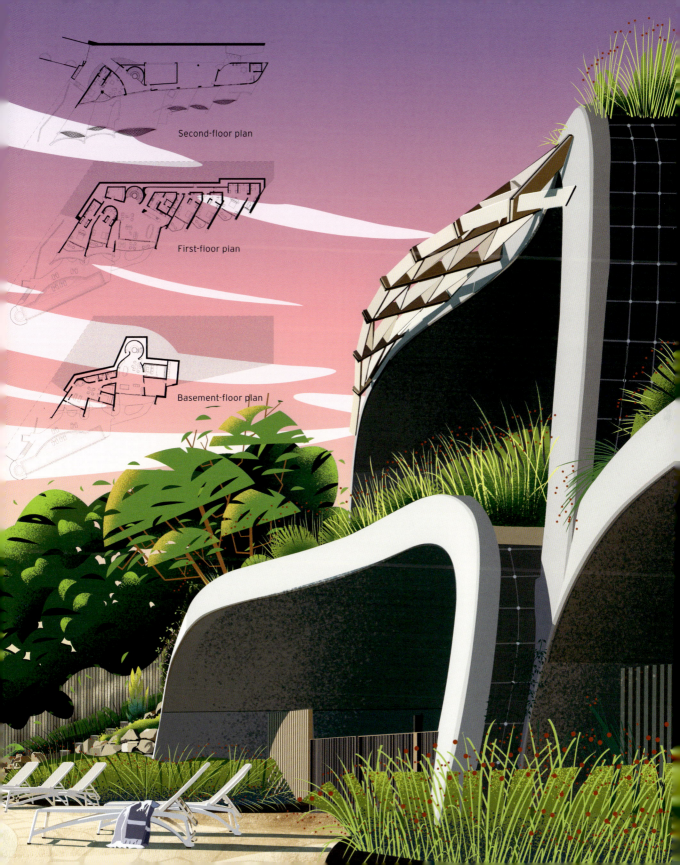

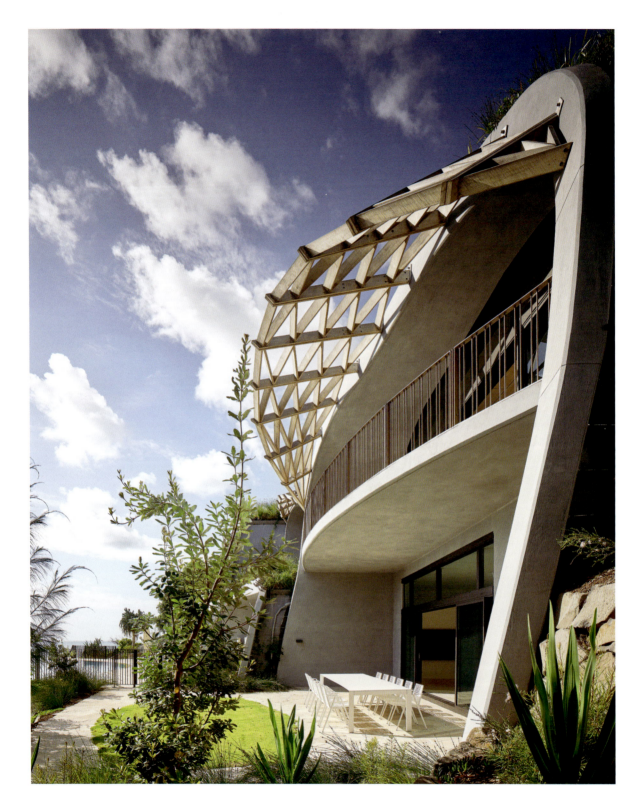

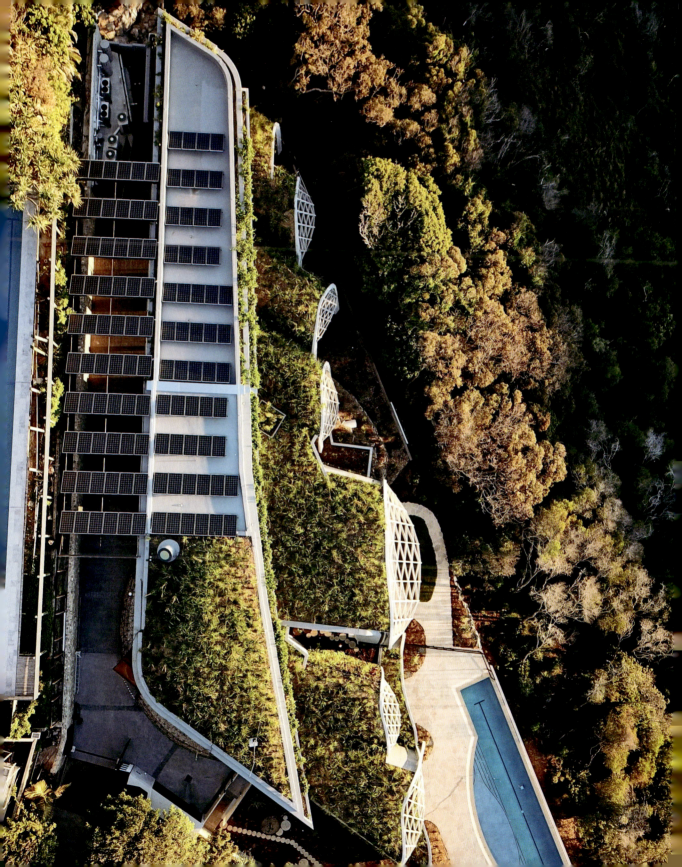

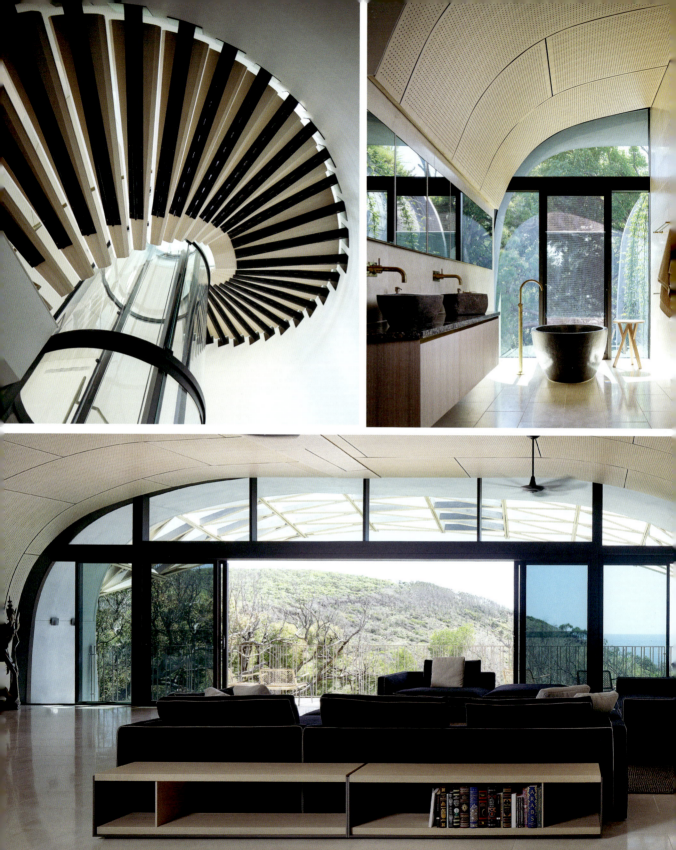

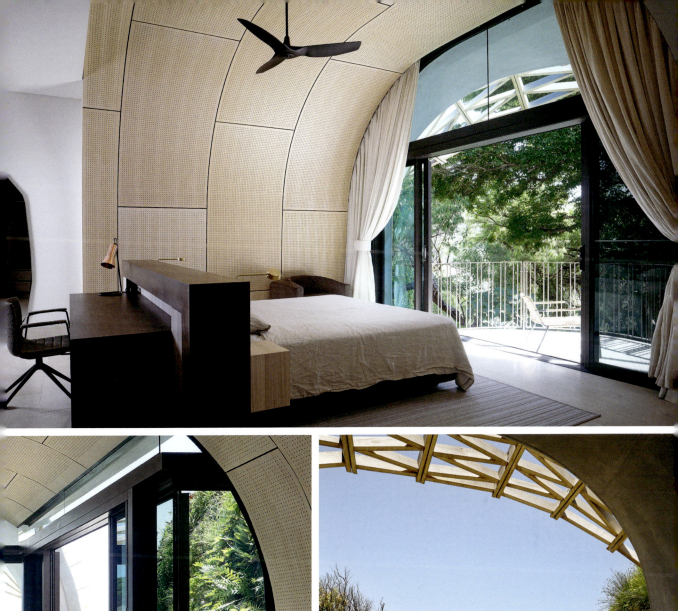
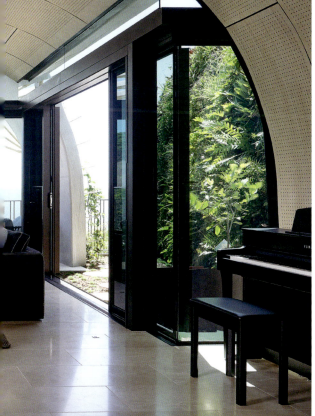
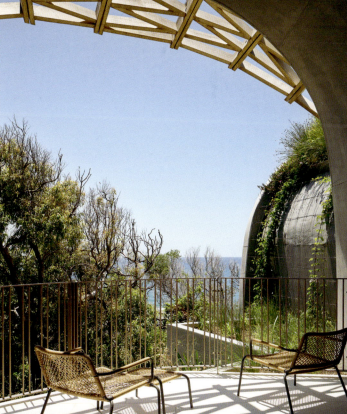

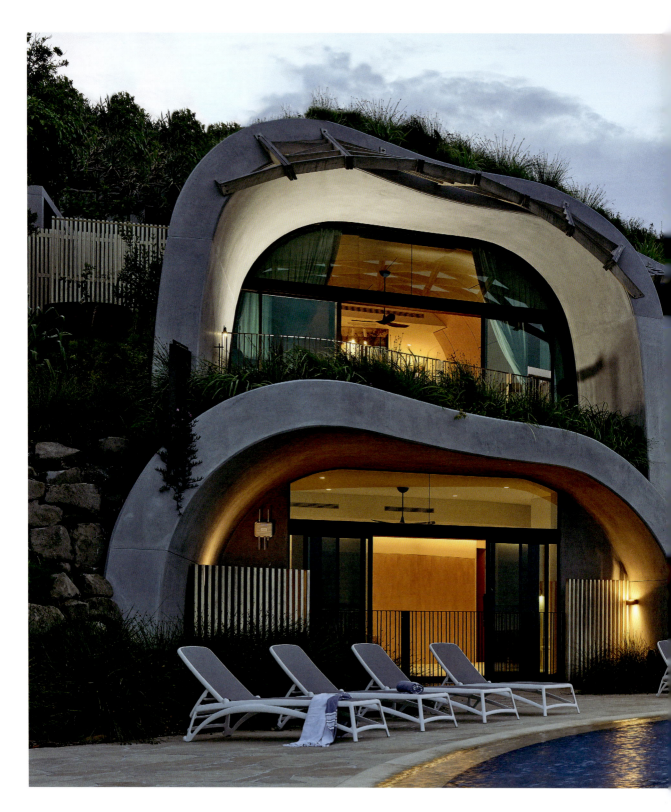

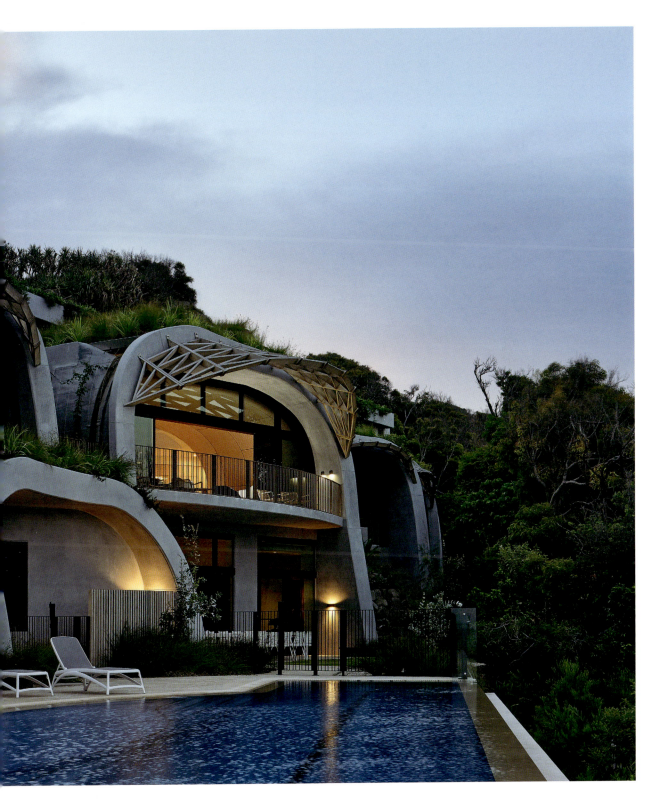

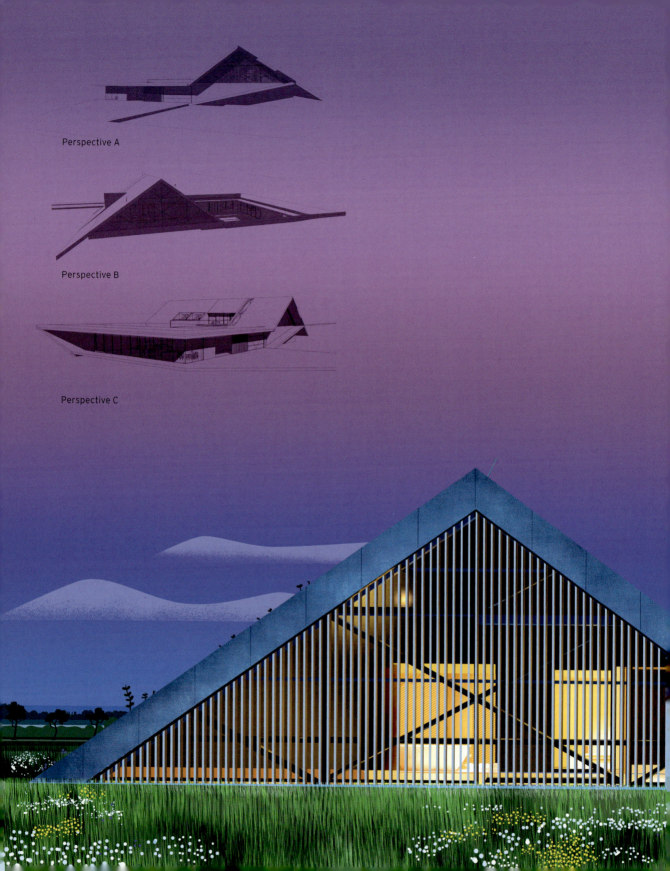

GREEN LINE HOUSE

**Mobius Architects
Warmia, Poland**

Green Line House is literally embedded into the landscape, while the architecture is skillfully adapted to ensure that the scale of the house does not overwhelm the context. Located in a secluded and wild area, this home draws on the tradition of regional architecture, but with modern updates, to discreetly blend in with its surroundings in the beautiful rural Warmian Lake District.

Green roofs are more common now than they once were in architecture, but they still include all the benefits such as insulation, in addition to the aesthetic importance of adding beauty to the landscape, and providing a feeding ground for insects and birds.

The difference with this home is the combination of traditional decorative motifs reinterpreted in a contemporary manner but also the green roof with the open void, providing privacy but also bringing the outside inside and extending the living spaces. The wooden lamella detail in the gable walls makes a clear reference to the gables of the Warmian-Masurian cottages that are often decorated with boards arranged in various patterns. The simplified form of the roof with a 45-degree slope also refers to traditional rural buildings.

The screen of glass walls provides a transparent shield against the strong winds that are frequent in this region, while also maintaining viewing aspects for the inhabitants. The architecture of the house remains visible to its users while adding value to the surroundings.

From a distance, however, masked by the green roof and an earth embankment, the house blends in with the wild landscape of Warmia, providing intimate camouflage so desired by investors, and almost disappearing from view. Yet, there are spots where the architecture reveals itself by organizing the space according to the needs of its users. As a final touch, only from the side of the open atrium are concrete slabs used as an aesthetic device designed to emphasize the modern nature of the structure.

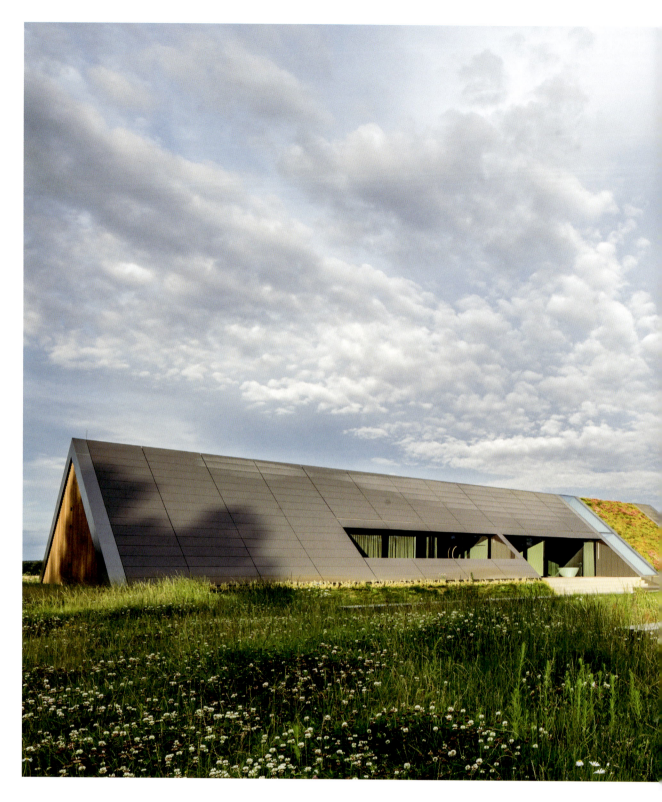

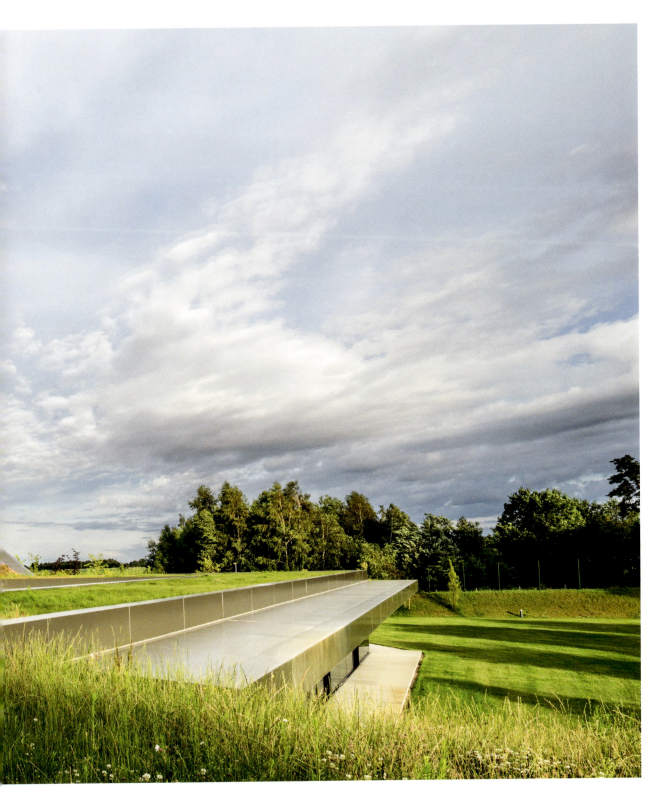

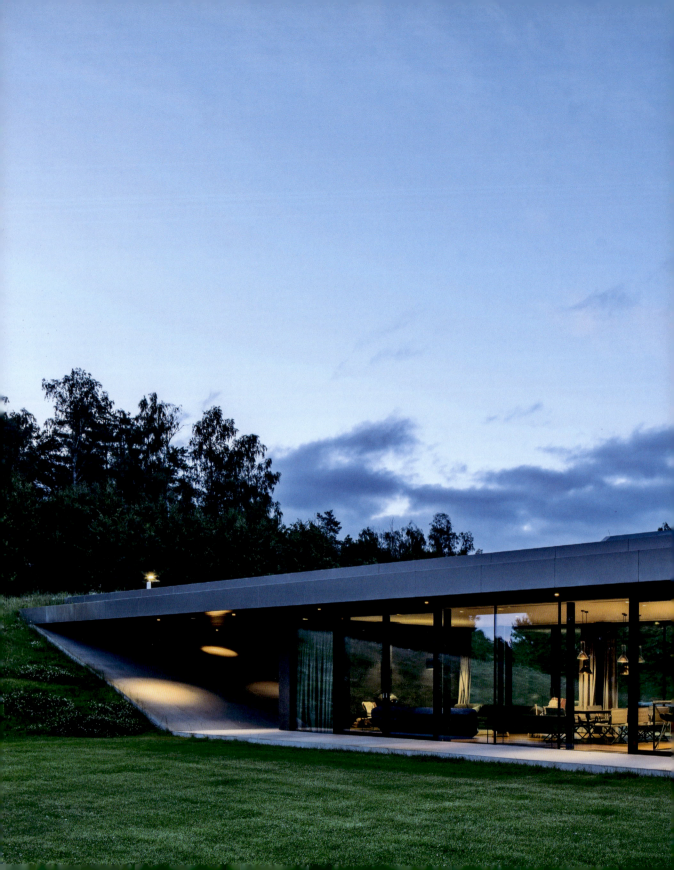

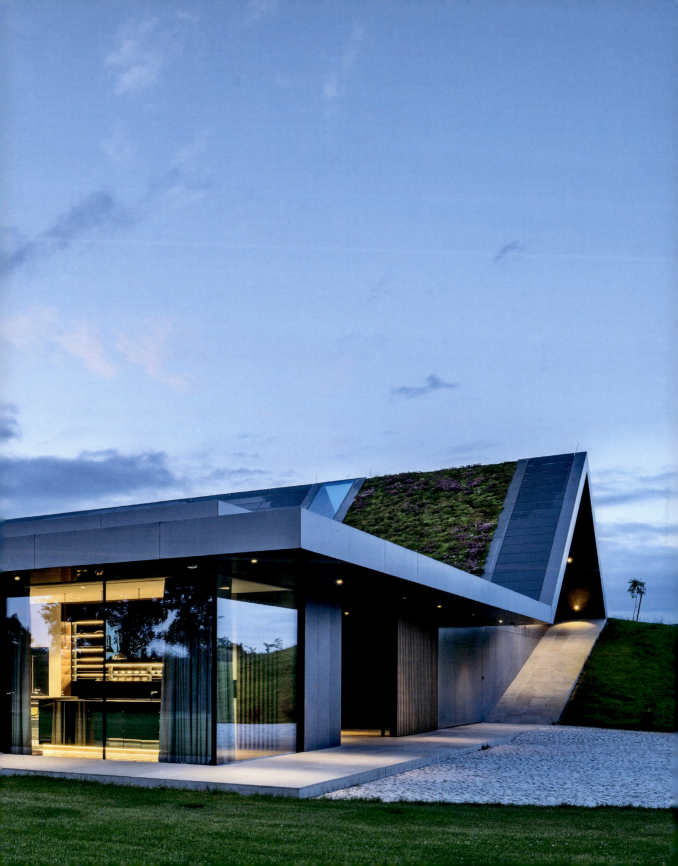

Tato Architects
Osaka, Japan

HOUSE IN HOKUSETSU

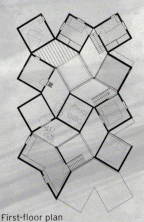
First-floor plan

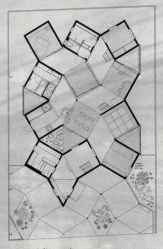
Ground-floor plan

Designed in the shape of a labyrinth, House in Hokusetsu was an experiment to rethink the geometric spaces within a home, and create a singular internal spatial awareness. Simple, angled geometric spaces are a familiar part and parcel of residential houses. But by slightly turning the corners where the walls intersect, the spatial awareness inside the home suddenly becomes complicated, and the inhabitants feel as if the limited space has expanded.

The design of this house has a simplicity similar to "a cross inside a square" plan used in old houses. Each part, while representing a different quality, is also compatible and expandable, and there is possibility for various circulations to emerge. This house is filled with autonomous spaces that can accommodate changes in lifestyle; it is a crystalline labyrinth where the spaces are repeatedly reflected into a prismatic figure. The design moved from experimenting with twelve squares to eventually culminating in a sequence of eighteen squares, providing the client with their desired multiple rooms but also engaging a sense of playfulness and discovery within the home.

The structure is made of wood, and each square plan is simply supported by pillars, resulting in a peaceful interior despite its unique form. The structure remains relatively closed to its surroundings, which was the client's wish. There are three garden spaces along the outer perimeter, and two courtyards on the interior.

As a result of the plan pattern design, both indoor spaces and courtyards are brightened by top light, and illuminated with various forms of light, which might make it easier to wend your way successfully through the labyrinth.

113

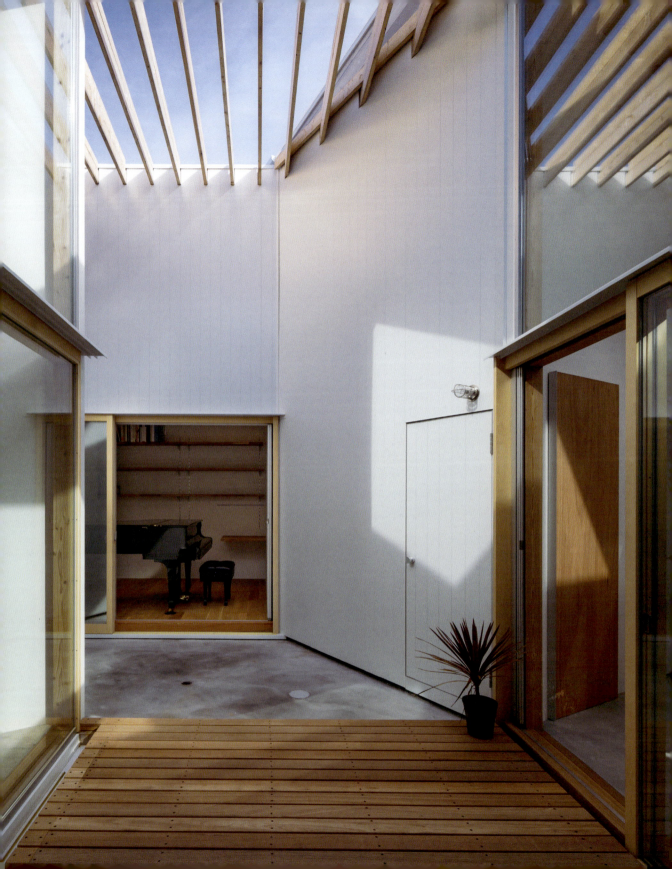

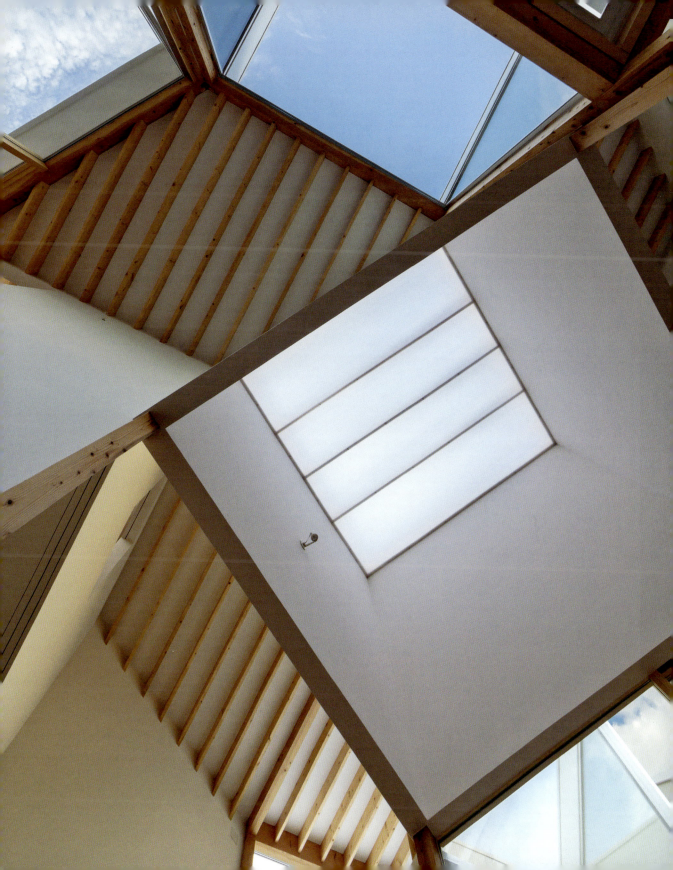

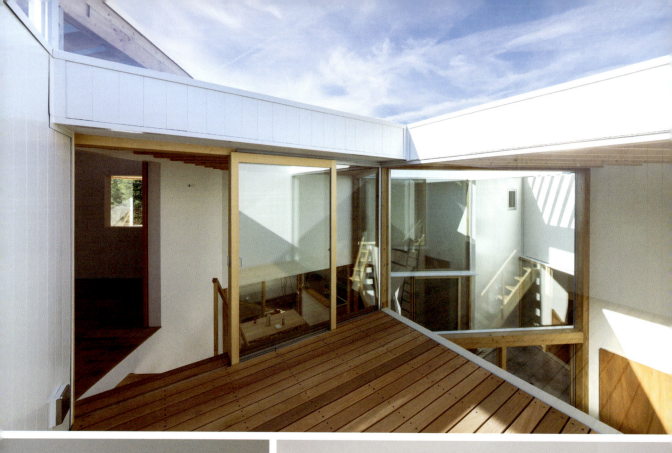
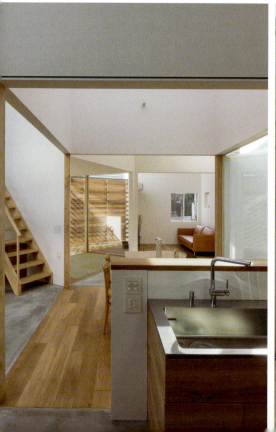
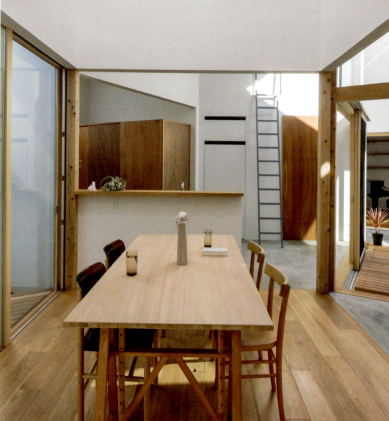

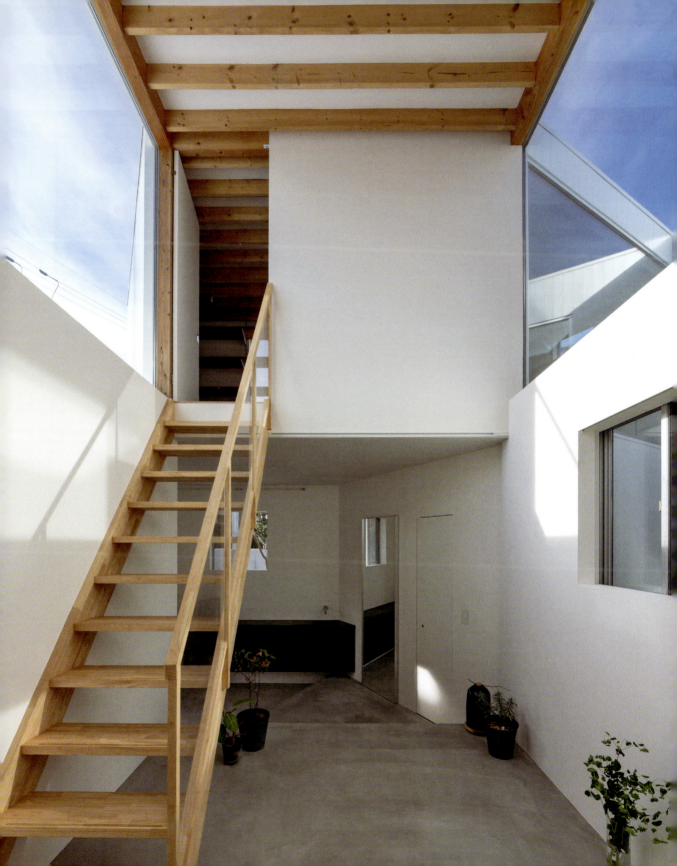

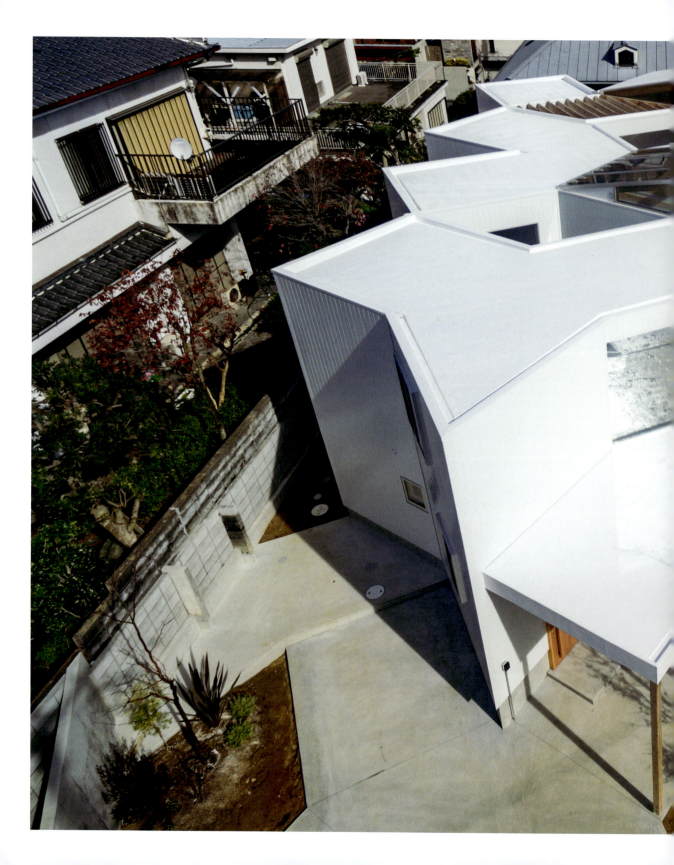

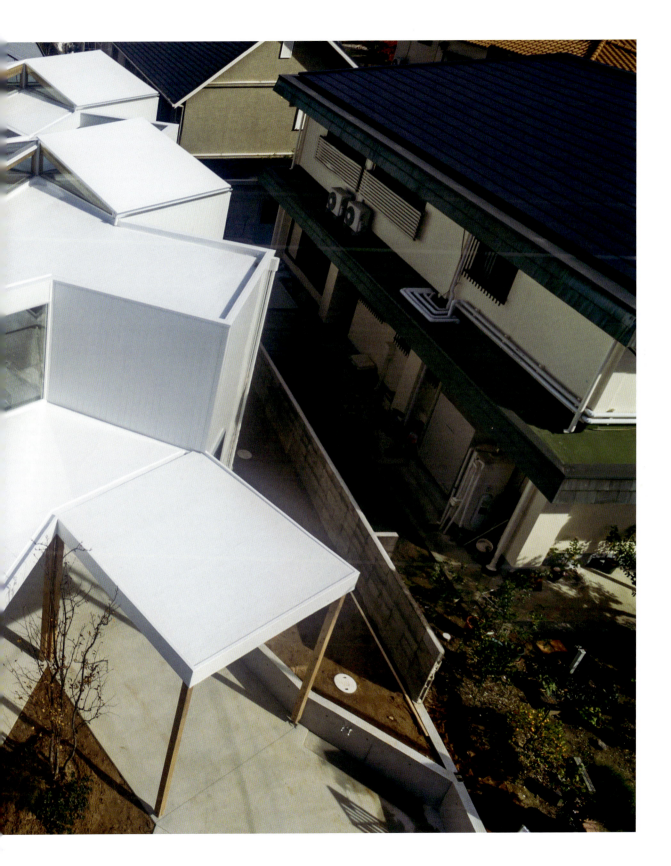

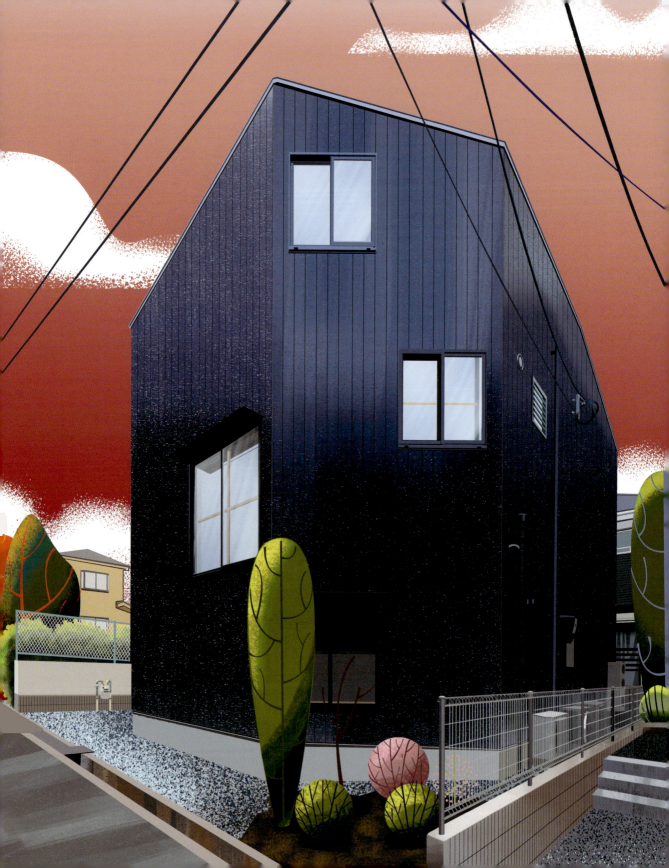

Tato Architects
Osaka, Japan

HOUSE IN TAKATSUKI

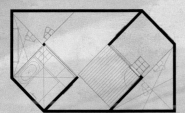
Third-floor plan

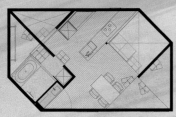
Second-floor plan

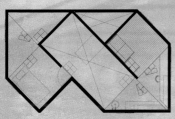
First-floor plan

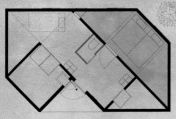
Ground-floor plan

The ingenious design for this residence provides sixteen different floor levels, and all manner of intriguing sight lines. One could never imagine being bored in this house with its creative internal structure.

Constructed on a small area in a suburban residential neighborhood, the designers explored the possibilities of a continuous floor arrangement, and used a series of triangular and rectangular platforms to create differing floor levels. The idea was to create a sense of expansion inside a small area, with everything loosely connected, while also providing an ever-changing sense of being on top of a space in one instance before being tucked away beneath a floor in the next moment.

The interior is done in a soft palette, with the wooden elements (selected for budgeting reasons) bestowing warmth. The spaces between the different levels are left open, to create a floating effect, and allowing the floors to be used as desks and shelves. While compact, the interiors benefit from direct natural light and manage to appear spacious.

The floor rises from two different points in a spiral, connecting on the floor that houses the dining and kitchen area, before separating once more before finally reconnecting again on the rooftop.

Perhaps most intriguingly, there are no staircases within the house. Instead, the residents use floating wooden shelves combined with wooden blocks to move between the levels. Or, they can also function as a small desk with a seat.

The architect describes the result as a "functional cave," though the design adheres to strict geometry. By being able to exploit the different spaces that result from the combination of spiralling triangular elements, more living space is provided for the residents.

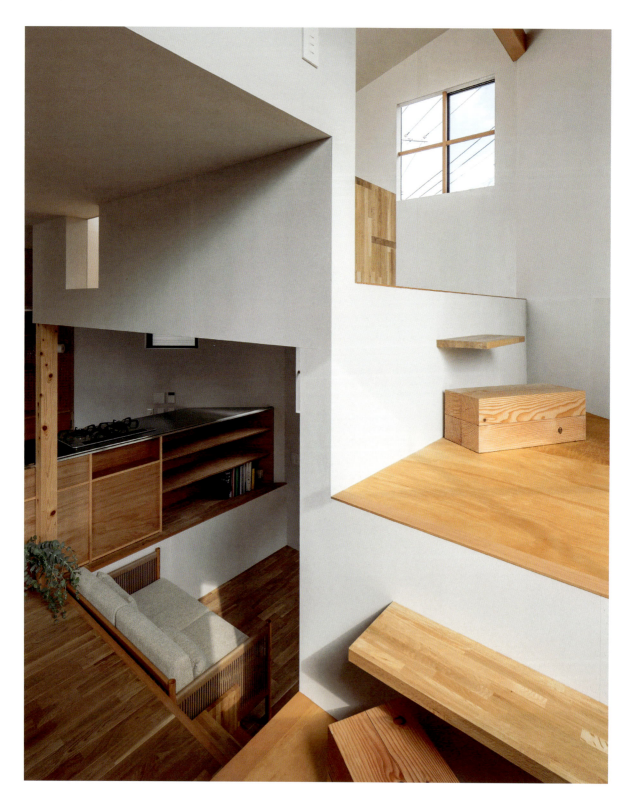

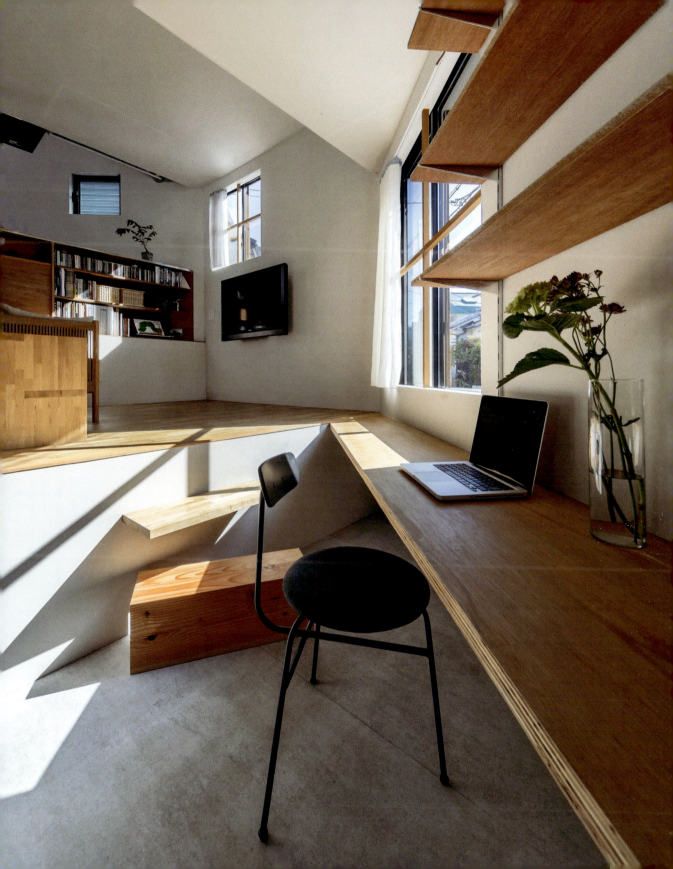

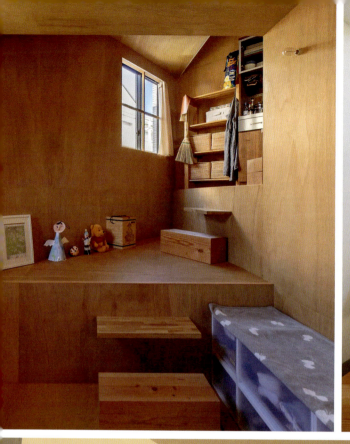
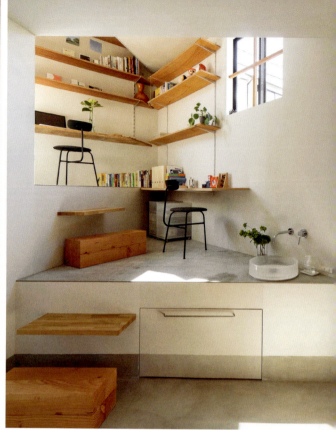
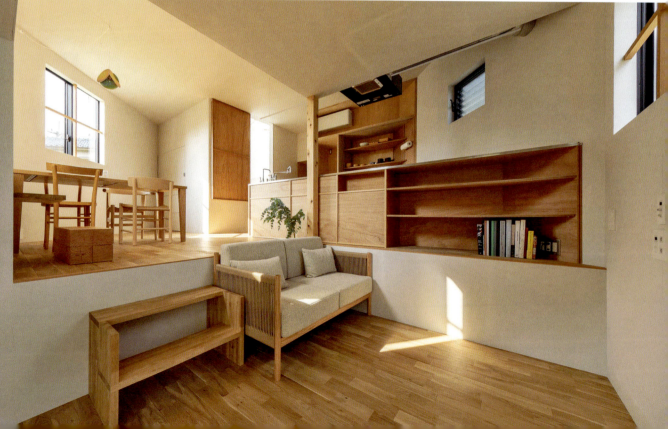

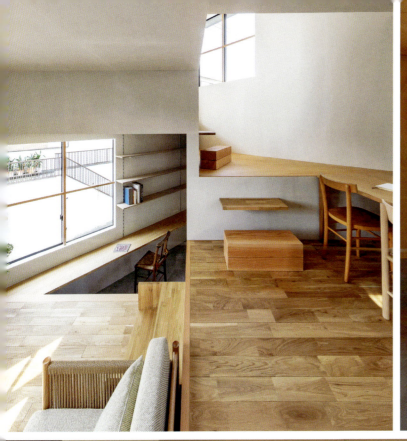
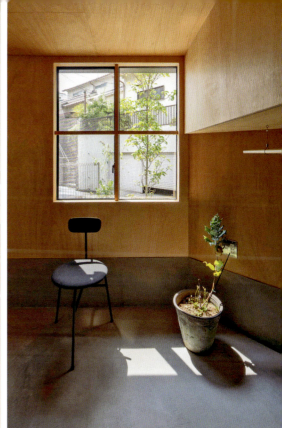
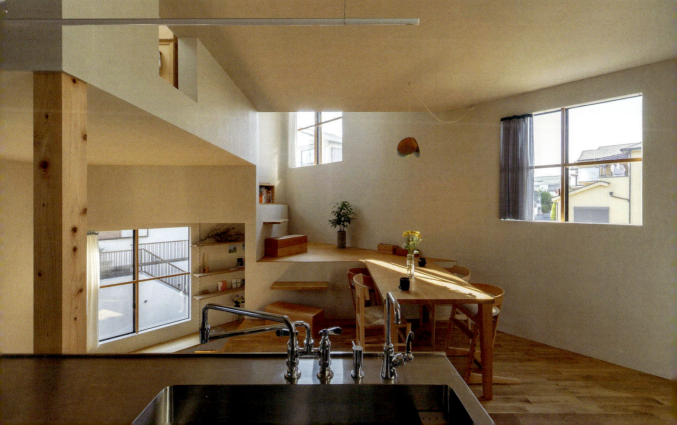

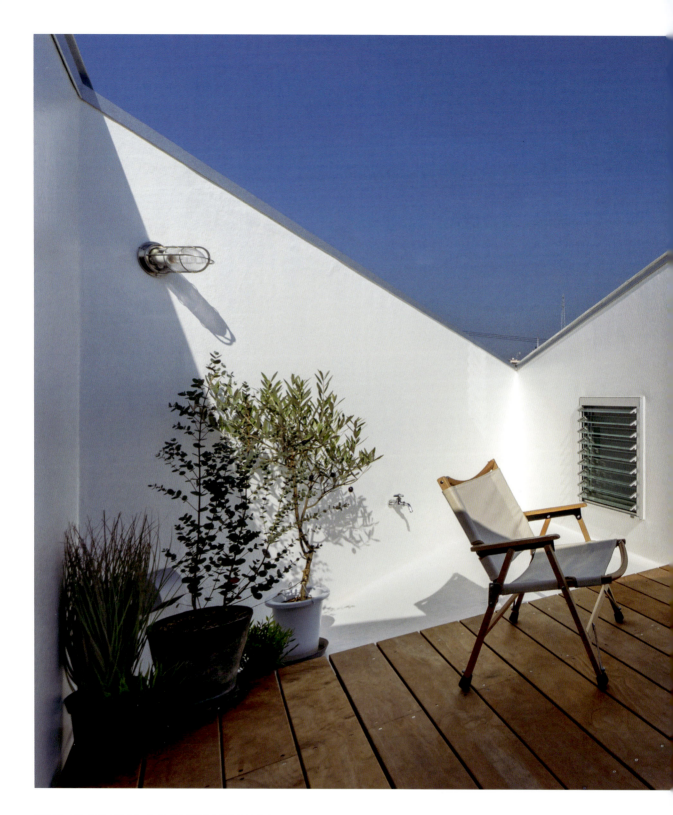

126 RADICAL LIVING | HOMES

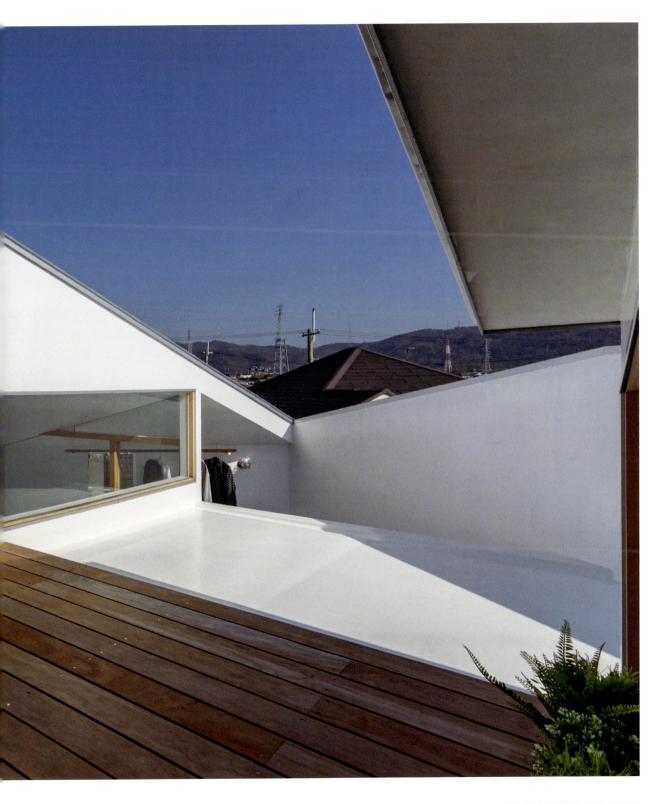

HOUSE IN TAKATSUKI 127

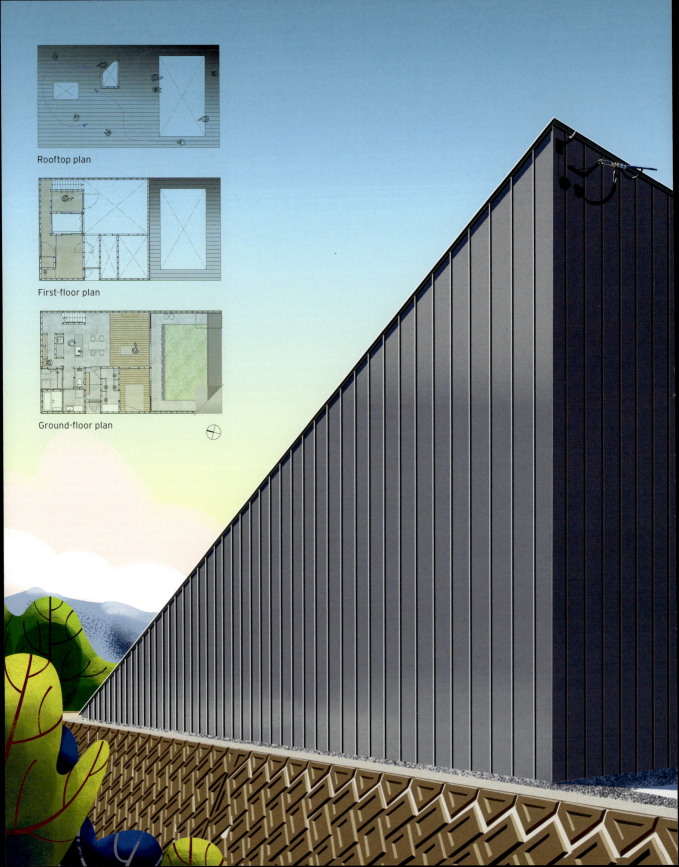

HOUSE IN USUKI

Atelier Kenta Eto Architects
Usuki, Japan

With no roof as such, this small compact structure sits in stark contrast to its counterparts, and offers a different methodology for future house design. The building appears as a slope that is neither a roof nor a wall. With a gradient of 4.5, the wall (or is it a roof?) rises determinedly at a 25-degree angle. The added bonus is that the residents can walk easily onto their "roof" from the ground, and sit to watch the world go by, or the stars at night.

The architect was driven by the desire to invoke a contrast in the scale between the human and the natural environment. He was inspired by the surrounding mountain landscape to design a structure that evoked "going down from the mountains in the south to the plain."

Inside, the walls are painted a pale chalky gray, contrasting with the warmth of the wooden ceiling. The base of the angle encloses a small grassy area for children to play, and includes a space under the eaves for people to sit outside in the shade. Two large rooms open onto this outdoor space via floor-to-ceiling high windows and sliding doors, letting natural daylight penetrate the interior and also providing a framed view to the distant mountains. The kitchen, bathroom, and master bedroom are situated at the Y axis of the angle shape, while the children's bedroom and a hobby room are located on the upper level.

The design succeeds in devising a prosperous home with a minimalist approach, providing a connection between the inside and outside via an intermediate courtyard, allowing the residents to experience the changes in the weather and seasons, either from the shelter of the living room, or watching the clouds from a unique rooftop vantage point.

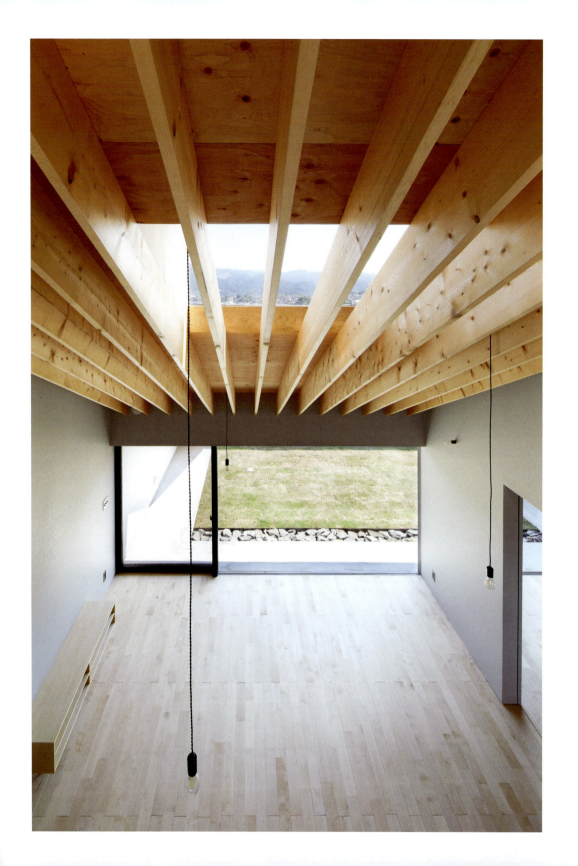

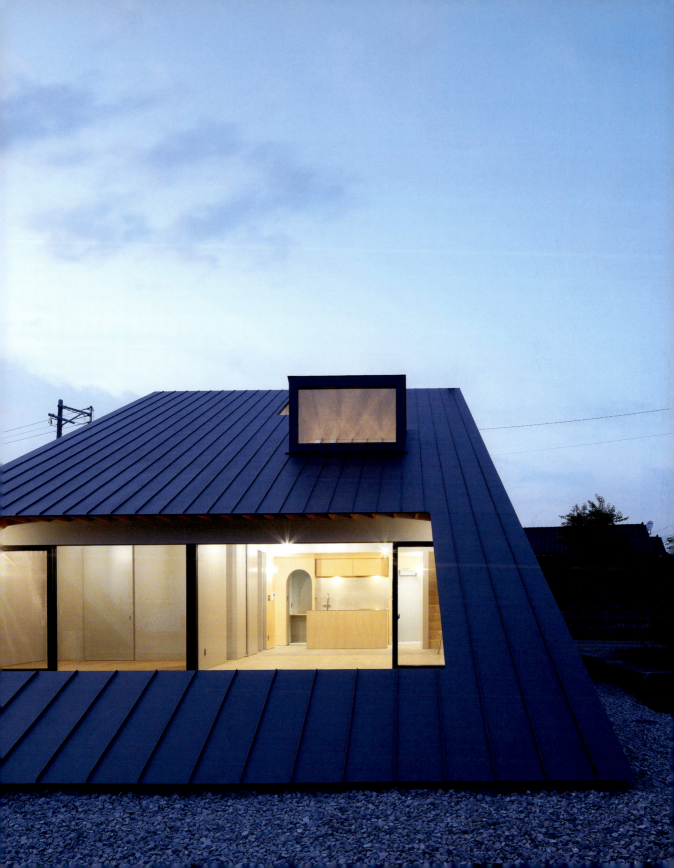

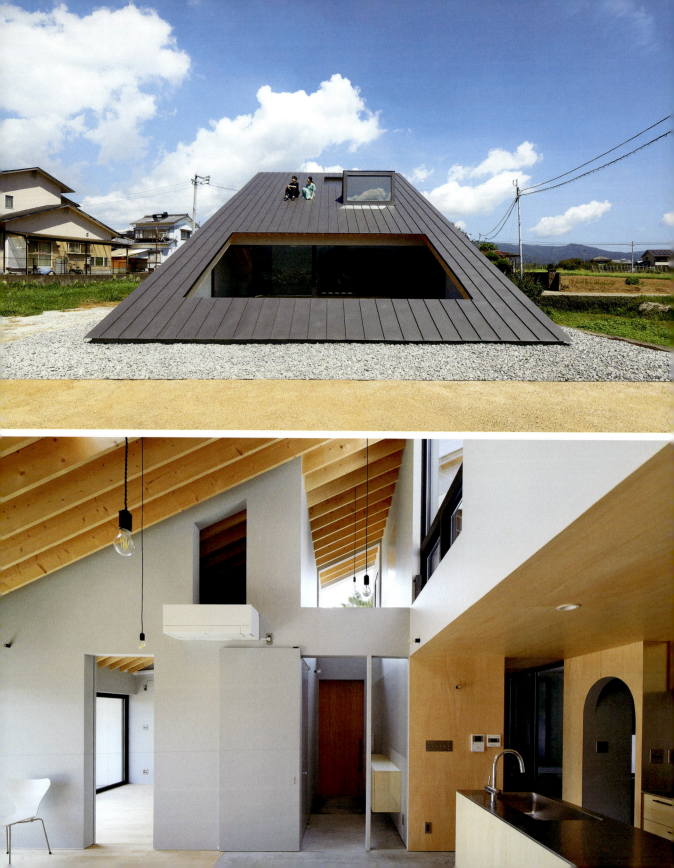

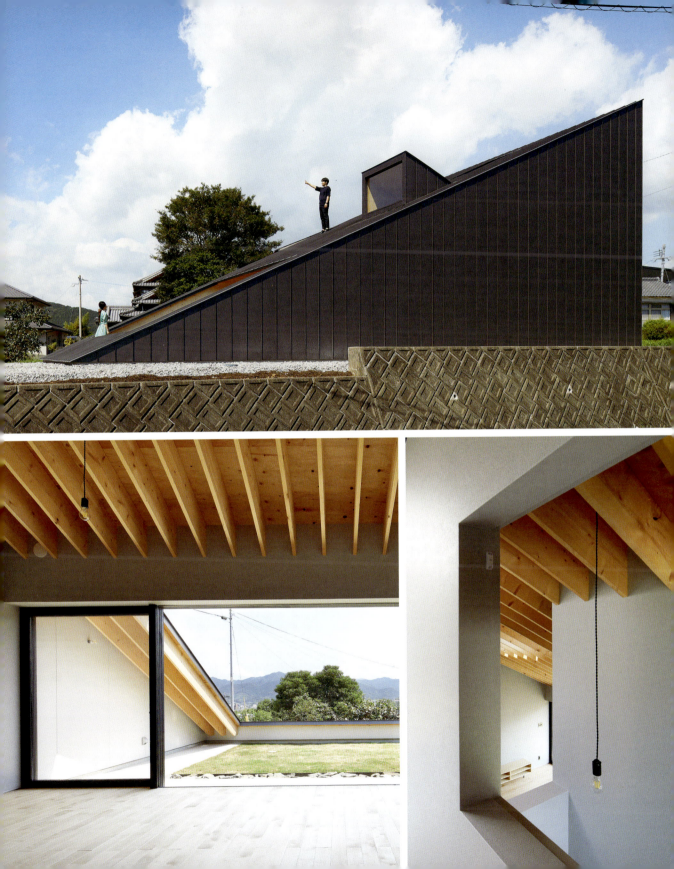

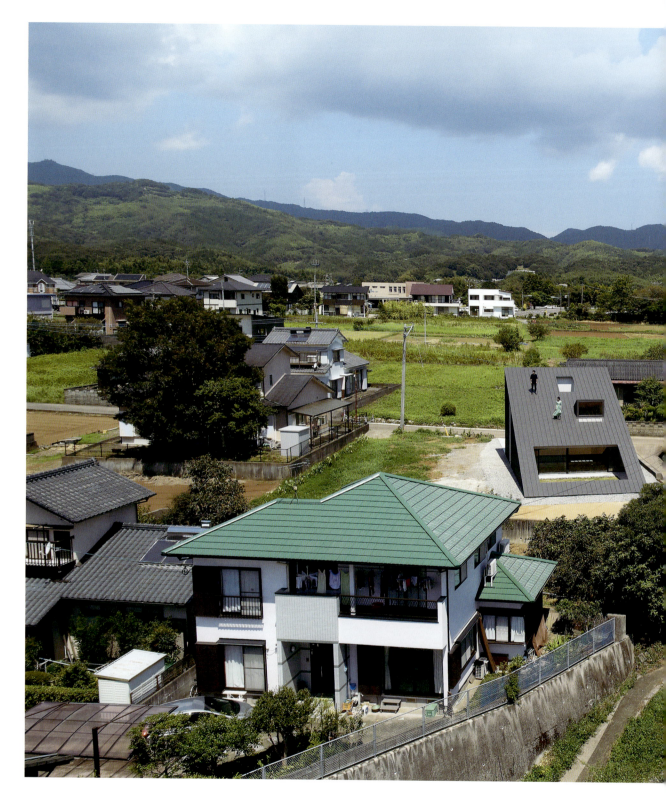

HOUSE ON AN ISLAND

Atelier Oslo
Skåtøy Island, Norway

When contemplating building a holiday home, one usually imagines a location on a flat stretch of land, perhaps surrounded by vegetation. This small house, however, was purposely designed to integrate the smooth and curved boulders, which go all the way down toward the water, into the project.

Located on an island, this incongruous home, rising up from the very rocks, was built for two artists who wanted a space in which to work but also have some quiet time to contemplate. The act of entering the building via stairs, which cross the space between the cabin and the rock, is out of the ordinary, and is meant to mark a transition, and to prepare you for life on the island.

Concrete floors connect the main levels of the topography and create a variety of different outdoor spaces, including a small deck perfectly placed to look over the ocean. The main structure is a simple prefabricated timber design. Over this is placed a light wood lattice framework that covers the cabin and filters the light while directing the views to the outside. This timber frame, which is designed to turn gray and will require no maintenance, creates depth, resulting in a play of shadows during the day, and evoking a calm feeling similar to sitting underneath a tree.

This simple yet inventive design sits lightly in its surroundings, yet offers a beautiful silhouette on the shoreline, and its timber frame will eventually transform into a weathered gray, matching the color of its rocky base. A perfect and minimalist artist retreat.

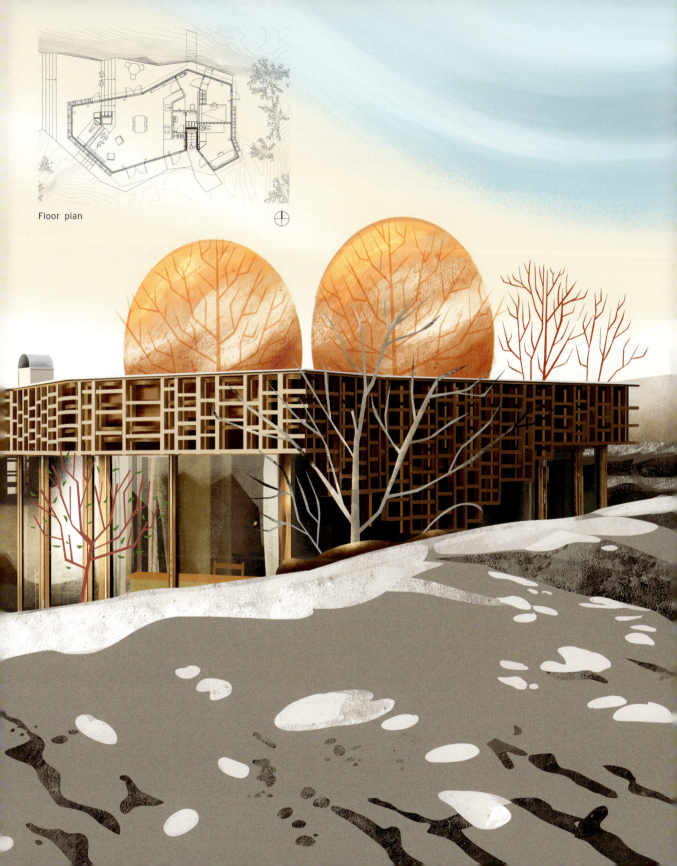

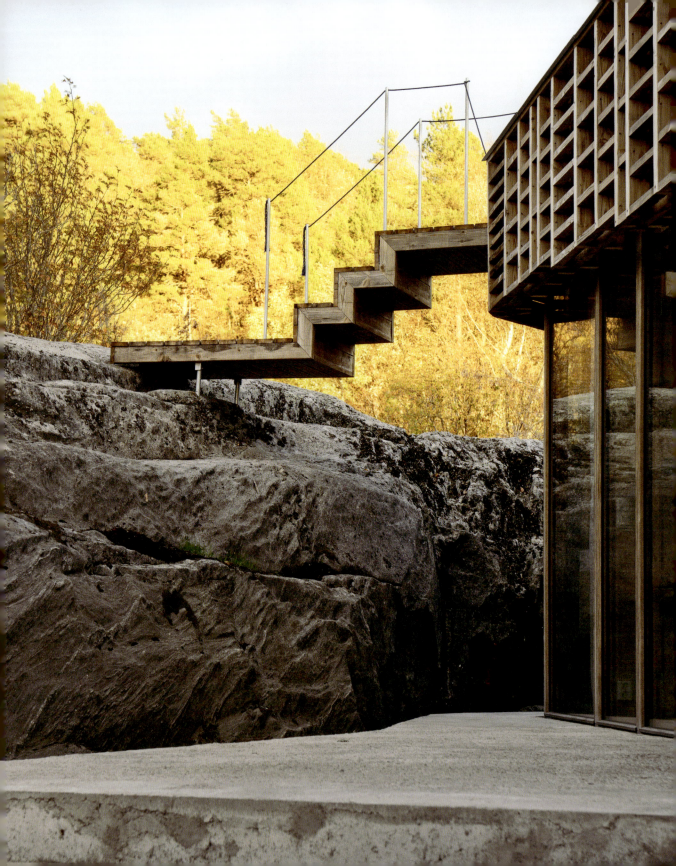

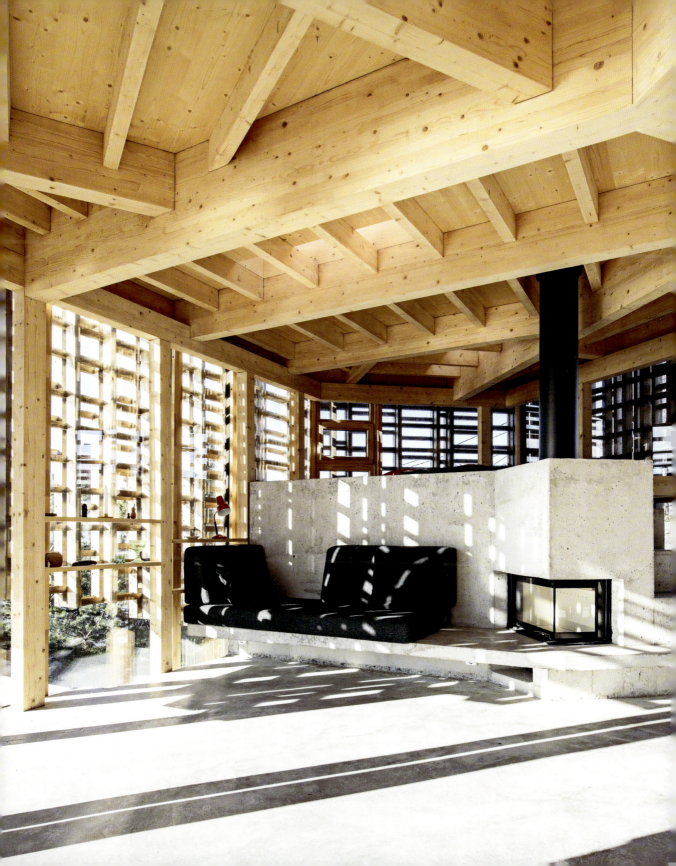

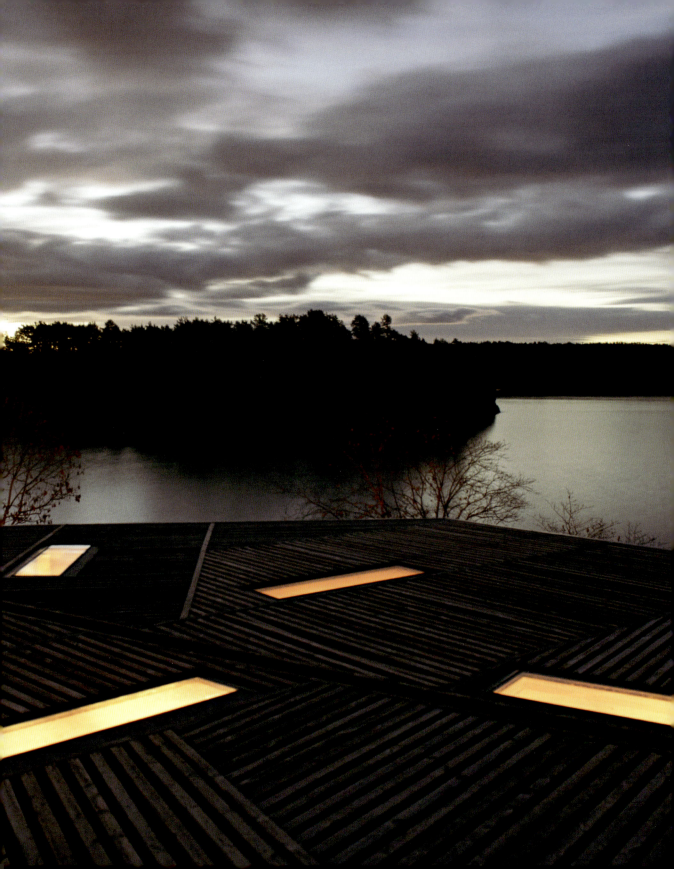

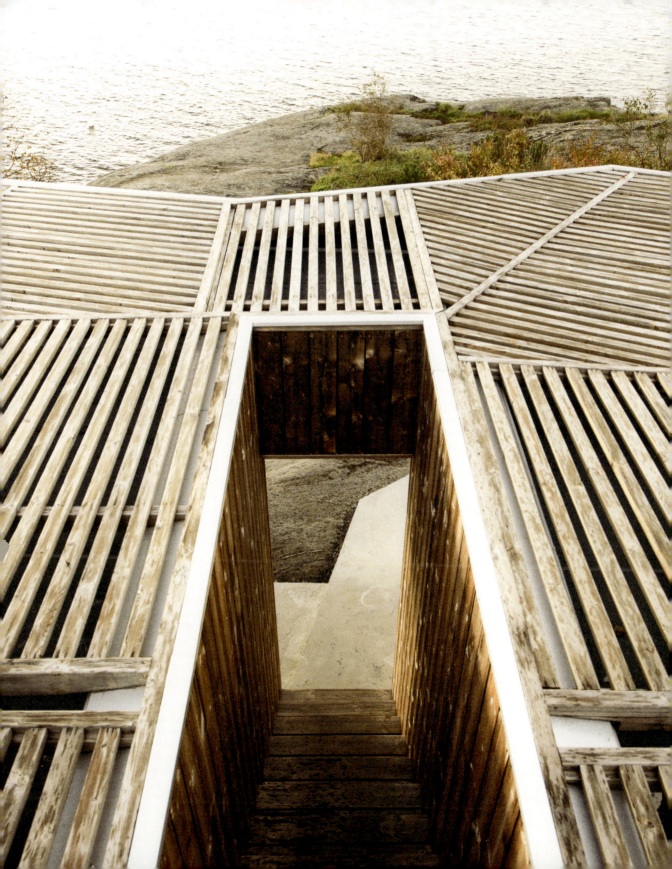

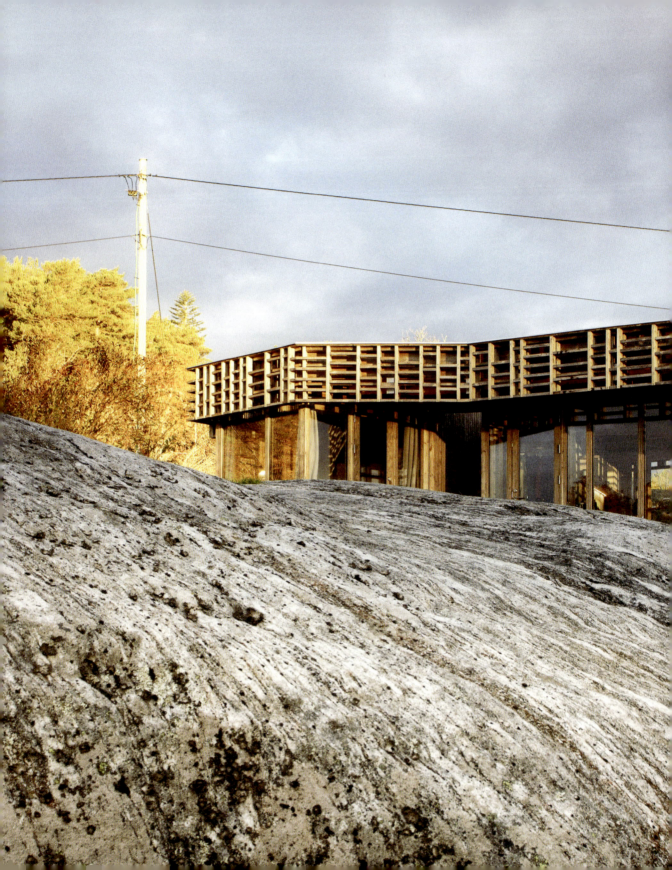

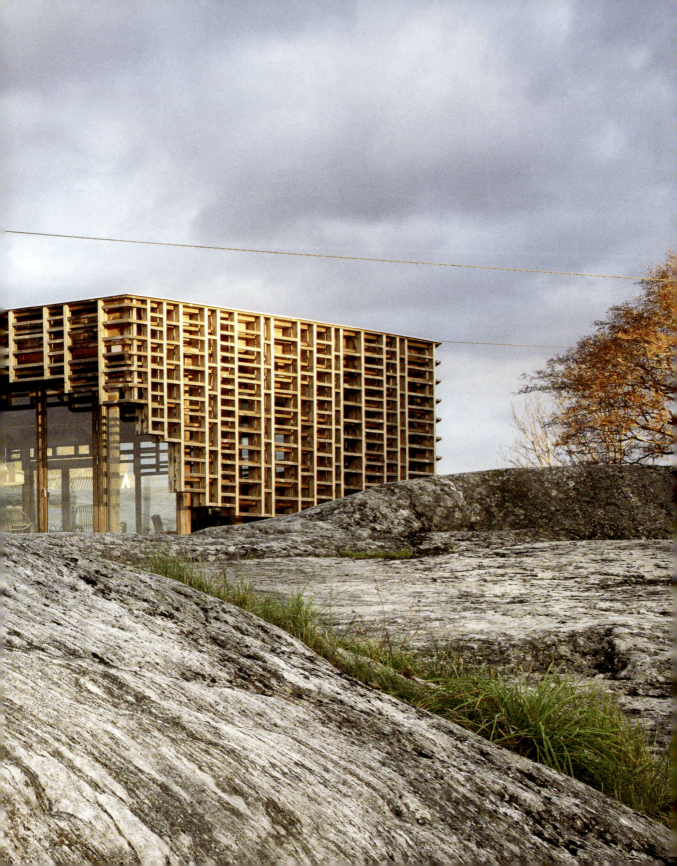

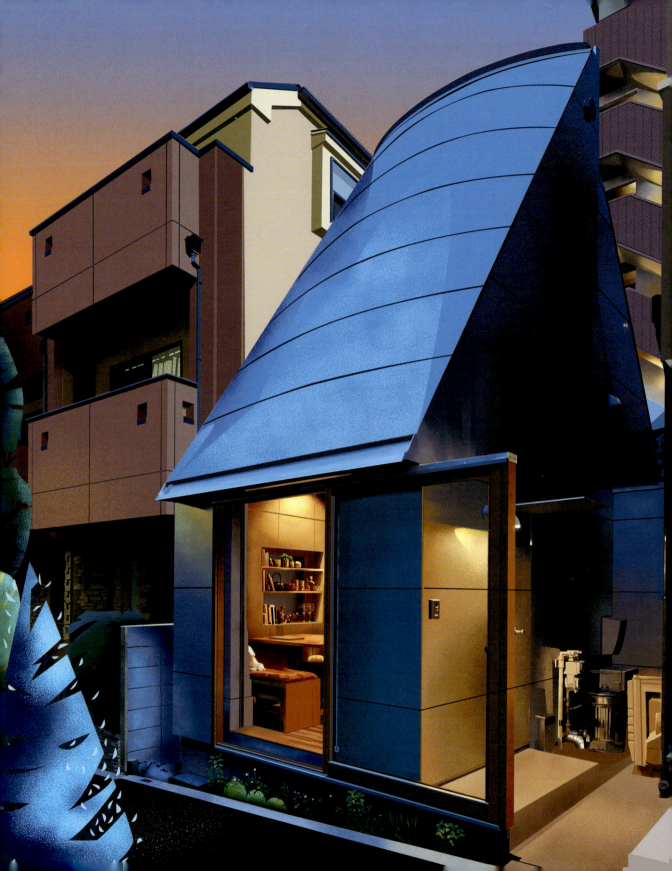

Takeshi Hosaka Architects
Tokyo, Japan

LOVE² HOUSE

Homes in Japan are often smaller than in many countries, but this tiny home takes things to a new level.

Created by Takeshi Hosaka on a seemingly prohibitively small 300-square-foot (31-square-meter) lot in Tokyo, this tiny house provides a residence much closer to the university where he teaches, and cut down on what had been a long commute.

His wife's reading material turned out to be a source of inspiration. The book, set in the Edo period (1603–1868) of Japan, discussed a family of four who lived in a 100-square-foot (9.6 square-meter) house. The floor plan of the land was, in comparison, a generous 194 square feet (18 square meters).

In addition to the challenge presented by the small size, the couple also wished to place importance on preferred practices, as favored by the ancient Romans, namely: learning, bathing, drama, music, and epicureanism (in this case, eating).

A site simulation revealed that the sun would be "absent" for around three months of the year. To get around this, he designed two curved rooftops with openings, which bring sunlight into the house throughout the year. The sloping roof bestows upon the small abode a traditional aspect. The interior does not, as you might expect, expand up to the second story, but rather is divided by seven short walls into three different zones: dining, kitchen, and bedroom.

The benefits of living small is immediately felt during the warmer months, as the couple are able chat to passers-by and even pat strolling dogs while eating. As Hosaka says, "We feel the town very close," proving that it is a small world after all.

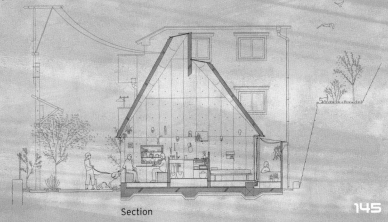
Section

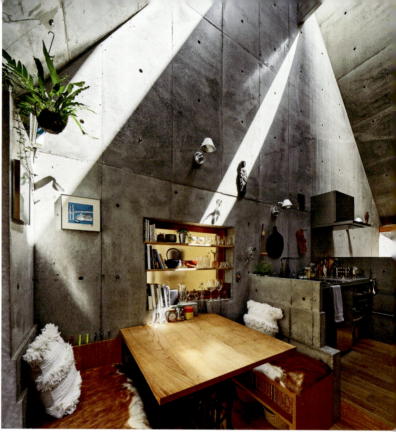
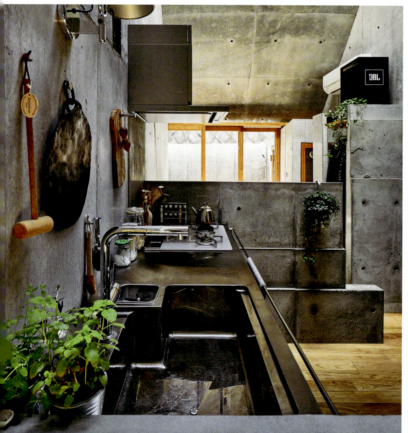
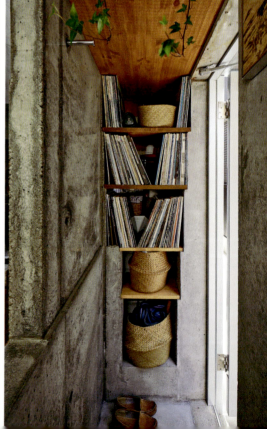

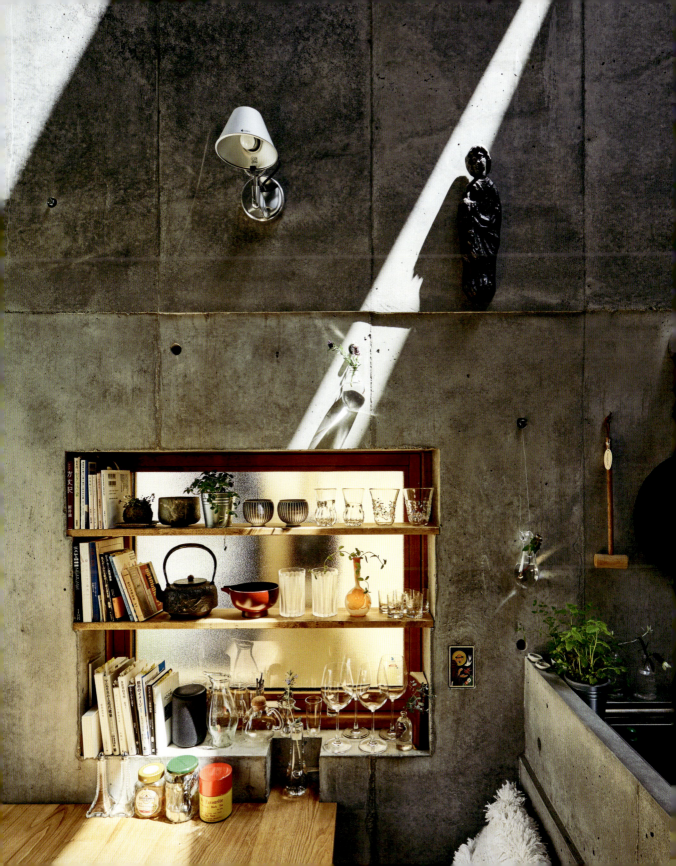

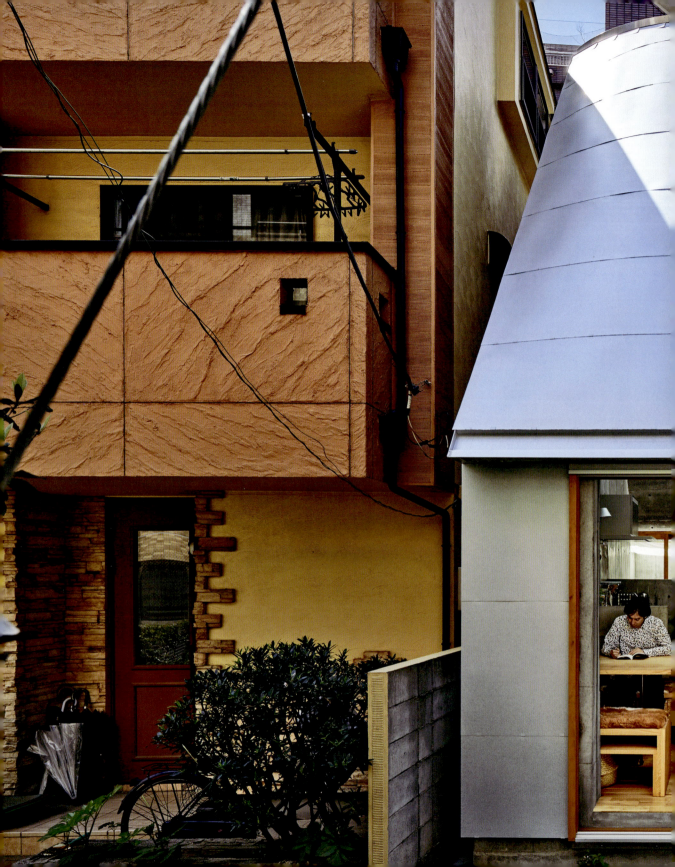

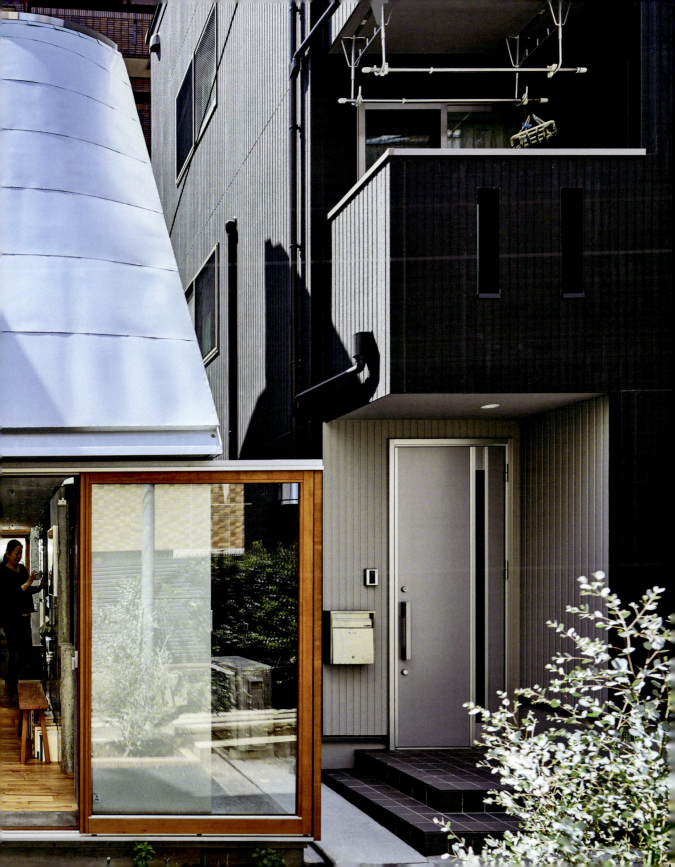

MONTEBAR VILLA

JM Architecture
Medeglia, Switzerland

This seemingly dark and brooding villa was designed to appear as a stone in the rolling hillside. Think of Switzerland with its alpine architecture, and a picture of a traditional wooden chalet might spring to mind. But the Swiss aren't all living in the past. There are, however, often strict building codes to adhere to. In this case, the local vernacular called for a dark gray pitched roof, for a better integration with the environment. Taking this design constraint and running with it, the architects developed the idea of using the same material not only for the roof but also the façades to bestow a monolithic aspect on the house.

Situated on a slope with vineyards, this wooden structure is entirely prefabricated and made from thermally insulated wood elements, ideal for the Swiss winter. A double layer of ventilation and thermal insulation provides high standards of energy performance. The exterior cladding is a ventilated façade with porcelain stoneware tiles, which also cover the custom-designed folding shutters. Each section of the six-sided roof is offset toward the mountain, for a better integration with the landscape.

Befitting its location in the picturesque Swiss Alps, the exception to the stark exterior is in the south, which faces the valley and has a spectacular 180-degree view through a glass curtain-wall that encloses the living area and folds inside creating a loggia to be used in the warmer months. The sleek, modern, and light interior belies the external dark façade.

The ingenious technology and advanced materials serve to keep the inside warm and toasty in the depths of winter, as the residents sip on warm drinks and watch the cold winter weather descend upon the valley below.

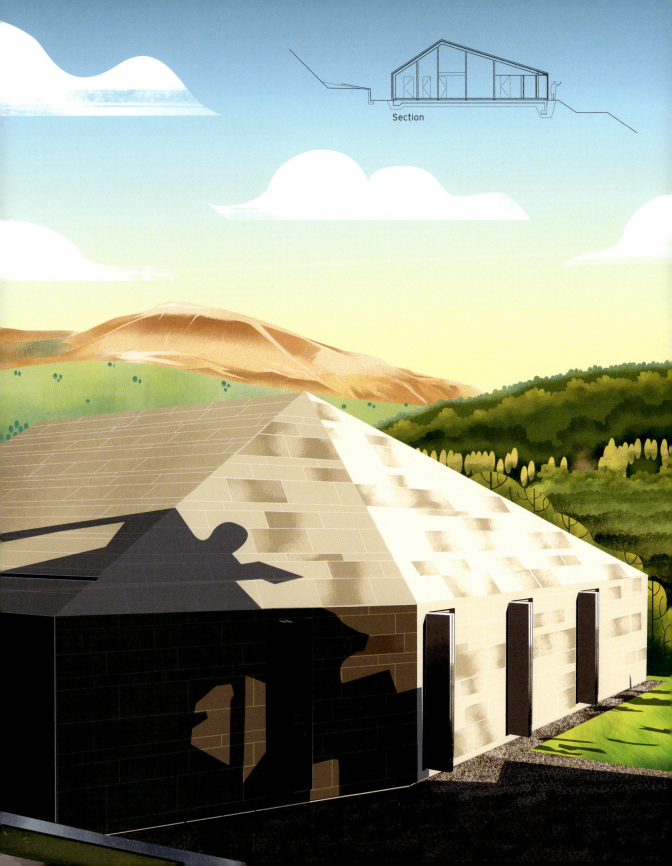

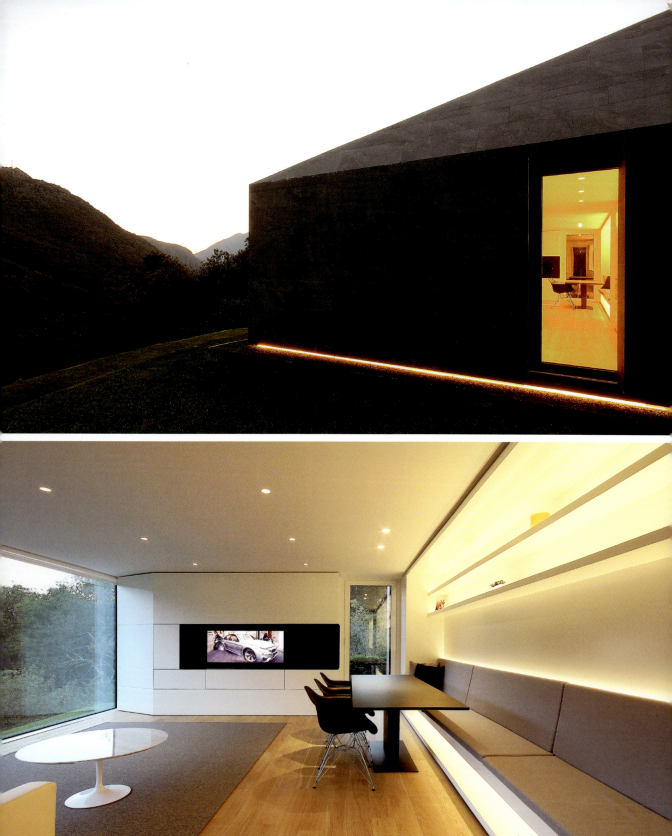

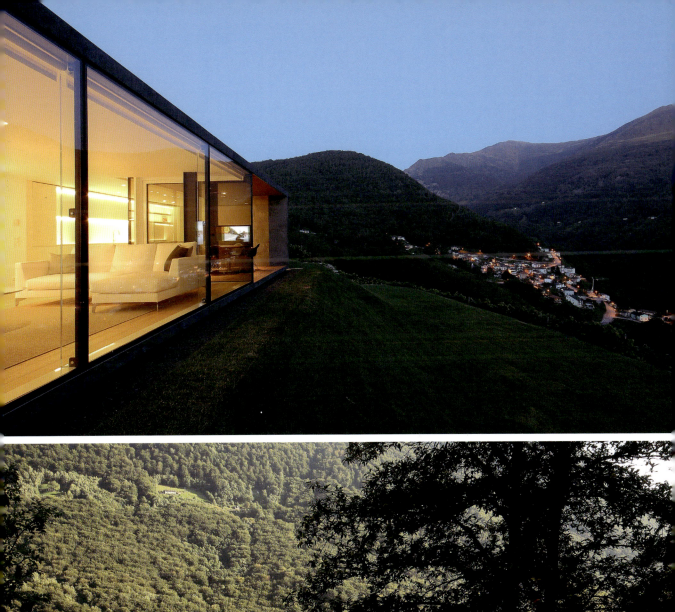
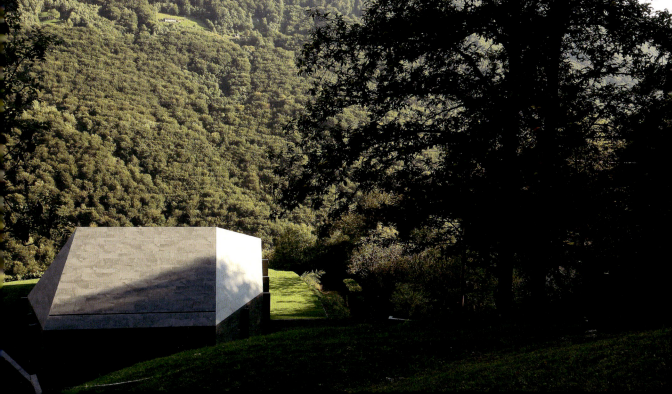

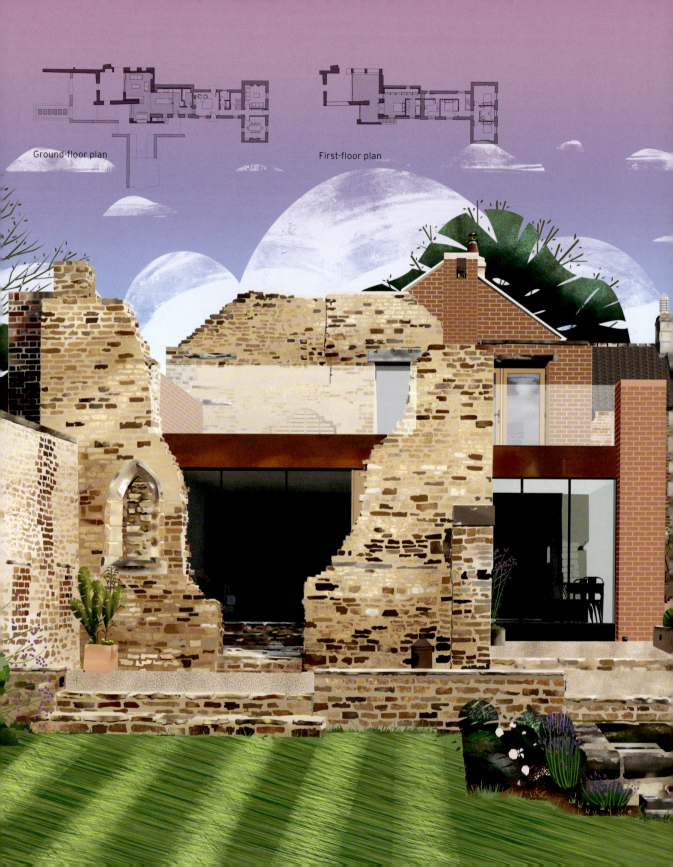

PARCHMENT WORKS HOUSE

Will Gamble Architects
Northamptonshire,
United Kingdom

Heritage buildings are taken seriously in the United Kingdom, and often impose constraints upon building work. In this case, the existing property consisted of a Grade 2–listed double-fronted Victorian house, a disused cattle shed, but also the ruin of a former parchment factory on the site, which formed a scheduled monument. The client initially wished to demolish the ruin, but was convinced to view it instead not as a constraint but as a positive asset that could in fact be celebrated through a sensitive but well-conceived intervention.

Instead of demolishing the ruin, the architects proposed "a building within a building," where two lightweight volumes could be delicately inserted within the masonry walls in order to preserve and celebrate it. A palette of honest materials was chosen both internally and externally that references the site's history and the surrounding rural context.

Externally, Corten steel, oak, and reclaimed brick have been used. The extension was built out of up-cycled materials predominantly found on-site, which was both cost-effective and sustainable, while allowing the proposal to sensitively blend into its surroundings. Internally the structural beams of the existing cattle shed were exposed as well as the steelwork to the new parts; the stone walls were re-pointed and washed in lime to create a mottled effect, and a concrete plinth was cast along the base to create a monolithic "skirting." A contemporary kitchen (also designed by the practice) juxtaposes the uneven and disordered nature of the ruin and continues the theme of a modern intervention set within a historical context.

The result is a stunning modern addition that incorporates the texture of the pre-existing architecture as well as providing views of the ruins of the former parchment factory, celebrating the previous architectural history and preserving it for future generations.

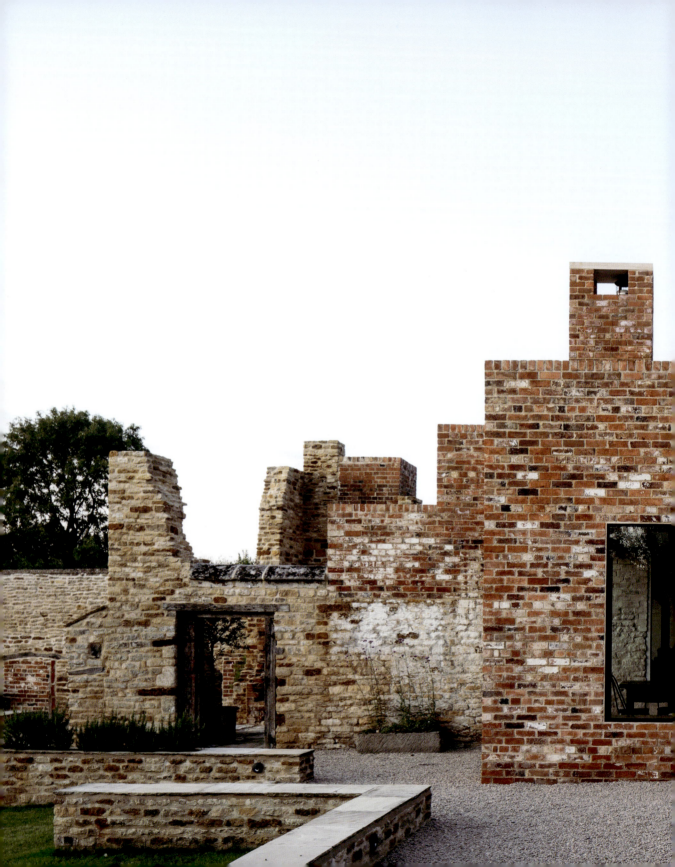

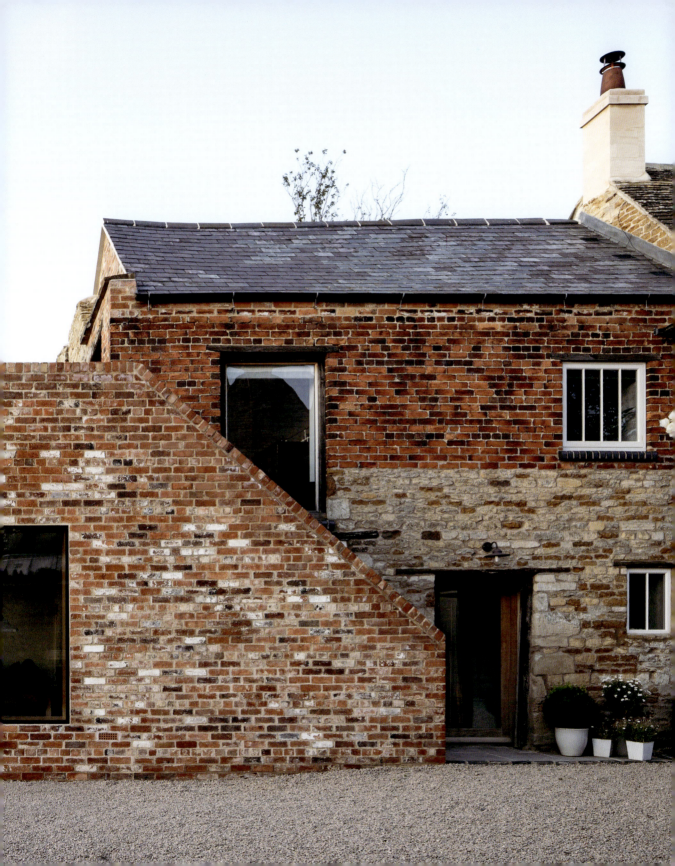

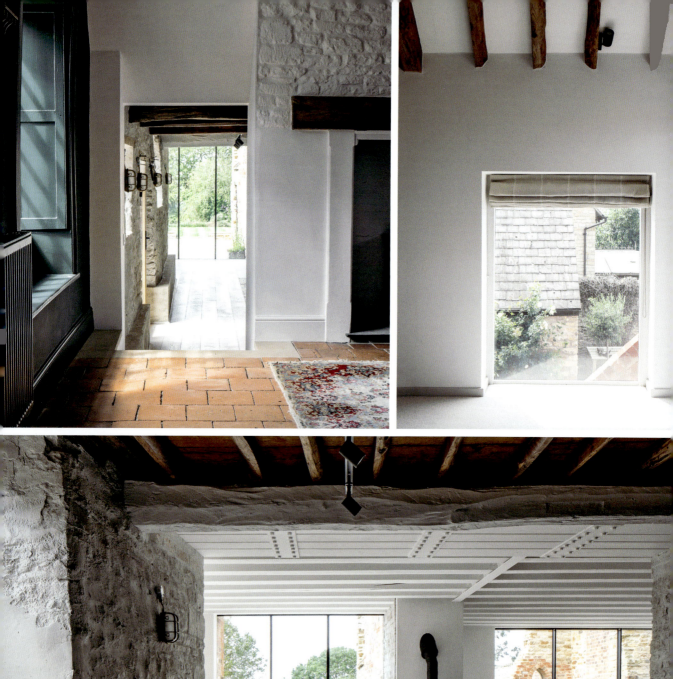

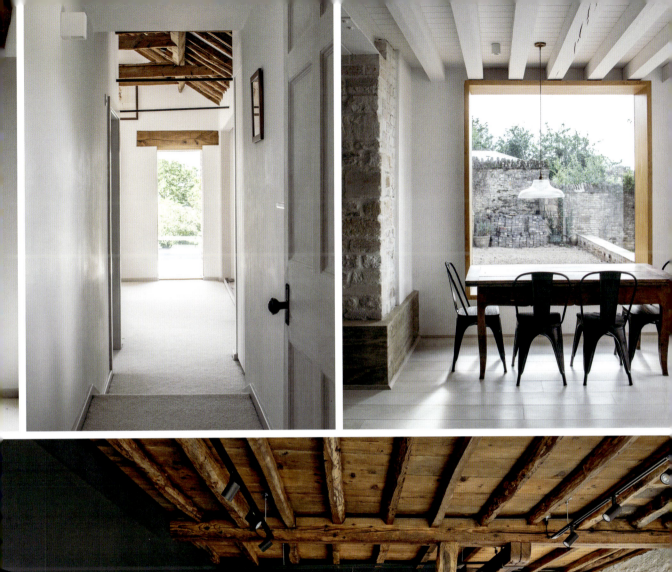
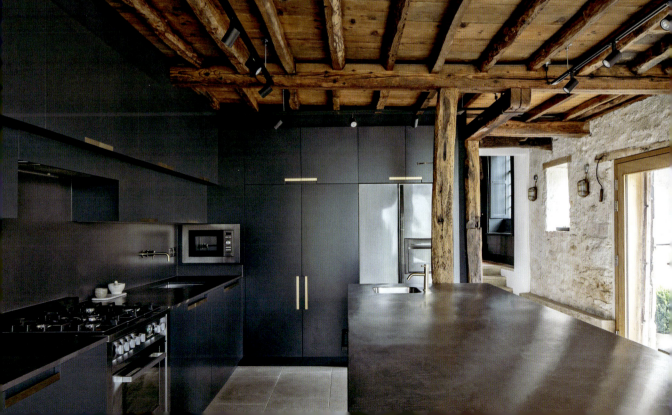

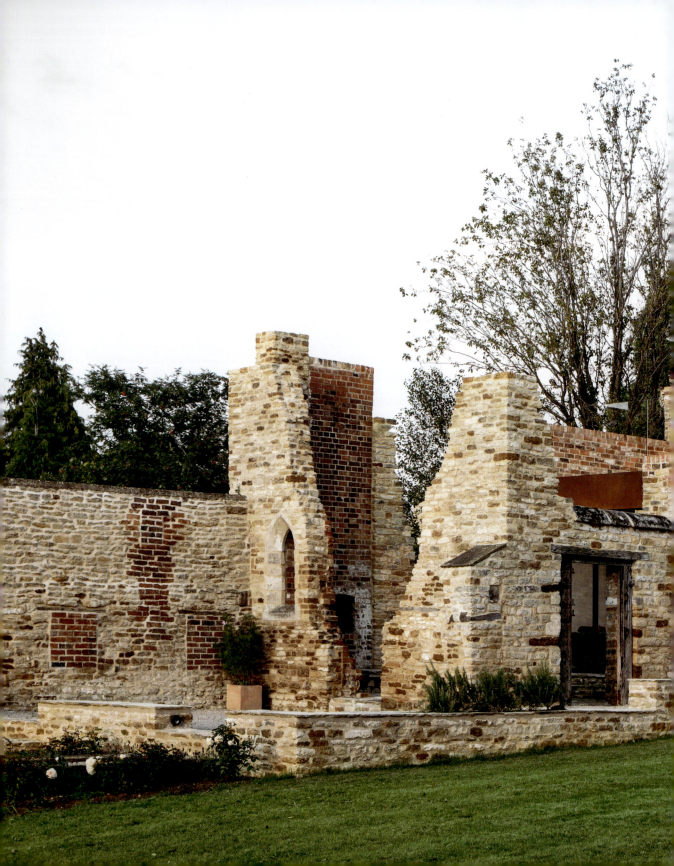

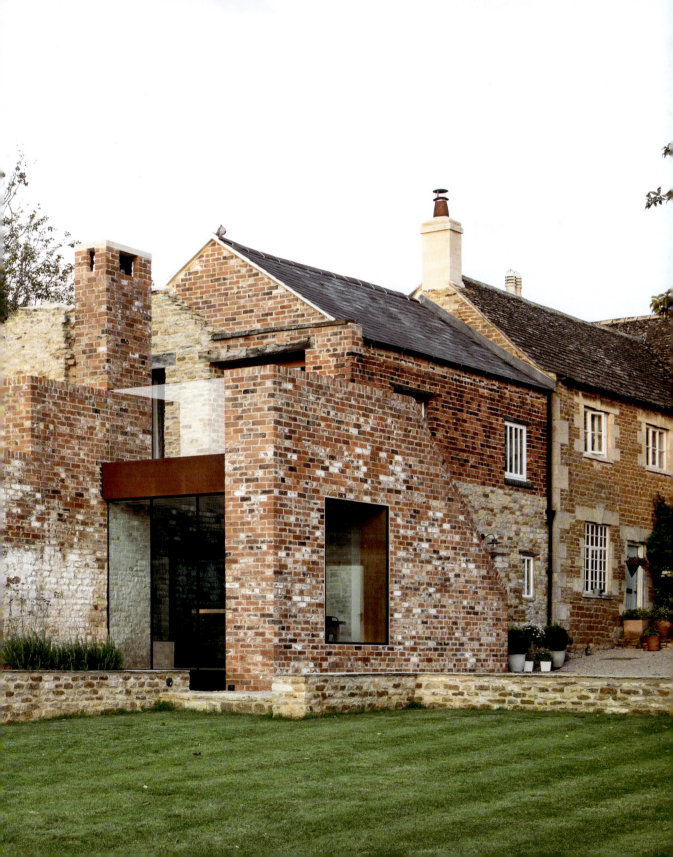

QUADRANT HOUSE

Robert Konieczny KWK Promes
Near Warsaw, Poland

Giving new meaning to the expression "chasing the sun," Quadrant House literally includes a function for a moving outdoor living space that pivots and docks with rooms on either side of the garden. And as if this wasn't enough, the moving terrace with its kinetic architecture actually reacts and follows the sun's movement.

Named after the device used by astronomers to determine the position of the stars, the motif becomes clear as the moving terrace pivots through 90 degrees.

The mobile fixture rotates between the living area and the spa. Consisting of a terrace, this area is permanently shaded as the section moves to follow the sun. When it docks against either of the interior spaces it creates an open-air extension to these rooms. It also offers protection to these interior spaces from direct sunlight. Residents can sit in its shade and enjoy the fresh air. The terrace also regulates the amount of sunlight in the spaces it adjoins, providing shadow in summer but additional sunlight during winter.

The drive system is fully automated, but there is also the option of manual control if needed. Advanced safety sensors will stop the motion if any obstacles are detected, so there's no cause for concern if something is mistakenly left out on the grass. Intriguingly, as the terrace is continuously in motion following the track set into the garden, the lawn does not suffer any adverse effects, and the grass continues to grow beneath the moving floor.

As the room literally moves to catch the sun and open up the main house to warm rays, we are sure that all cats would agree that this is a delightful concept, and the perfect way to relax while chasing the sun.

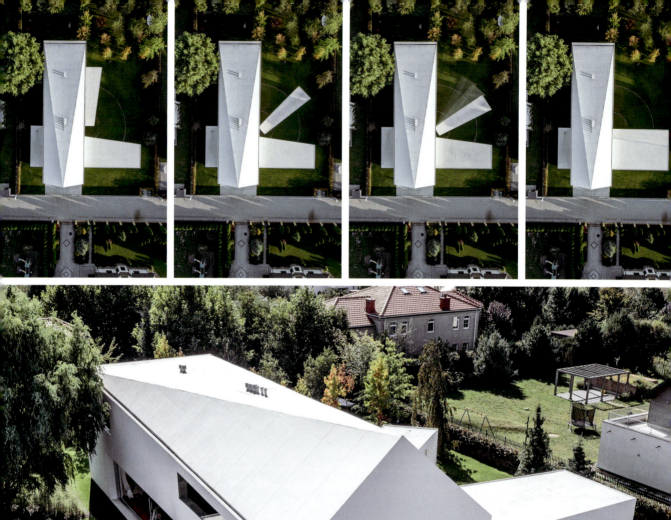
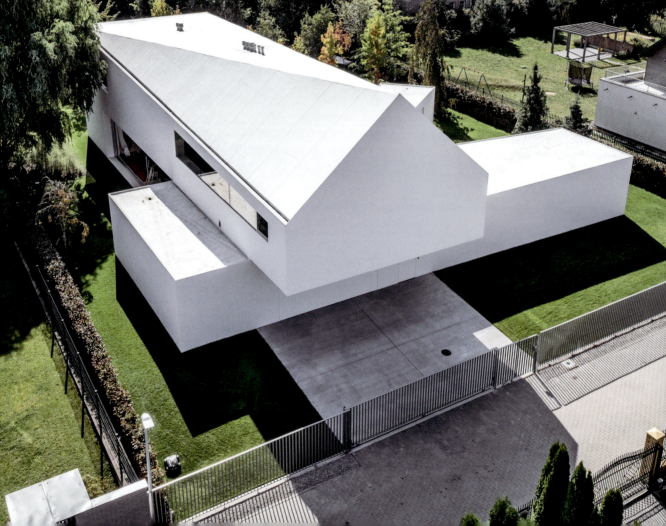

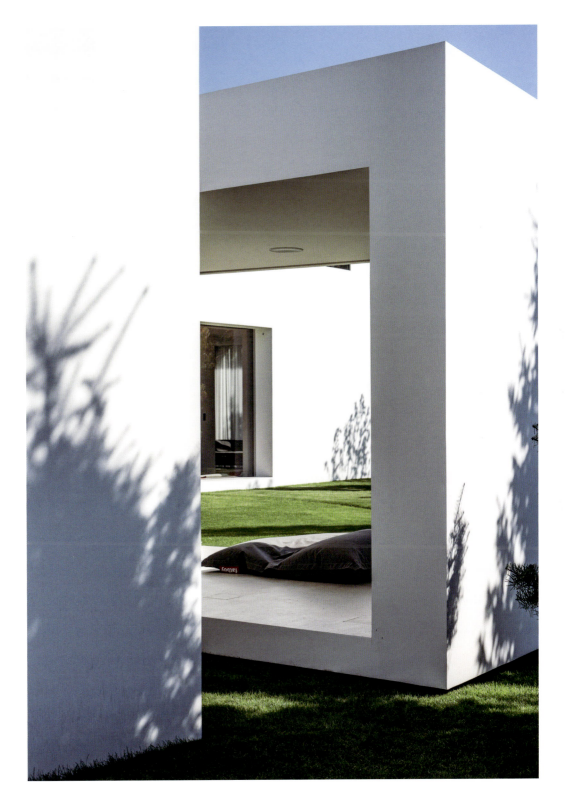

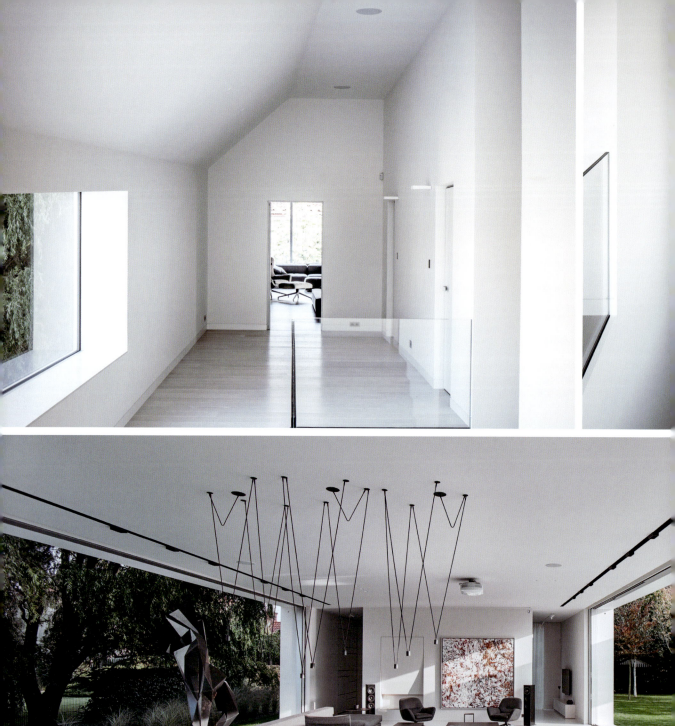

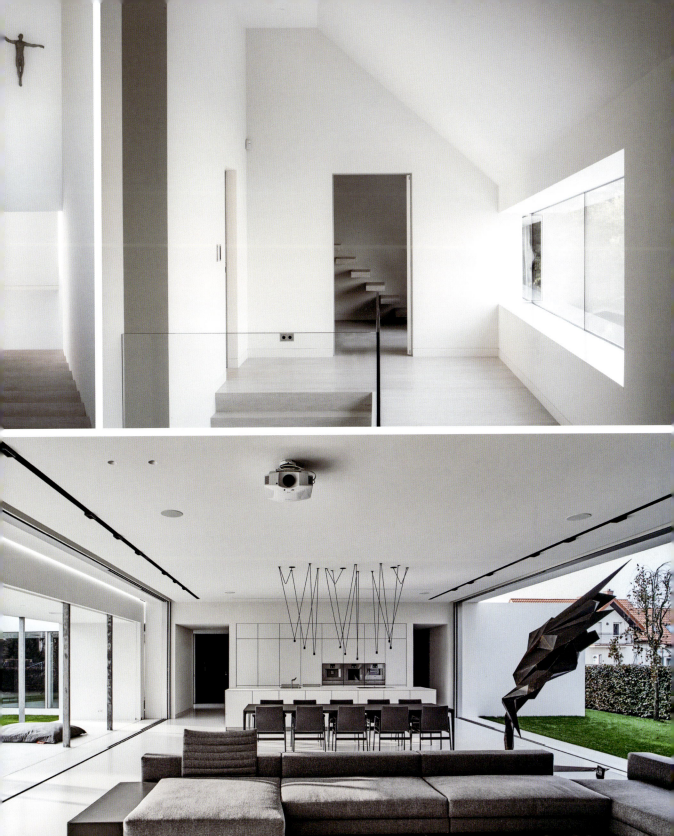

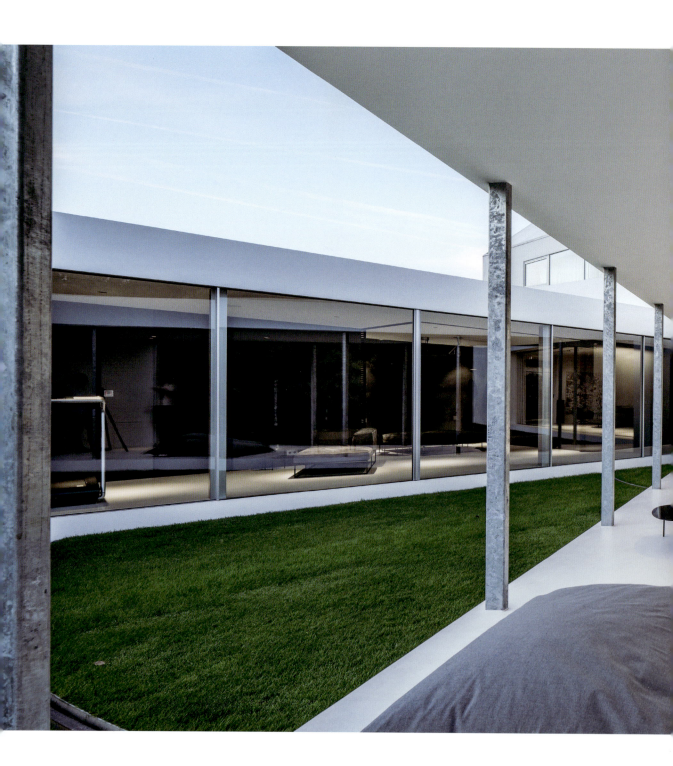

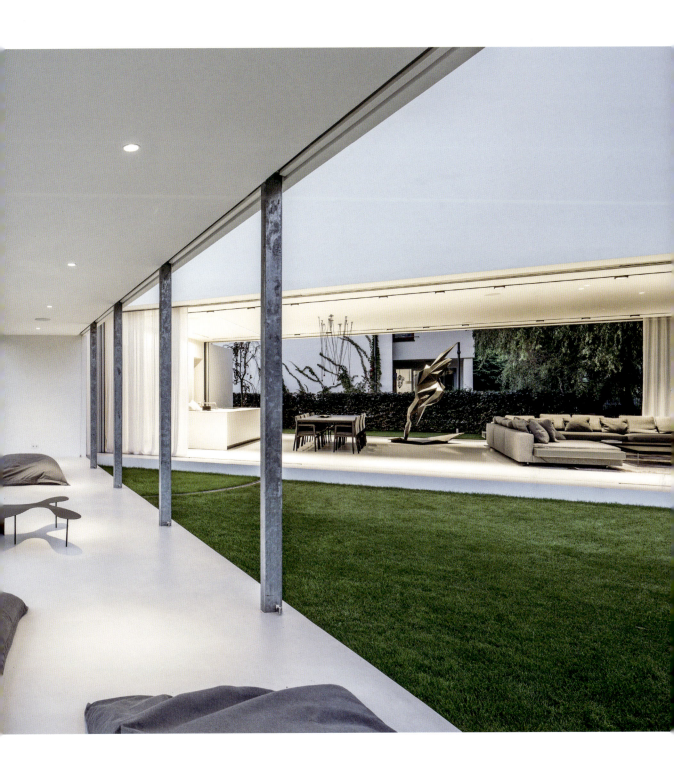

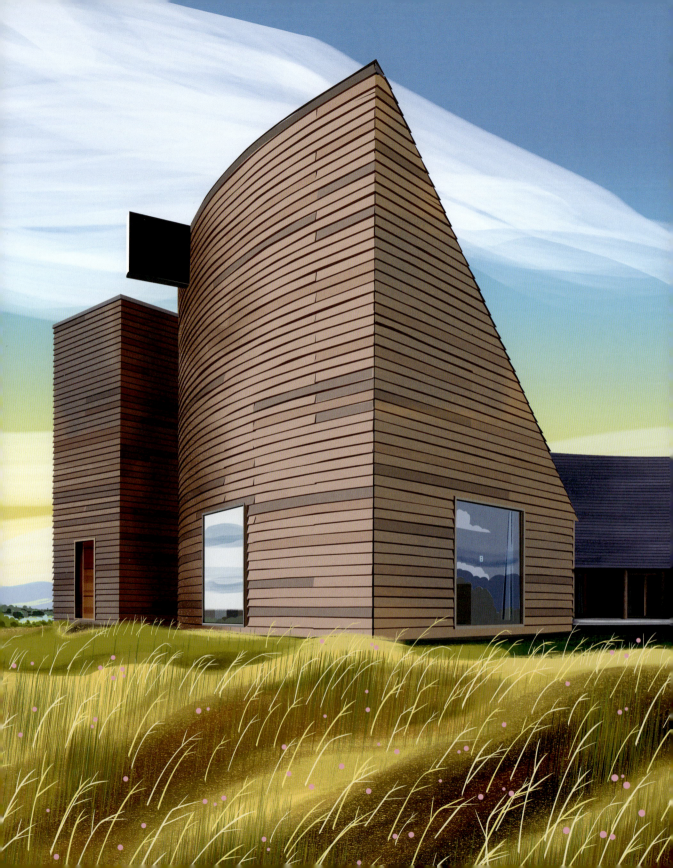

Pezo von Ellrichshausen
Chiloe Island, Chile

RODE HOUSE

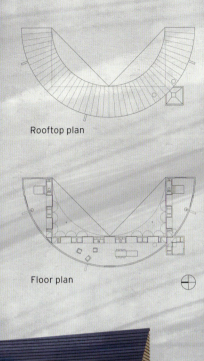

Rooftop plan

Floor plan

Approaching Rode House from one direction, you might expect to stumble upon a beautifully circular house. But with this design the circle is never quite completed, resulting in a beautiful, wooden semi-circular house that curves around a courtyard.

Set high on an exposed hill, this construction presents two very different faces. "From one side it stands as a massive and hermetic fortified refuge; from the other it appears as a large pitched roof almost without supporting walls," note the architects. There is a good basis in this fortified front face: it provides a shelter from the strong winds that sweep in from the sea.

The living areas are mostly positioned to face onto the more sheltered courtyard, with the exception of two windows set into the walls of each bedroom that look out across the surrounding scenery. The two bedroom wings are placed at each end of the building, with one facing north and the other south, and creating a different relationship with the sun in each space. In the interior of the curve is a turfed garden, with two large courtyards formed under the sweeping roof. These two corner areas are protected by a combination of the steeply angled roof and walls to create a welcome place of shelter from the biting rain and wind.

Entirely constructed from local timber, the architects employed carpenters from the area who are renowned for constructing wooden churches and for boat building. This skill becomes apparent when one gazes up at the underside of the huge roof that resembles the underneath of a beautiful boat.

This house with two faces draws upon the heritage of the local boat builders to produce a comforting vision on the landscape, and a welcome shelter from the wind.

171

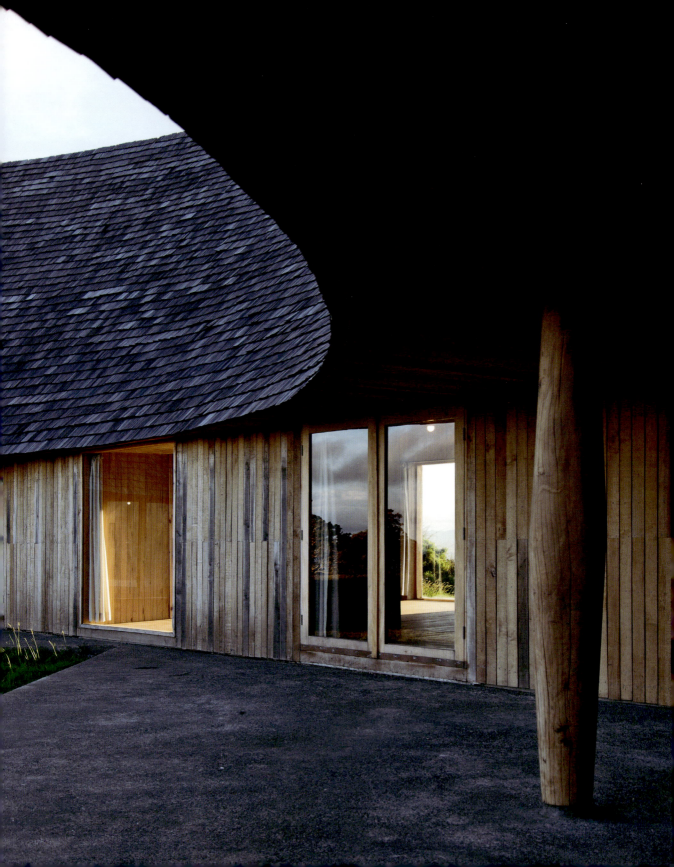

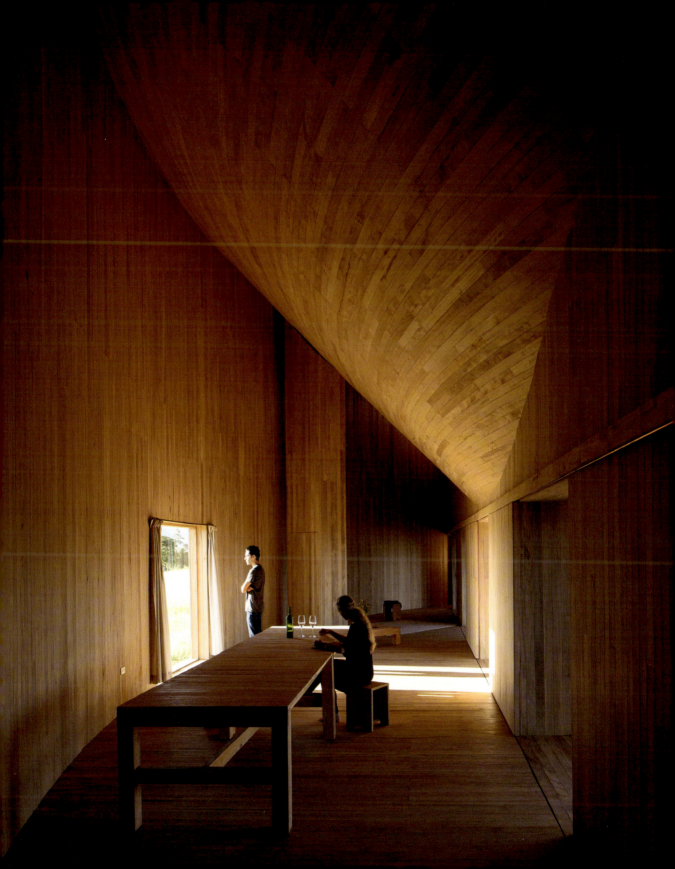

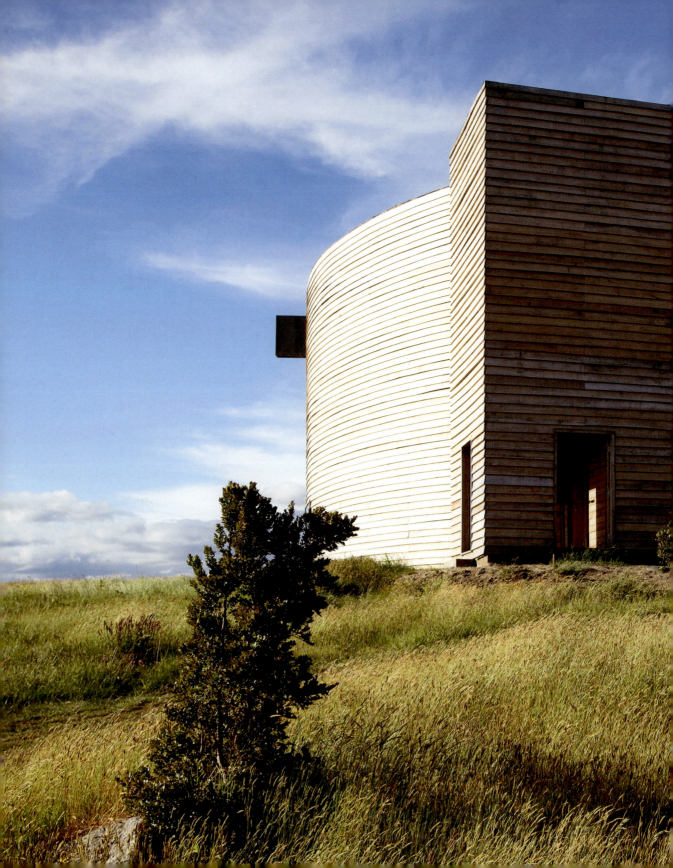

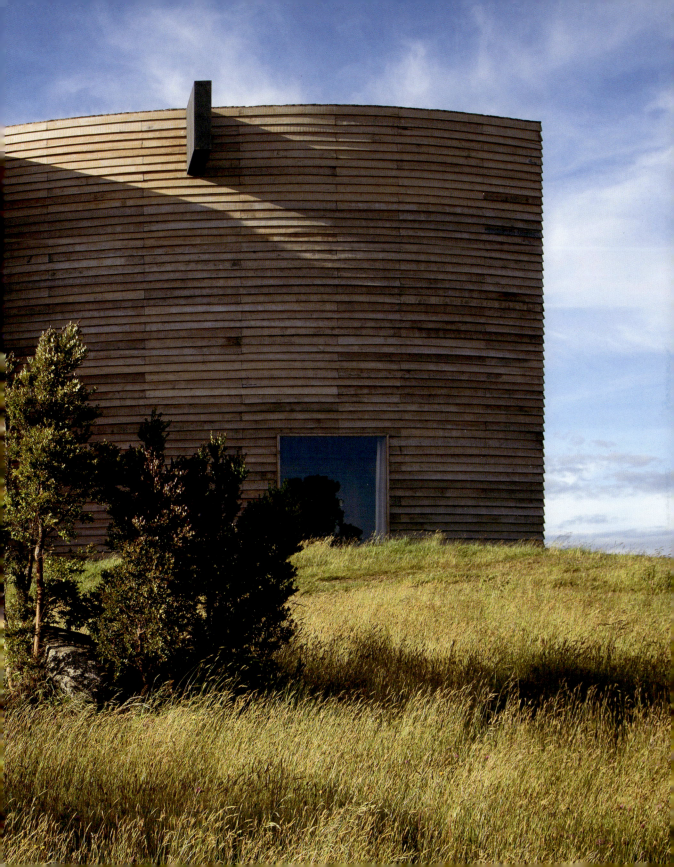

SHKRUB

MAKHNO Studio
Kyiv, Ukraine

When an architect has the chance to design and build their own home, the result is a playful expression of their own ideas and interests. Shkrub, built by Sergey Makhno for his family, is no exception, and is built in contemporary Ukrainian style with a strong influence of the Japanese philosophy of wabi-sabi: finding beauty and harmony in imperfections. The result is a unique Ukrainian design, transmitted through the lens of Japanese perception of what is beautiful.

Of course, designing your own home allows the architect to embrace their passions, in this case, a superb collection of Ukrainian ceramics, housed to great effect in bespoke settings. Makhno also designed the furniture and lamps, and the patterned wallpaper in the children's rooms. The rug, however, was designed by one of his sons at the mere age of two.

Makhno drew on Ukrainian tradition, not only with the thatched roof, and the decorative motifs on the wood work, but also the wall coverings. Clay has been used in the Ukraine for generations and Shkrub uses several types. To achieve a texture with rhythmical dents, the walls were covered with clay and knocked with a wooden spoon until it dried, providing not only an aesthetically interesting texture but the ability for it to soak up acoustic noise.

The home is studded with technological advances, including a smart home system. It is also energy efficient, equipped with solar panels, and a geothermal well. Much of the wood used in construction was salvaged from other buildings. Storage remains concealed, to allow the home to breathe and is in keeping with the principles of wabi-sabi.

The house is an ode to creativity and art, with poetry throughout. Shkrub is a fictitious word used by Makhno and his partner, and means respect and patience, but mostly love. Love for each other, love of the family, the objects inside all with precise meanings, and love of their Ukrainian heritage.

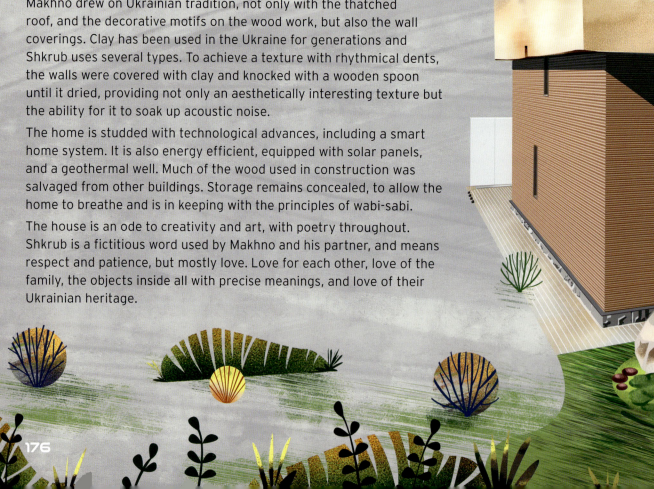

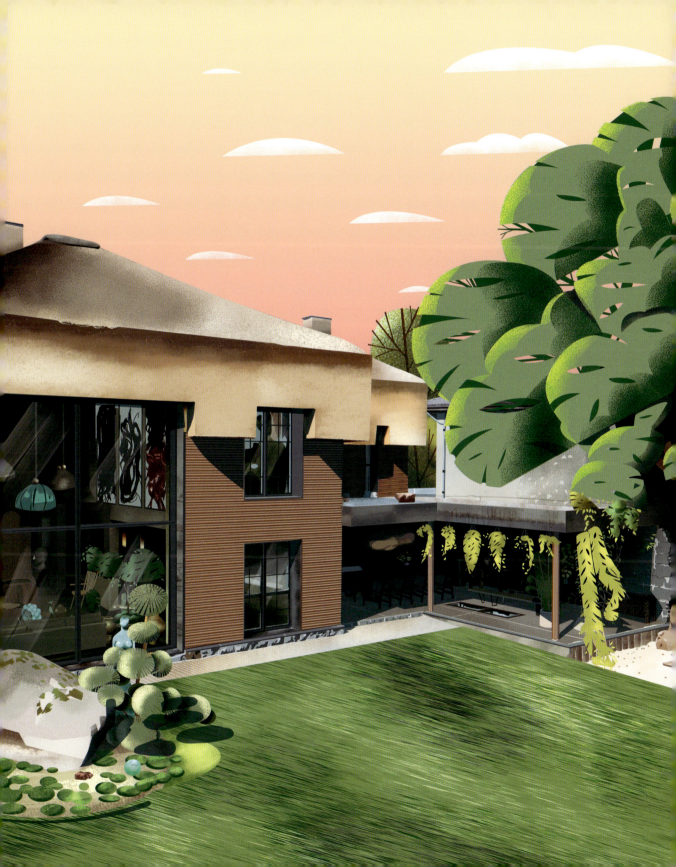

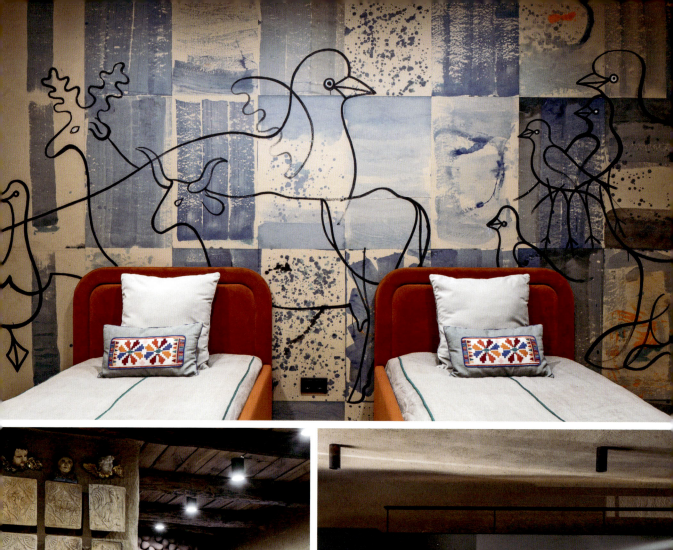

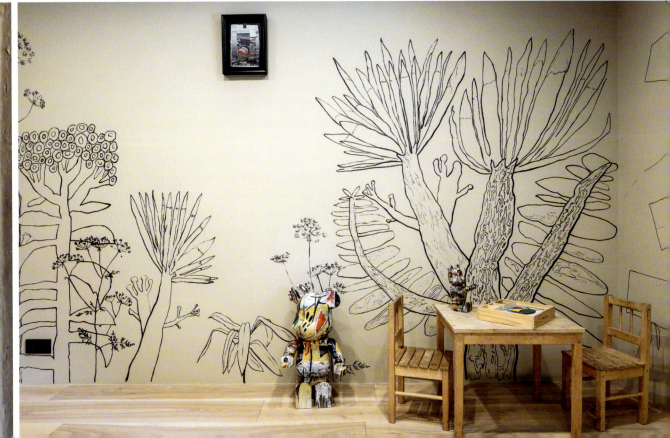

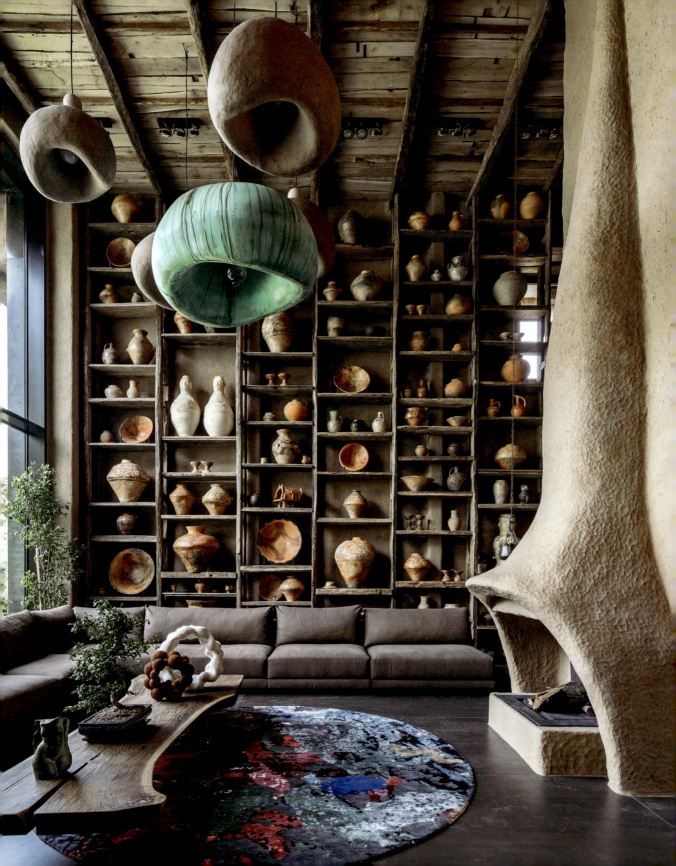

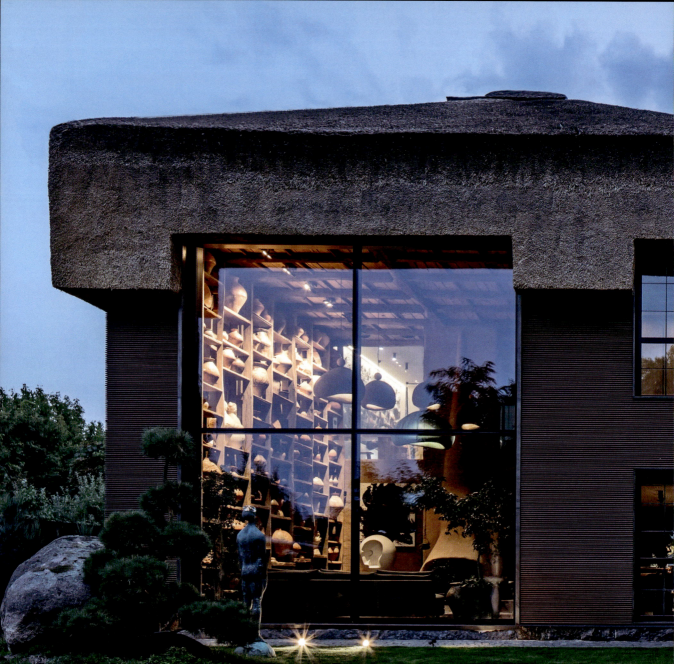

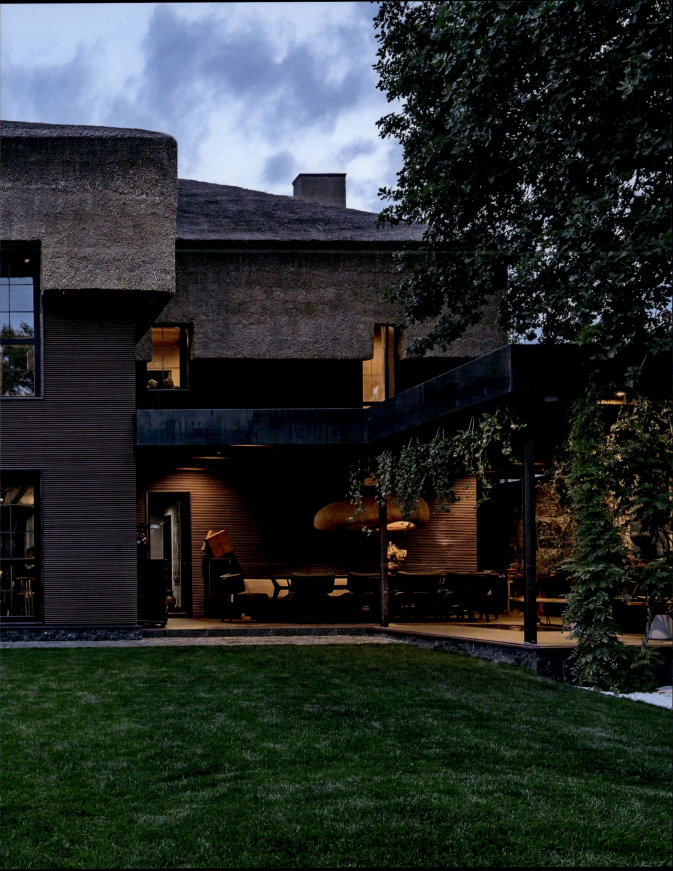

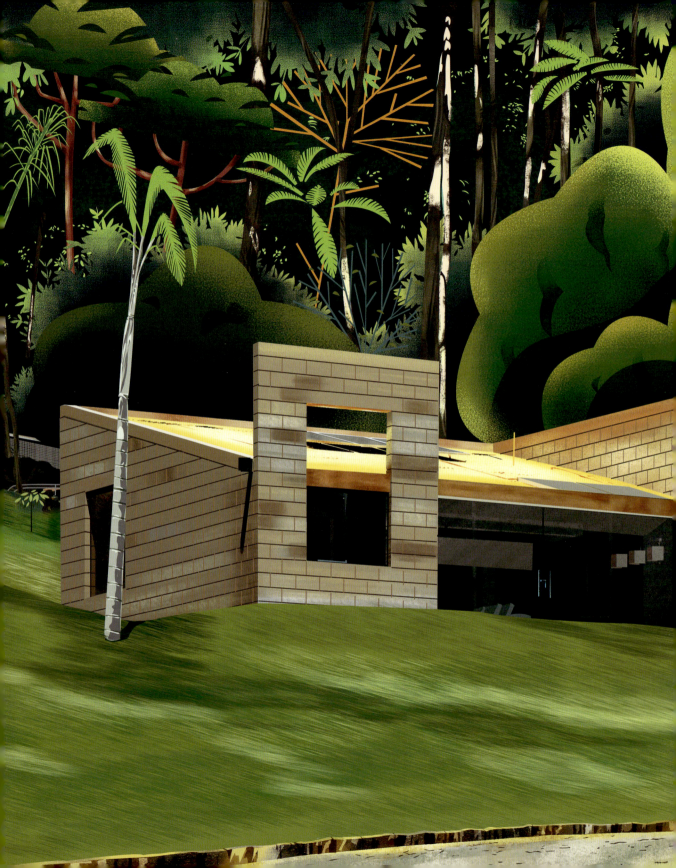

SUSTAINABLE HOUSE

Gustavo Penna Architect & Associates
Ouro Branco, Minas Gerais, Brazil

Sometimes, as the slogan goes, the simple things in life are often the best. Sustainable House is just such an example, a basic design yet one that seeks to repurpose unused by-products of mining activity to produce an ecologically friendly residence.

The design forms the pilot project of the Gerdau Germinar Program's environmental education equipment that presents the public with new concepts of sustainability applied to mining and the concept of circular economy in housing. This house is a test model for studies and improvements, to achieve the ideal result for the construction of sustainable cities and neighborhoods. The architects sum up the result as being made of matter and spirit. And a strong dose of determination and ingenuity you might say has also gone into this unique unit.

The design needed to be more than purely functional, but also a home, a place for each person to feel valued. Every home, even the simplest, must be able to create a sense of pride and self-esteem.

The design values the needs of its inhabitants, offering unusual features and spaces, such as an open kitchen, a living room that integrates with the garden, solar water-heating system, and wind energy. The structure has environmentally friendly systems that are already accessible to the market, such as solar heating, power generation, biodigesters, composting tanks, and rainwater collection.

The playful and dynamic volume of the house plays a role in its functionality: improving its natural ventilation by driving and directing the winds, shading the transparent façade, and enabling interesting unit mounting combinations.

For the development of this technology and the construction of the residence, about thirty people focused on solving this challenge that unites sustainability, education, and quality housing. The home was designed by architect Gustavo Penna, who sought the ideal combination of design and the best use of natural resources.

The house is both a simple and powerful example of coordinated planning that integrates current knowledge of sustainable technology and building processes.

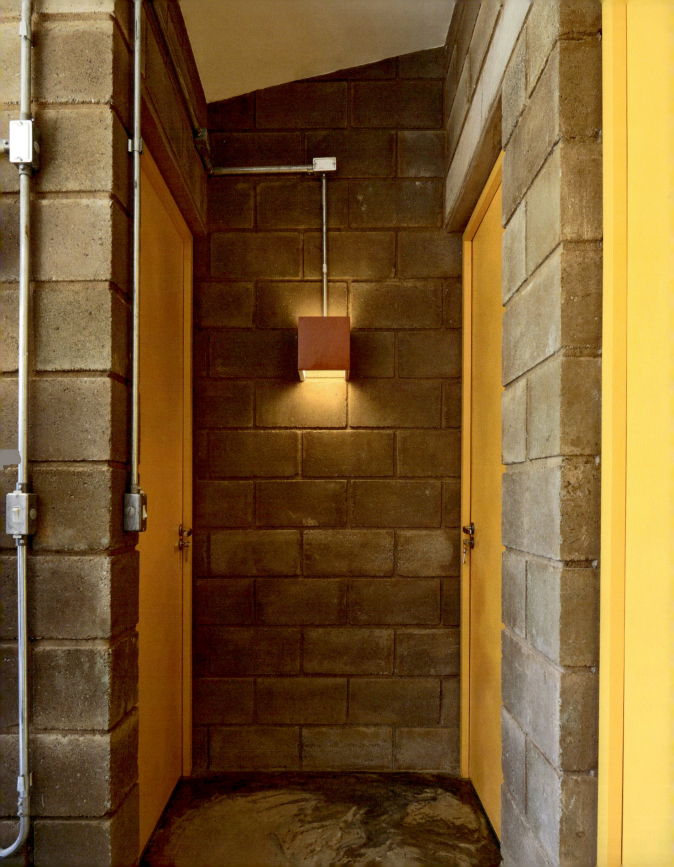

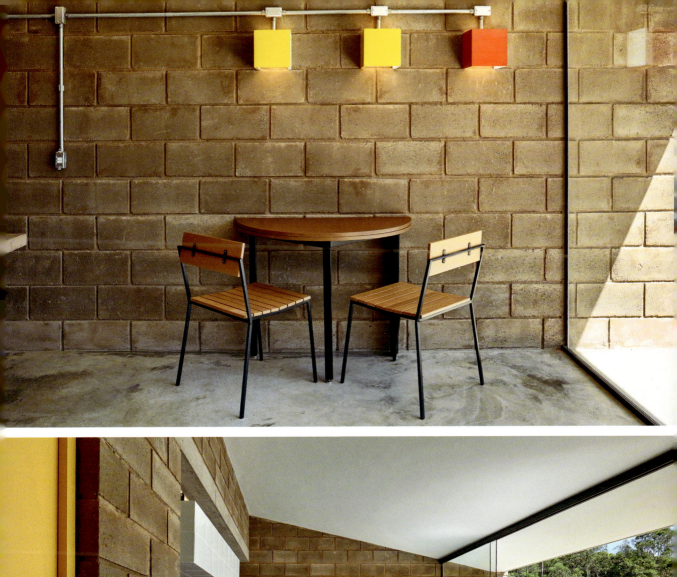
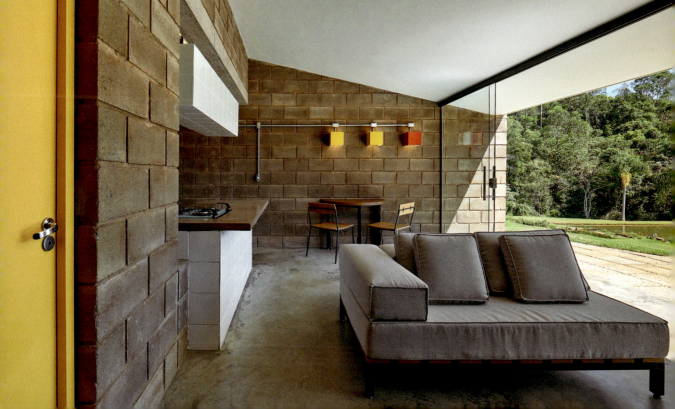

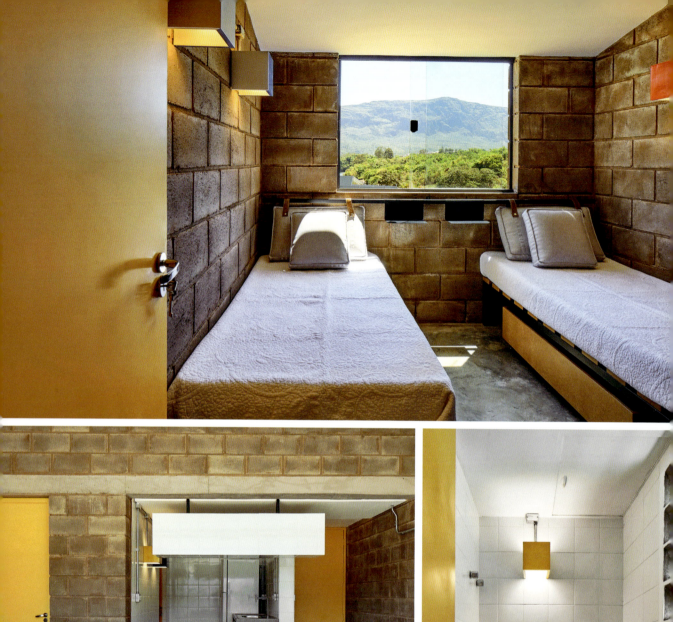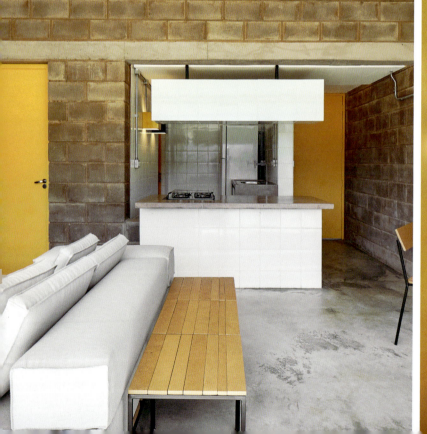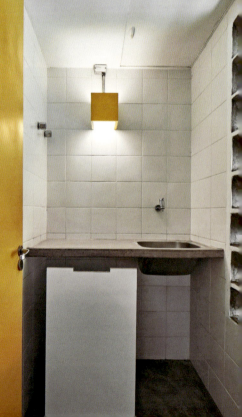

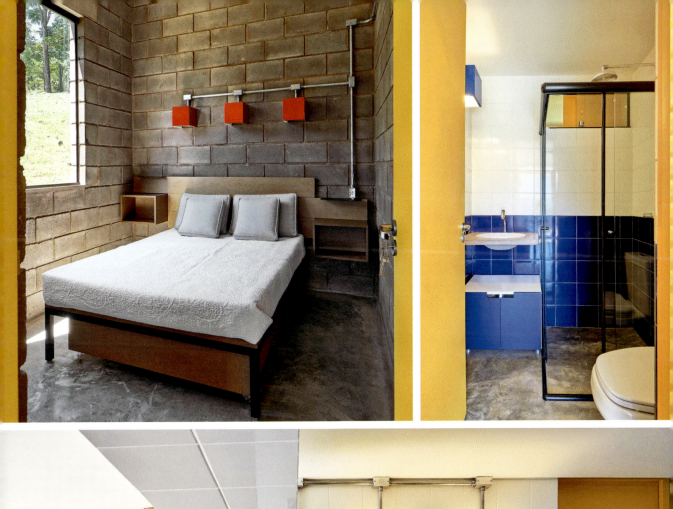
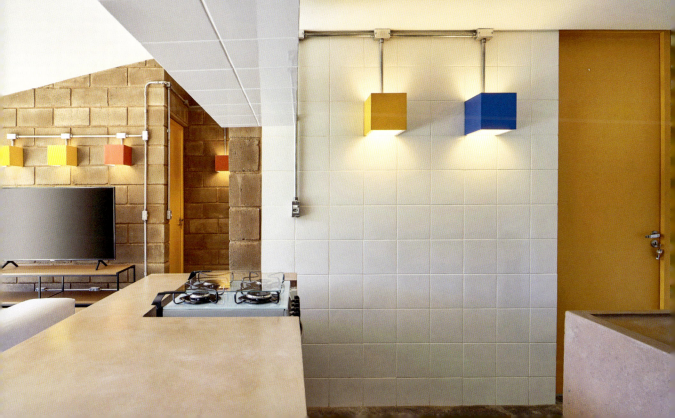

TRI HOUSE

Urban Agency
Dublin, Ireland

By rethinking the traditional elements of a standard residence, Tri House succeeds in producing an entirely new and innovative way of designing a home. This bold dark structure sits in direct contrast to its fellow two-story brick residences in a typical Dublin suburban estate, and offers a novel idea for how to better fully utilize land for housing rather than rely upon the standard two-up, two-down house with a deep garden space that is so prevalent.

The awkward angular shape of the site sparked the idea of a triangular plan for the house with the corners extending to the edges and trimmed to create three porticos. From the outside, the house plays with the typically traditional ingredients of a suburban house, with its blue-gray pitch roof, painted render, and attic rooms, in order to fit in to the surrounding suburban typology but in fact upends these notions and delivers something unique and quite different.

Made from reinforced concrete, the exterior is covered in render, producing the dark monolithic shape, while the internal walls are left exposed, creating a modern and brutalist look. Sharp angles inside enhance the futuristic aspect, while brightly colored furniture provides a pleasing contrast to the gray. Skylights allow natural light to stream into the curious corners created through the addition of the central triangular stair case by the unusual shape. Windows have been carefully located to frame important views and also to avoid overlooking neighboring yards. The roof is sloped to minimize any projection of large shadows onto the neighbors.

While looking like it could suddenly lift off into space, the building overall creates a dynamic series of interconnected spaces where family life unfolds. The bridge-like form has at its heart the family living areas, with the windows and doors forming yet another triangular space, echoing the theme of the overall design. This unique building succeeds in showing a new way of thinking about how to create capacious and stylish residences while making the most of limited land availability.

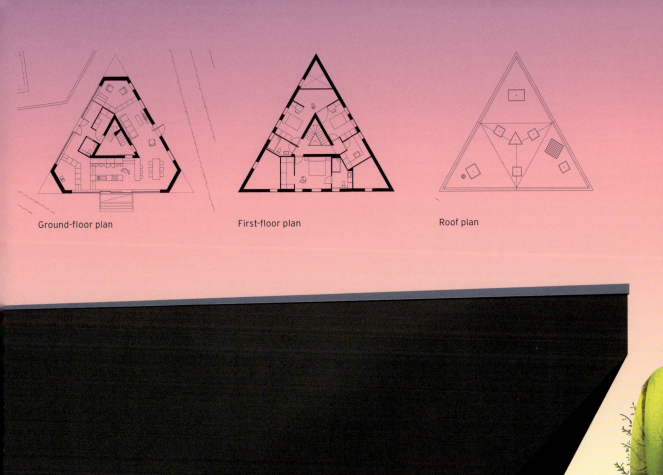

Ground-floor plan · First-floor plan · Roof plan

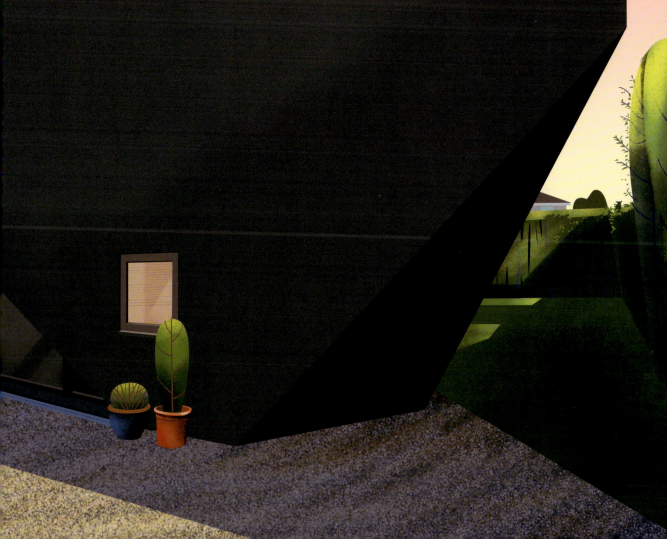

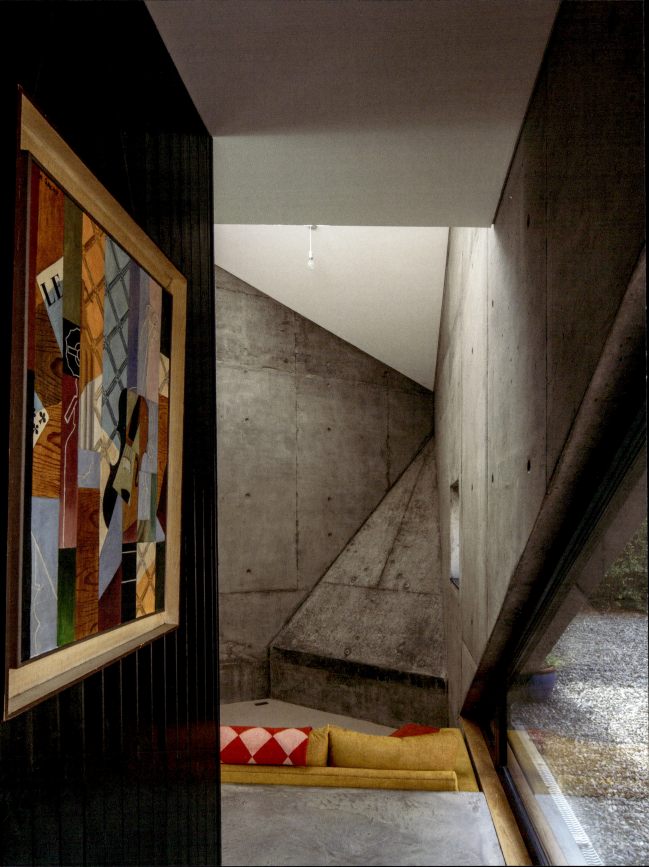

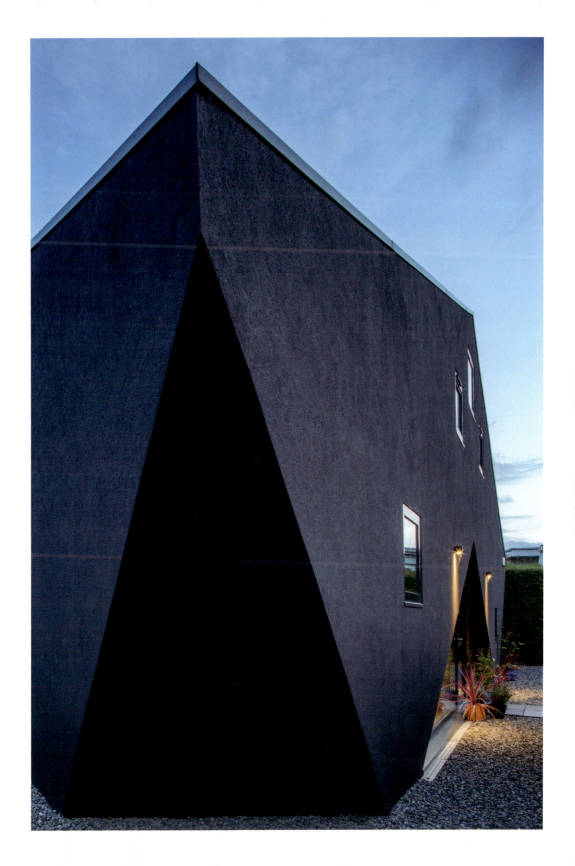

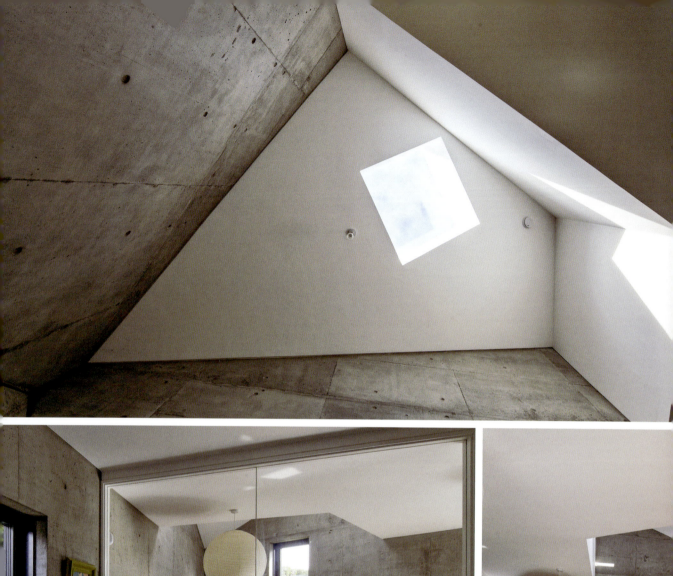
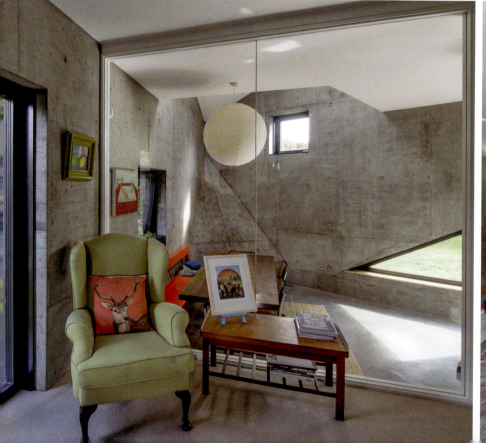
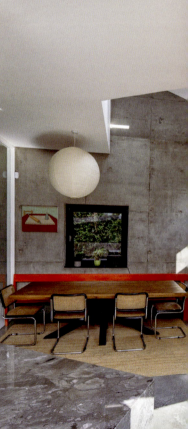

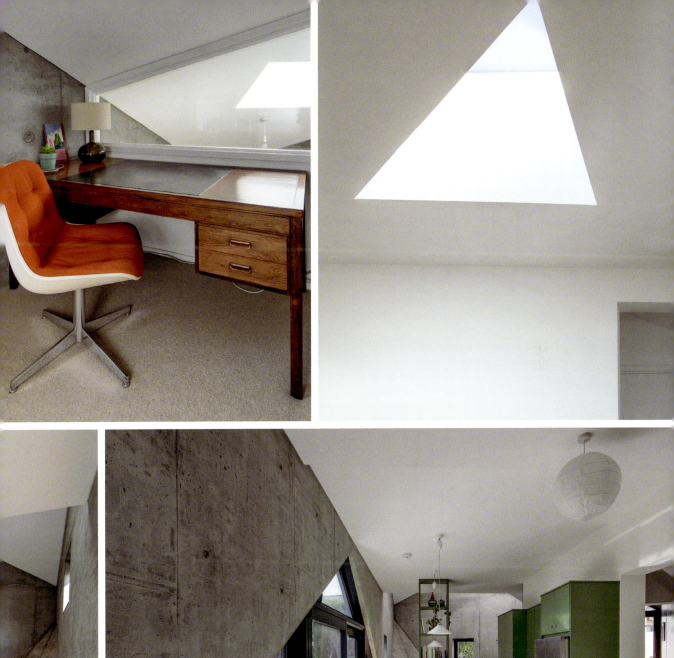
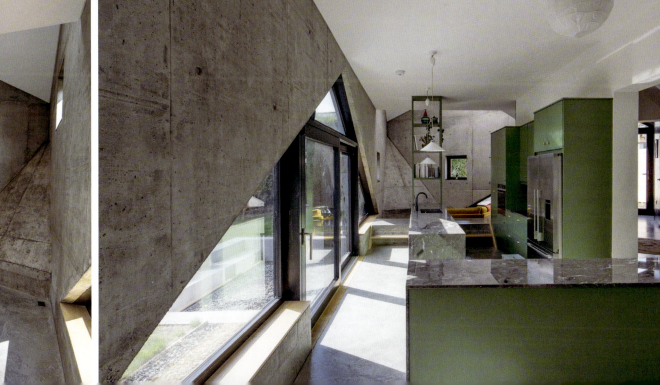

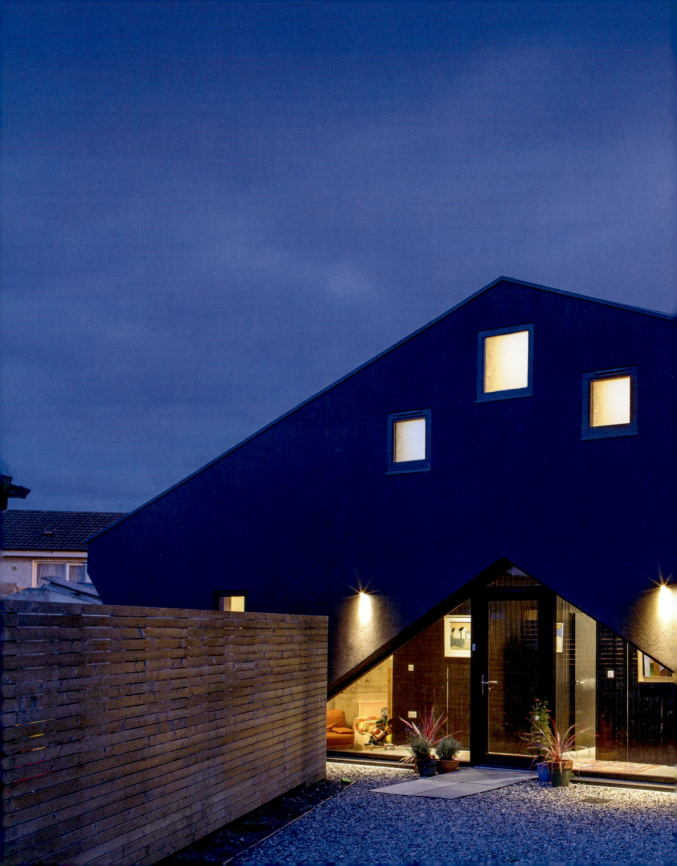

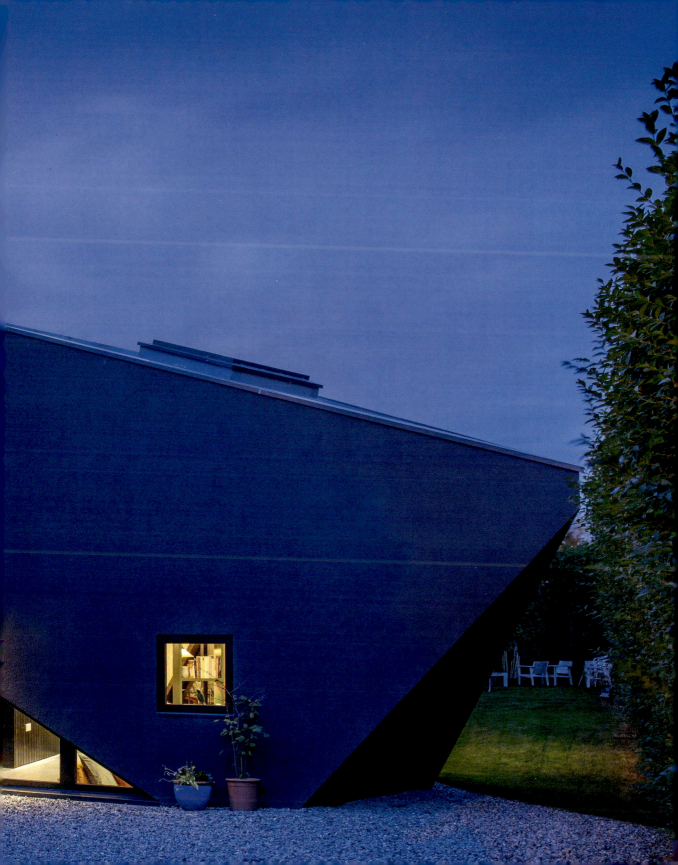

VILLA F

Christoph Hesse Architects
Medebach, Germany

Circular houses crop up in the architectural narrative from time to time, providing challenges to delight the designer. But even in the history of unusual round houses, this off-the-grid example managed to offer entirely new challenges.

It isn't every day that a client makes the following request of an architect: "I would like to have a round house that changes the whole resource consumption of my village." With an agricultural background, the client was a pioneer of waste to biogas-technology, and wanted to extend this concept to his house, and the whole village also wished to join in, eliminating their CO_2 emissions entirely.

Villa F, with its round cylindrical form, certainly stands out from its gabled farmhouse neighbors. In order to help the structure blend into the landscape, locally sourced materials, such as stones from the nearby creek, were used for the exterior cladding. The sloped roofline is designed to mirror the surrounding mountainous terrain. The simple design may fool the bystander into thinking the inside is devoid of any luxury, but the presence of a sauna and outdoor loggia with a heated circular pool overlooking the landscape puts paid to that notion.

While the most striking aspect of the home is its form, it is the purpose of Villa F that truly has had the most impact. It houses the family on the upper levels, and meanwhile the ground floor provides the technical production for the biogas, from which the entire village independently sources its energy, decreasing the total energy costs by more than 50 per cent, and completely wiping out any CO_2 footprint. So successful has this scheme been that the next village in the valley also plans to join.

One might even say that the circular form of Villa F is a fitting tribute to the circle of recycling waste into fuel.

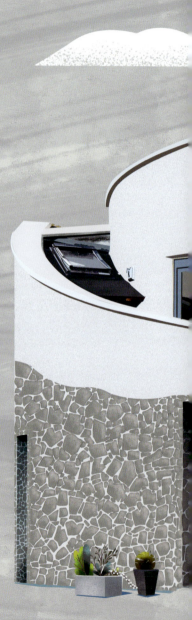

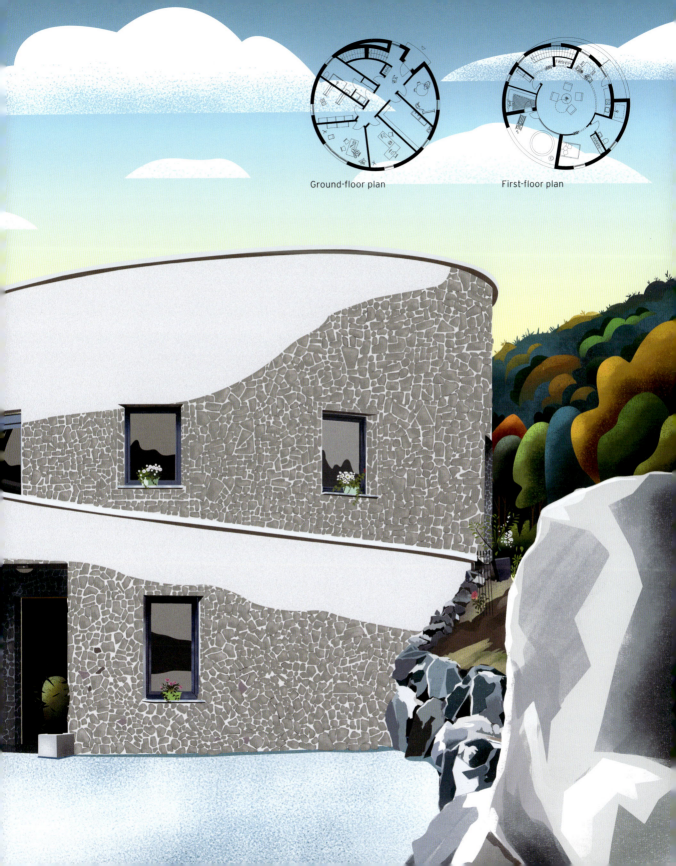

Ground-floor plan	First-floor plan

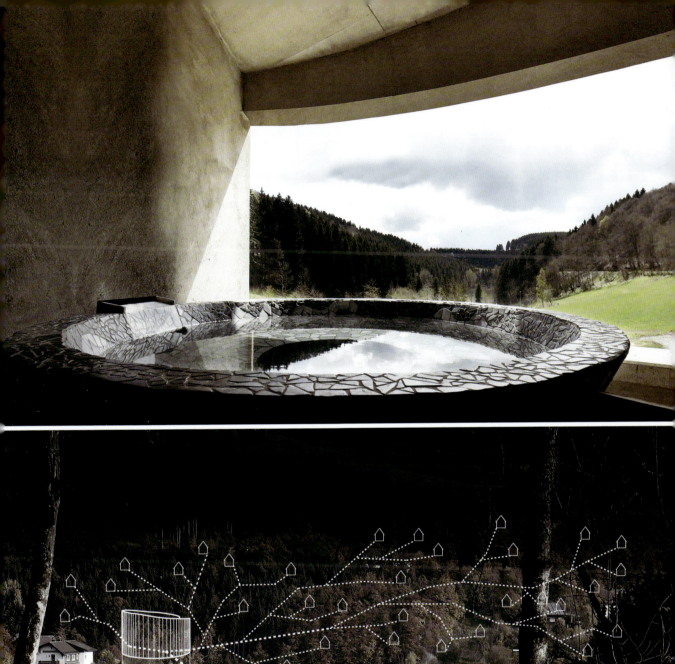
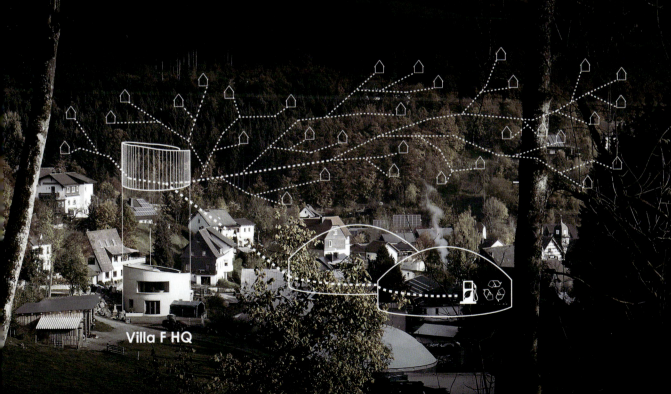

Villa F HQ

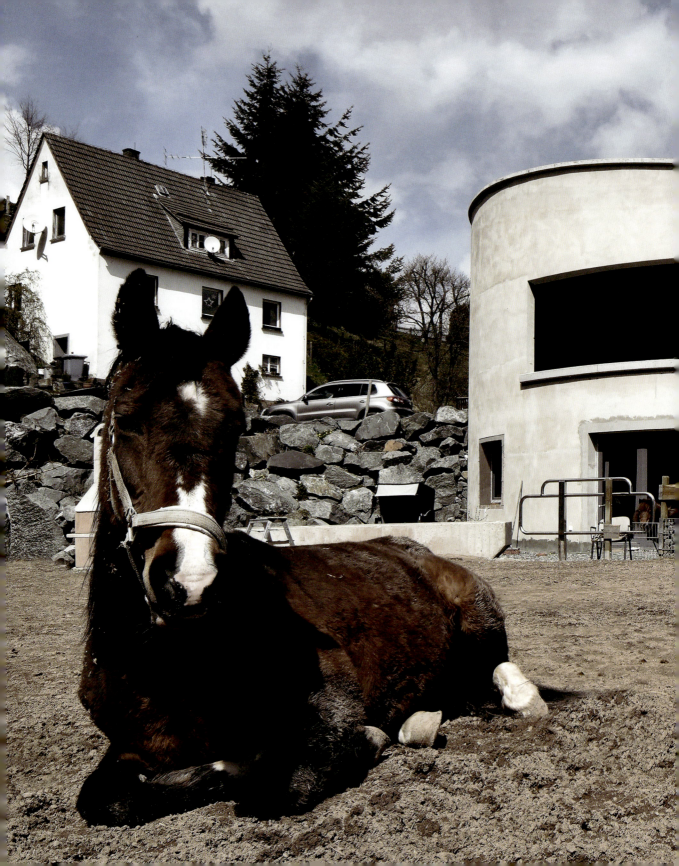

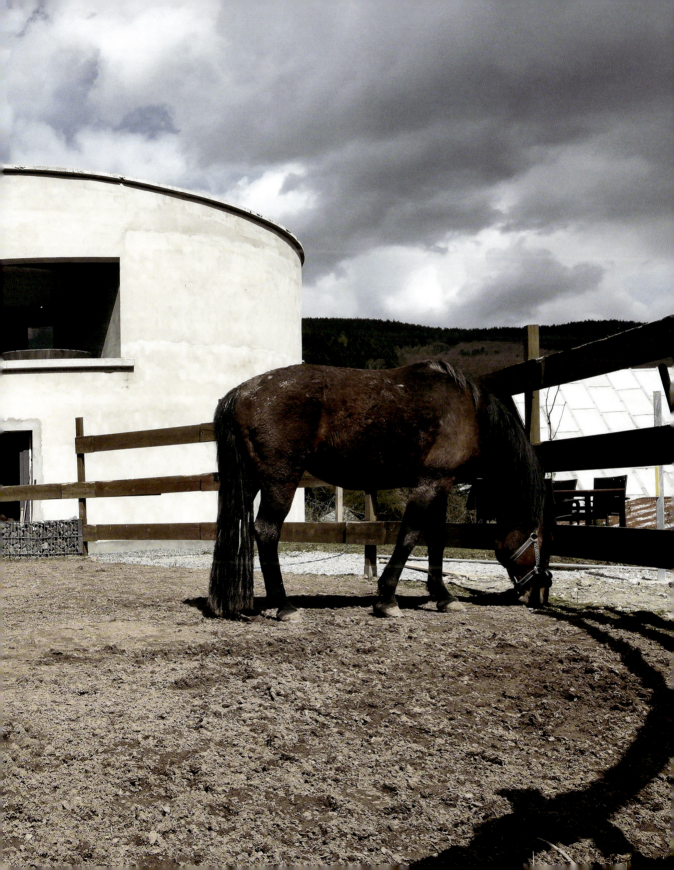

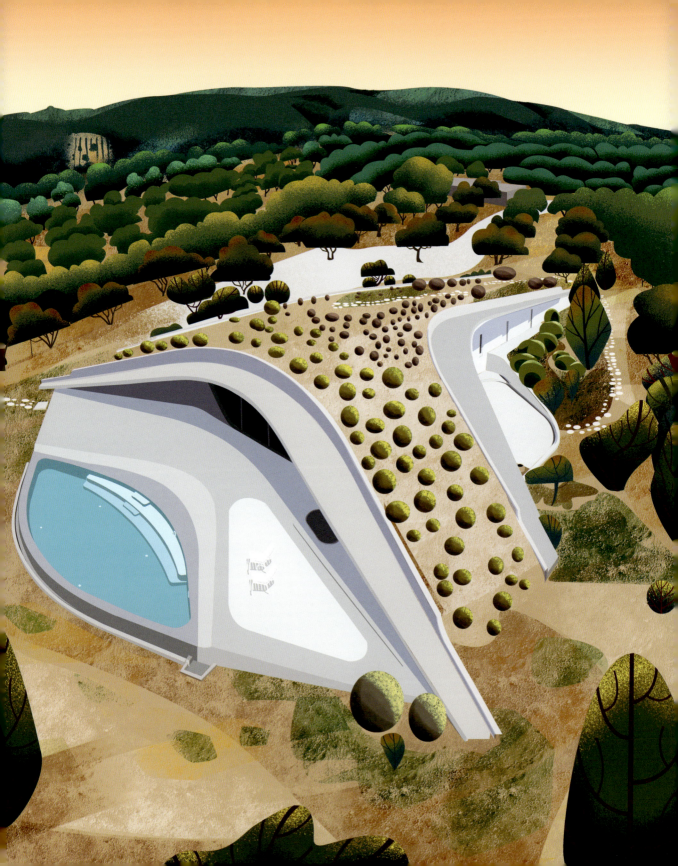

LASSA Architects
Peloponnese, Greece

VILLA YPSILON

Floor plan

There's environmental adaptation and then there's complete integration. A truly exciting design spectacle, Villa Ypsilon, as its name suggests, is characterized by a Y-shaped green roof acting as an accessible extension of the terrain. Plus, you can walk on it.

Looking for all the world like a visiting spacecraft from another world, the villa is located on the top of a hill amid an olive grove, and the home provides vistas toward the bays of Schiza and Sapientza as well as mountain views toward the east.

The roof's bifurcating pathways define three courtyards that form distinct hemispheres with specific living purposes, depending on the course of the sun. In order to achieve integration with the landscape, the roofline is only as high as the surrounding olive trees. The circulation through, around, and on top of the structure forms a continuous promenade comprising indoor and outdoor activities.

The form of the concrete shell coupled with the planted roof and cross-ventilation strategy provides an environmental response that prevents the need for mechanical cooling systems. The large overhanging eaves create shade at different points of the day for the courtyards, and serve to protect the building volume from the direct rays of the sun. Each courtyard is designed for use at different times. Little window spaces allow natural light into the interior, and produce interesting and varied shadows that evolve over the course of the day. Due to the remoteness of the site, much of the structure was prefabricated off-site.

The futuristic feel continues as you enter the villa. The large window in the kitchen living room is of a plastic and fluid shape, complementing the overall design, and requiring custom window frames. The interior colors are a bold white, offering a nod to traditional Greek residential typologies, but also adding to the pristinely modern atmosphere. The living room boasts an acoustic ceiling, softening the echoes from a concrete ceiling, and providing an interesting textural vision, one which is echoed in the room divider.

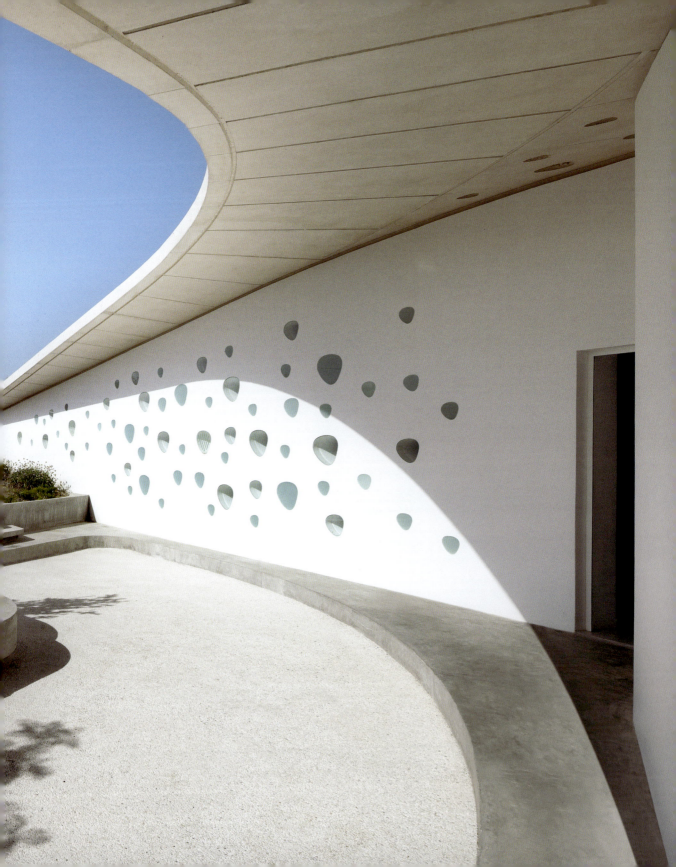

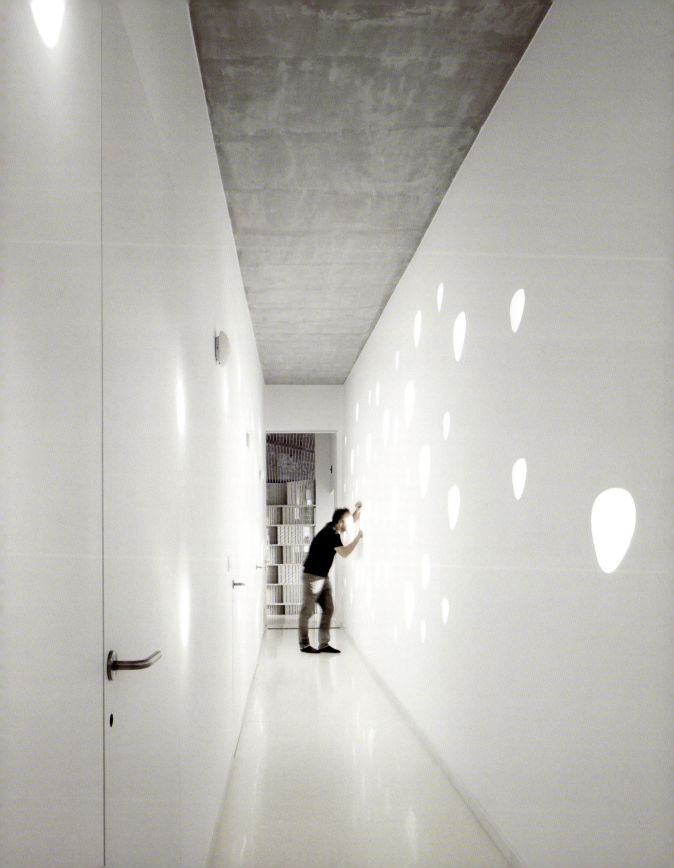

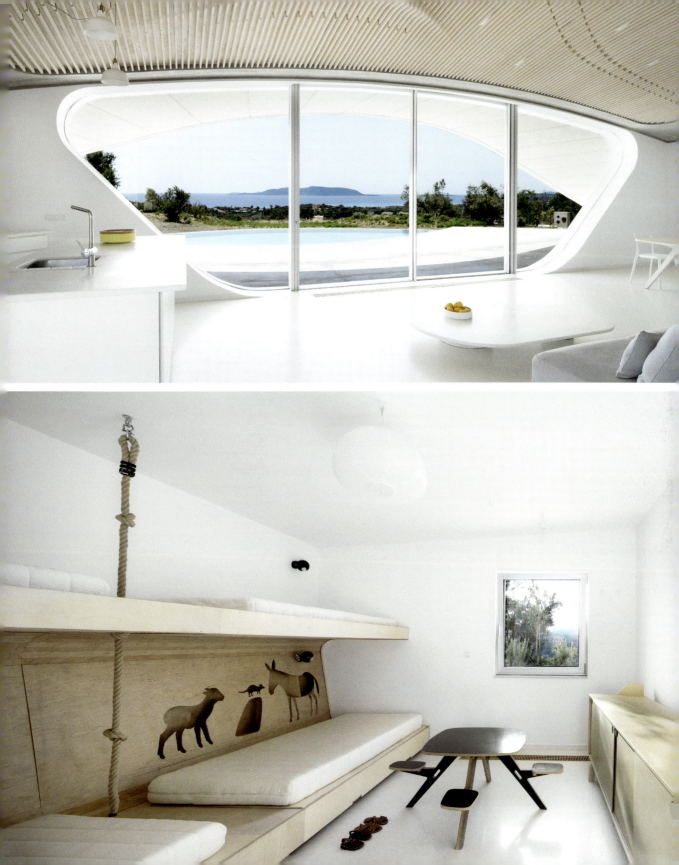

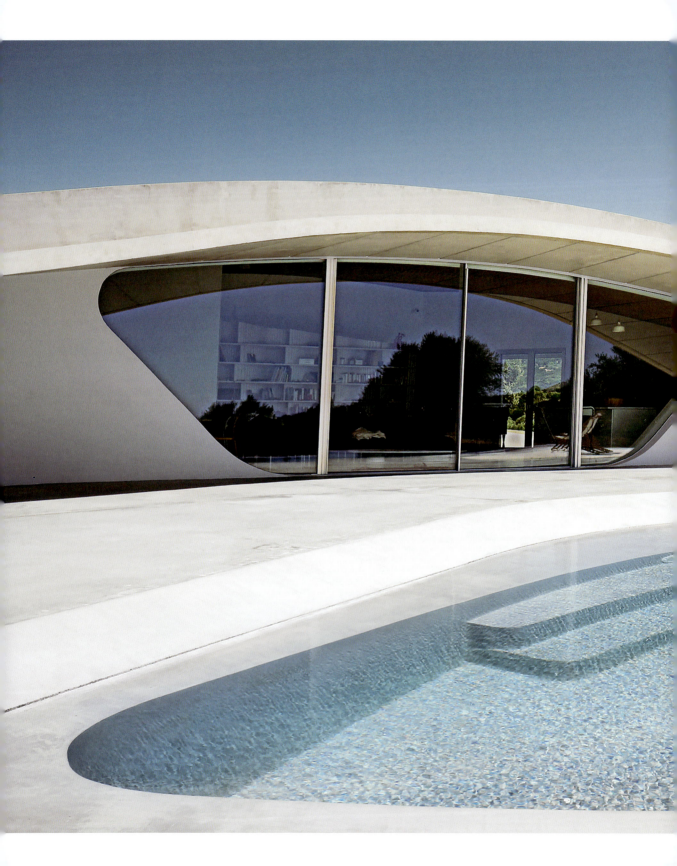

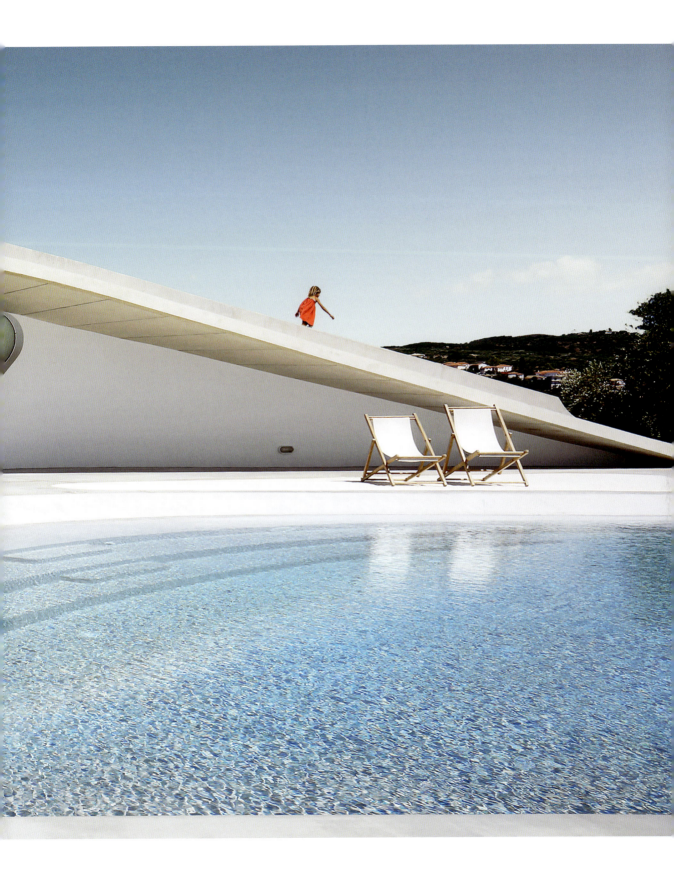

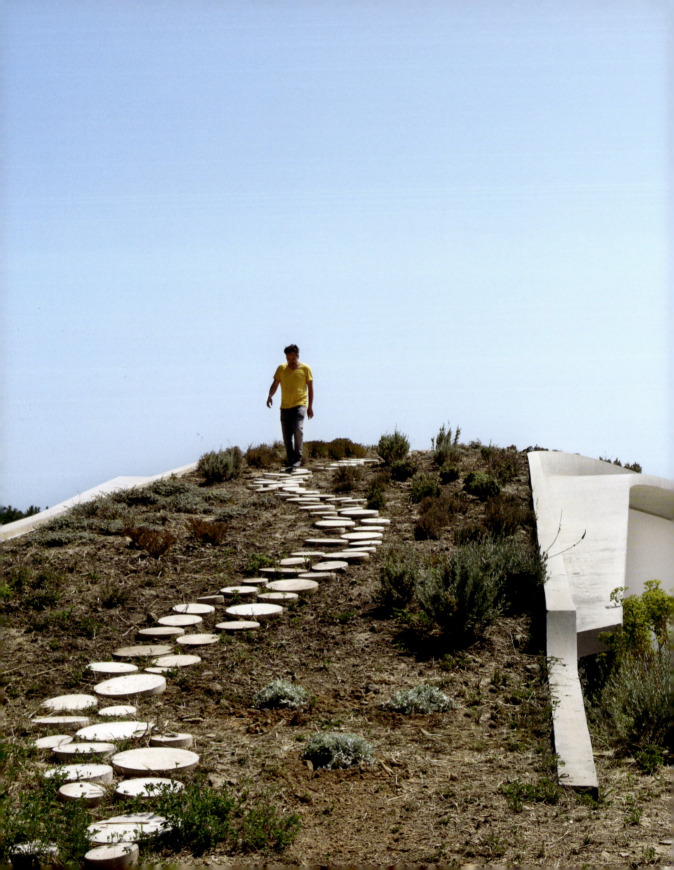

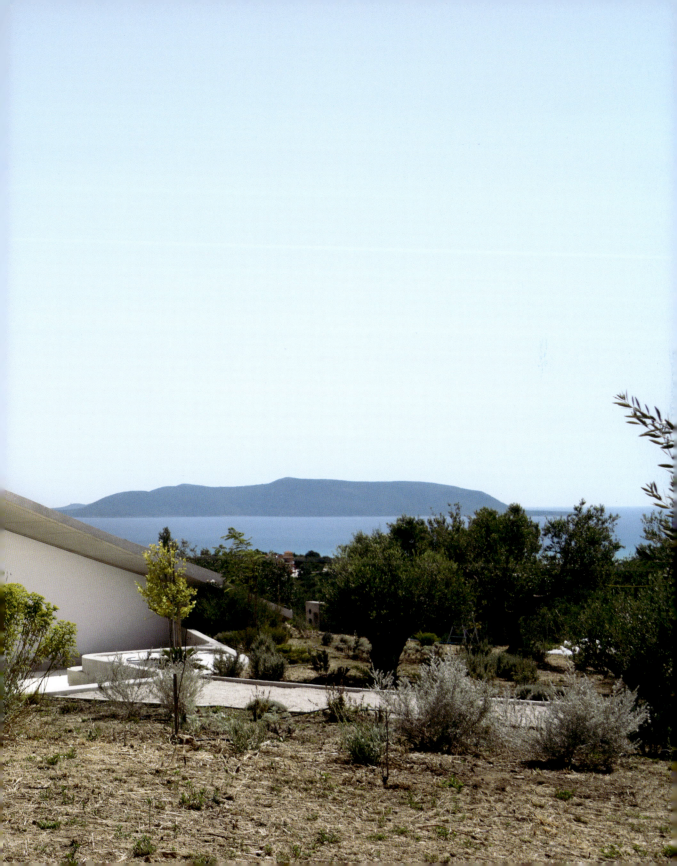

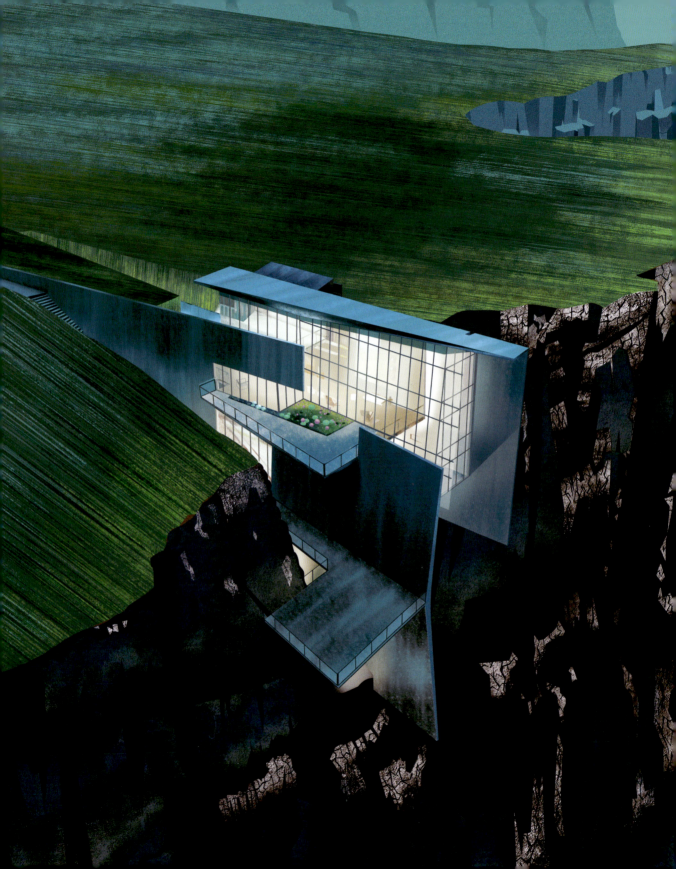

Alex Hogrefe
Selárdalur, Iceland

CLIFF RETREAT

When an architect dreams up a project to use in a tutorial about how to create design renderings, you can be sure that the result is something fantastic. Here, Alex Hogrefe, an architectural visualizer, designed a clifftop retreat that fulfilled his teaching purposes to discuss techniques, derived from his background in painting and drawing, that he uses in his work, such as focusing on light and shadows, texture, and atmosphere. He deliberately set out to achieve a bold design to illustrate his discussion, and Iceland, known for its stunningly grand cliffs, proved the logical site.

The retreat is framed as a place of escape, including meditation spaces and access to the surrounding nature. It hides within a furrow within the cliff face, exhibiting Hogrefe's belief that a design needs to have a dialect with the surrounding landscape, engaging with the site and calling on inspiration from the surrounding landforms. Above all, a structure should not merely be dropped on top of the site.

The retreat program reflects a transition from public to private as one moves up and down the floors. A large grand stair connects the floors both inside and out, and terminates at a large cantilevered overlook projecting over the ocean. The upper floors encourage interaction with large open-floor plans and several places to congregate including the kitchen and lounges.

These floors also serve as multipurpose rooms for nearby communities. The lower rooms gradually become more private, allowing for more private activities like sleeping and reading. The bottom floor opens back up to the outside with quiet meditative spaces and access to the lower gardens.

Section studies best express the relationship of the retreat to the cliff. Nearly every room inside the retreat visually connects with the landscape. Similarly, light reaches into the structure through strategically placed courtyards and light wells, as well as generous full-height glazing. Concrete is used throughout the scheme to relate to the exposed cliffs and further blend with the landscape as it weathers.

Ultimately, the architecture acts as a backdrop to the environment that surrounds it. The grandness of the cliff edge and energy of the waves crashing below allows the architecture to frame an experience, rather than dominate it.

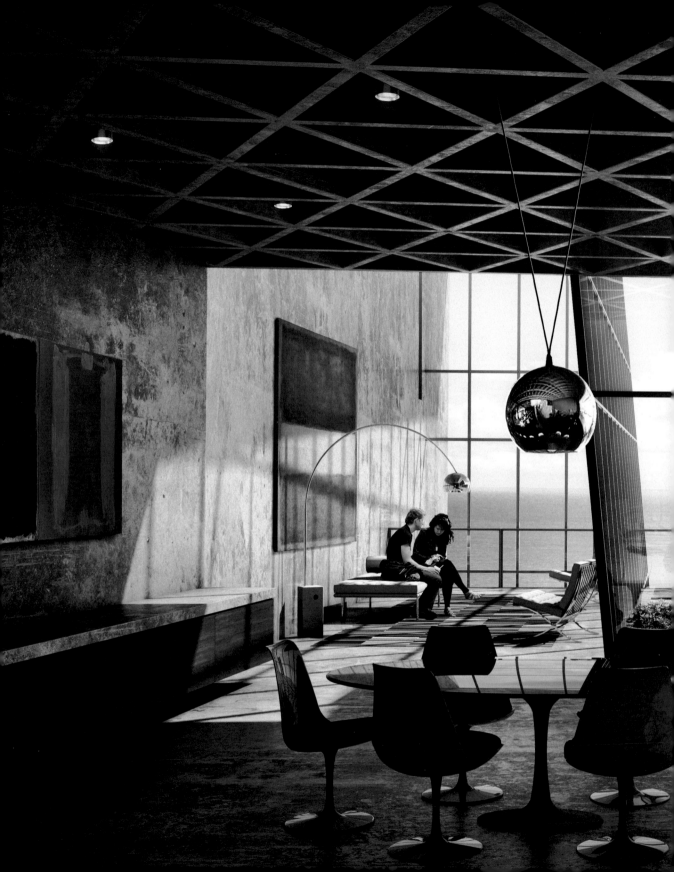

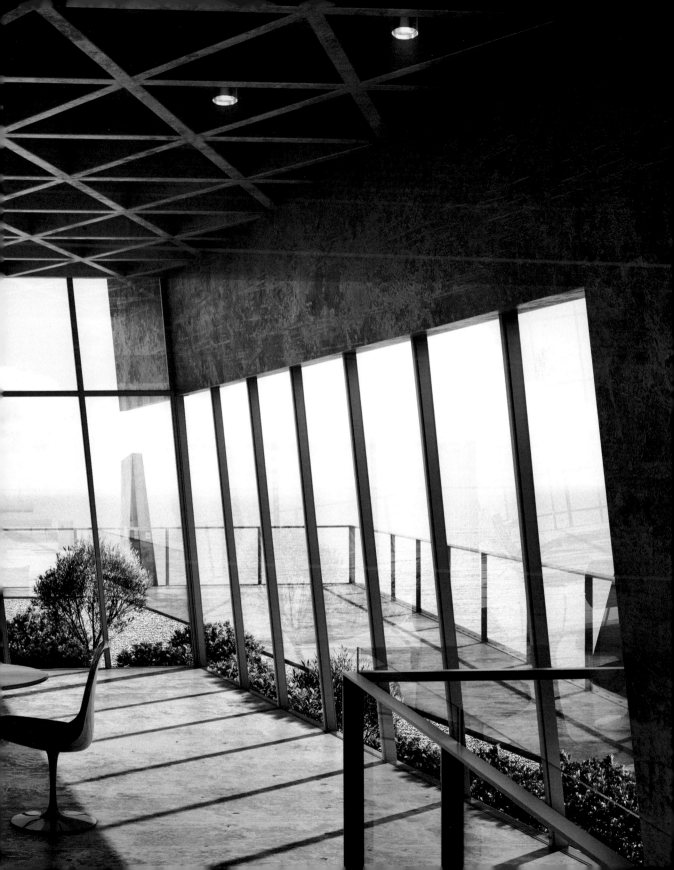

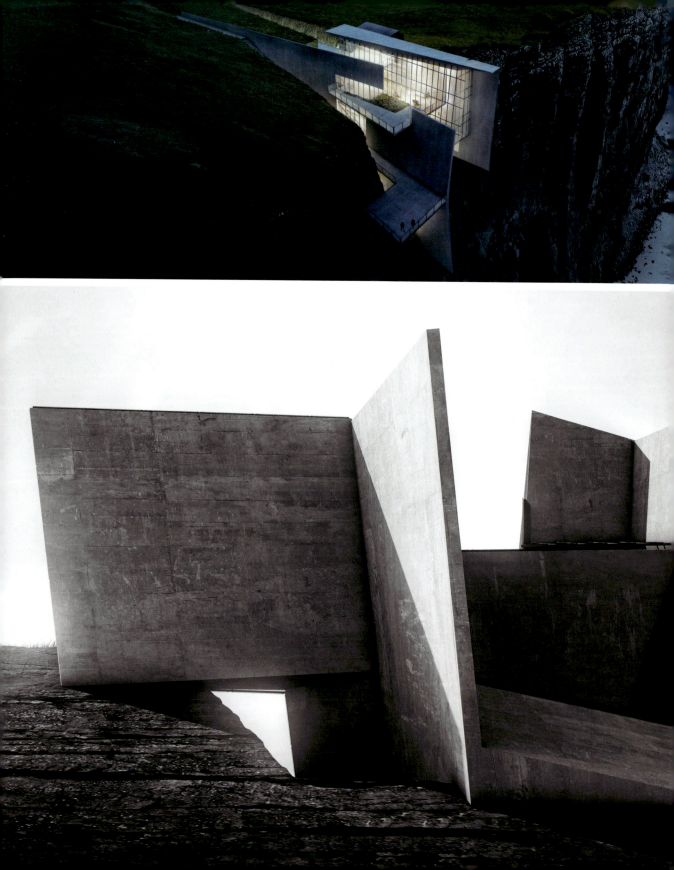

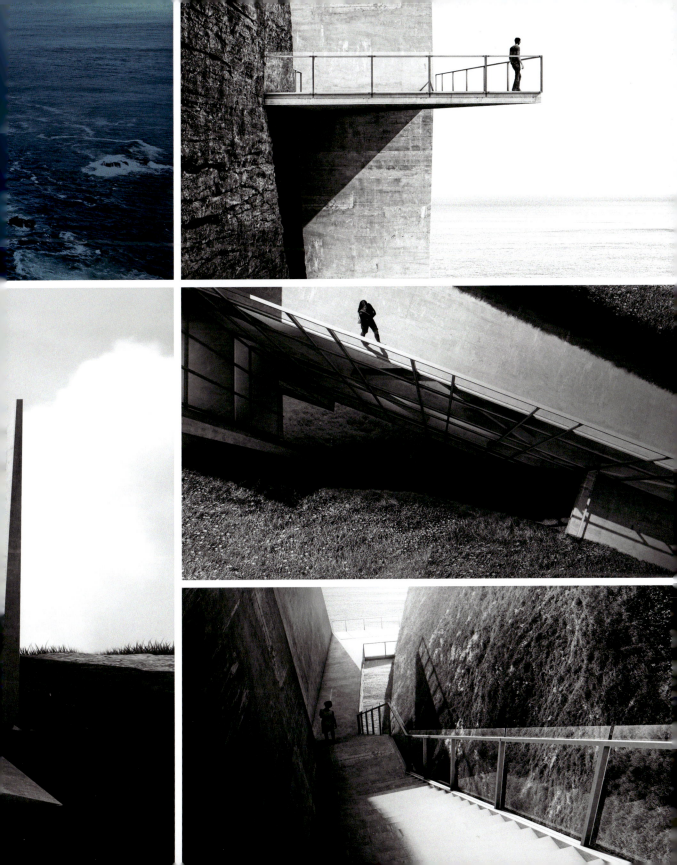

DUNE HOUSE

Studio Vural
Cape Cod, United States

Architecture firm Studio Vural has come up with an impressive design for an off-the-grid vacation home literally carved into the sand dunes. Designed for a coastal site in Cape Cod, principal architect Selim Vural was inspired by summer vacations in the area where he spent years studying the local climate, terrain, and vegetation. But it was the sight of a squid's rainbow flash during a nighttime fishing expedition that provided the final impetus when Vural realized a fully autonomous power system would and should be possible. "If squids can do it, so should architecture."

The unplugged house suggests an autonomous nervous system, self-sustaining in high-capacity power generation, producing more clean energy than consumed, which is made possible by self-storing solar panels and super insulation via burrowing. Anchored in the geothermal temperatures of sand via deep steel piles and blanketed with earth on all sides, the Dune House is what Selim calls the next generation of hyper-sustainable houses that "must be aggressively pursued to turn the tables on climate change." The concept also embraces the recent research on absorptive building materials and soil engineering for a sponge effect on carbon mass.

The design is also a success in natural preservation since it is only recognizable from sea and blends seamlessly with nature; immersed and not imposed like many conventional houses in the area. A habitat-sensitive construction scheme is being developed.

The Dune House embraces technology through smart heat-recovery systems, auto-climatic adjustment and self-storing solar panels, and miniaturized wind turbines. There are no machines but humming electrical devices that power, heat, cool, and vent. There is no chemical waste, trash, or fuel. The only carbon emission is the dinner table candles.

In the Dune House, human, bird, energy, and earth blend as an inseparable whole as technology finally makes peace with nature. The design and eventual construction are a powerful prototype for the future of homes at a global scale.

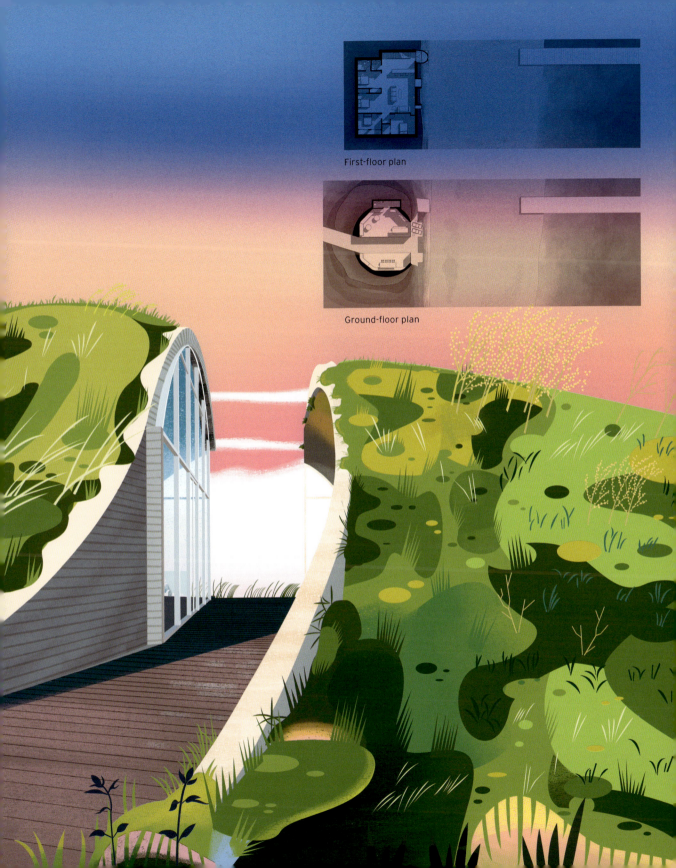

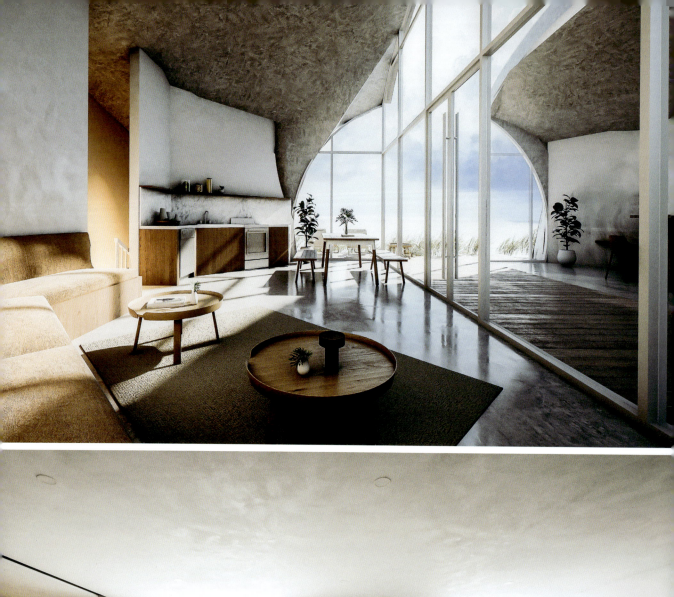
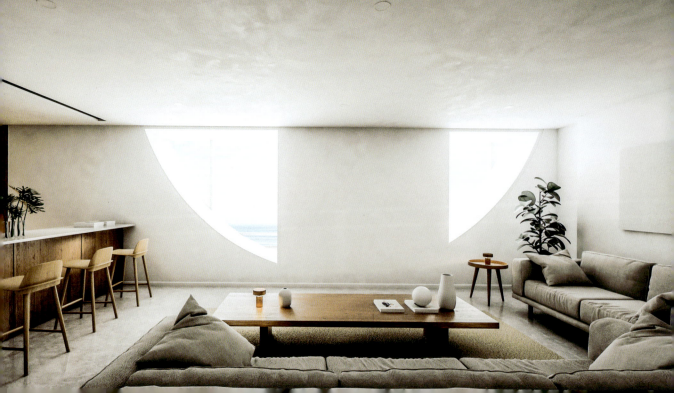

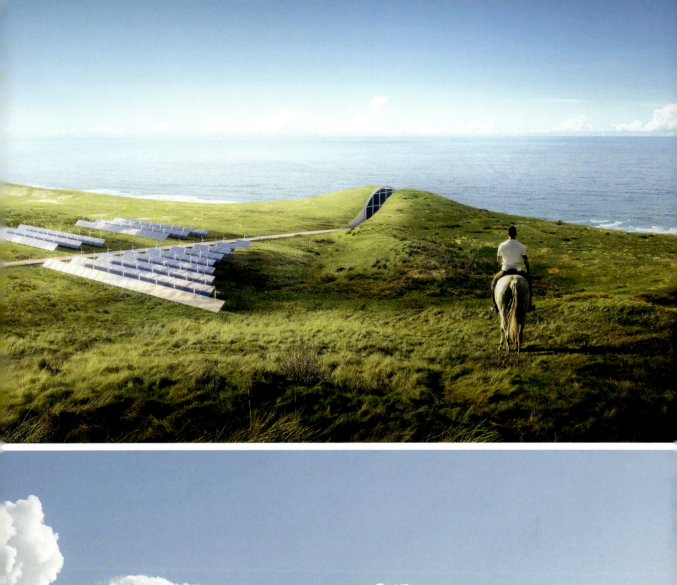
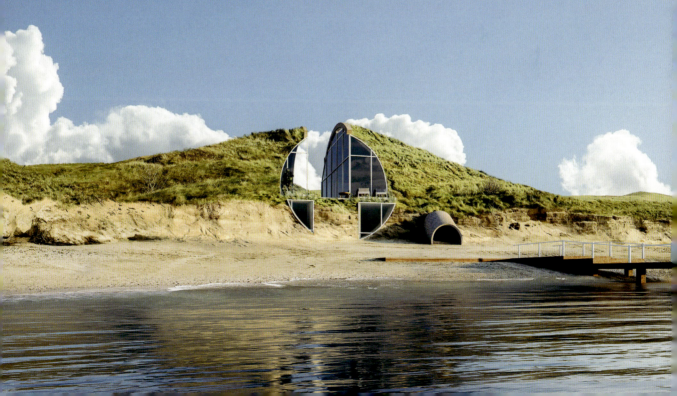

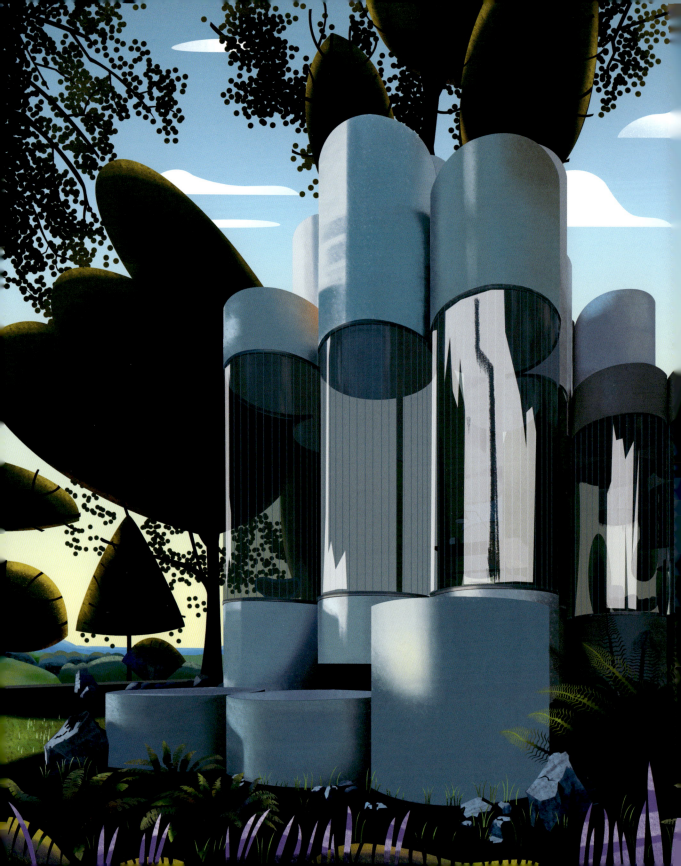

Cyril Lancelin/ town and concrete, Lyon, France

HOUSE CYLINDER

This futuristic design consists of a group of glass cylinders, playfully arranged. While it may not yet have been realized, it certainly grabs attention, and we can only hope that it will be built one day, bringing this innovative design to fruition.

Envisioned by Cyril Lancelin of town and concrete, the space is designed to fit snugly between mature trees in a wooded lot. But it is the proposed materials that capture the imagination. Using the idea of a glass cylinder, a residential space is brought into existence. The cylinders can be open, semi-open, or closed, allowing for an intriguing delimitation of space.

There are no corridors or windows as such in the design. This is a modern reworking of an open plan house, with everything open to the outside, and where the cylinders themselves act as posts within the structure.

Placement of furniture marks the space, denoting its function. The floor plan is not fixed, and is able to change at the discretion of the occupants, as their lives evolve and their needs change. One can simply relocate furniture to invent a new internal space.

This intriguing design shows a path to a vivid and ultra-modern future of house design. Living in such an intriguing residence would be an ongoing adventure but keeping the window glass clean would certainly prove an interesting challenge.

Ground-floor plan

Rooftop plan

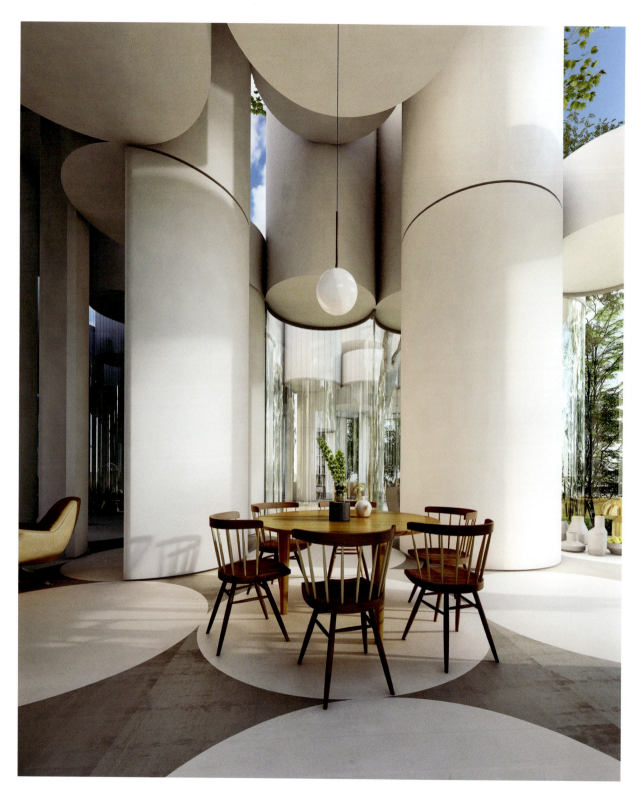

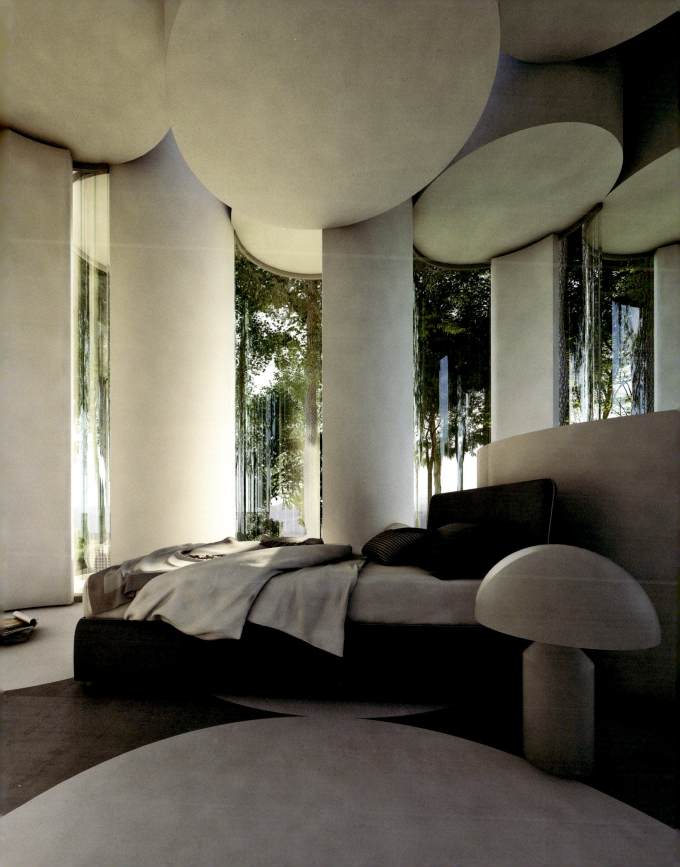

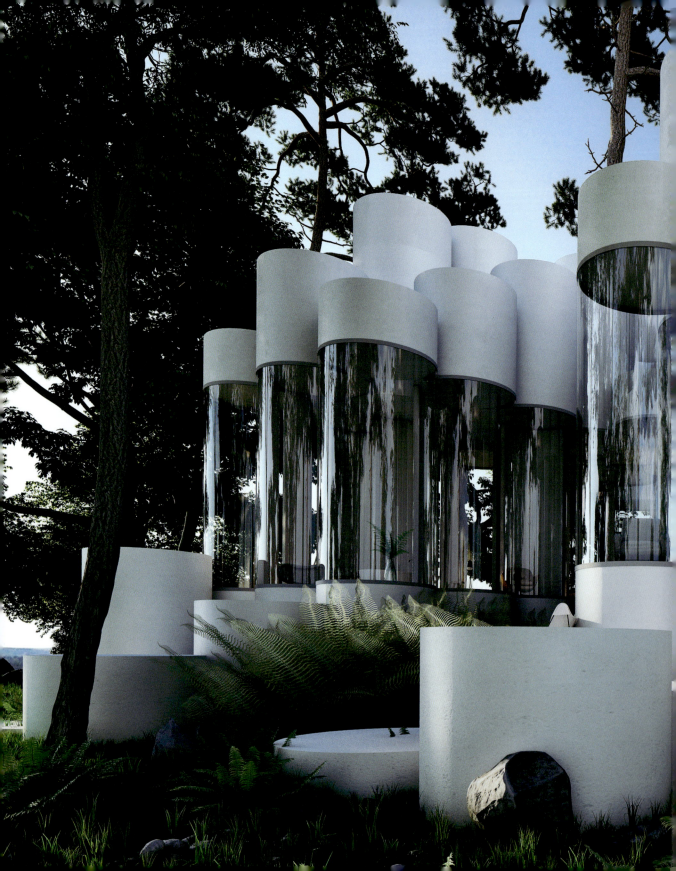

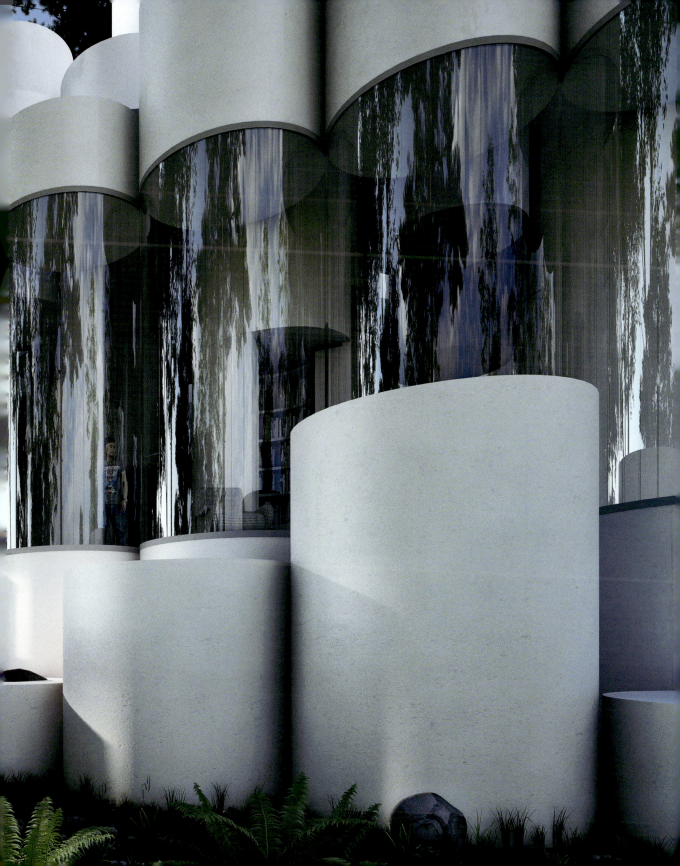

SKÝLI CABIN

Utopia Arkitekter
Iceland

Iceland is famous the world over for its wintery conditions and (sometimes violent) volcanoes. The landscape is also popular for mountain trekkers. This striking design plans for a compact trekking cabin for multiple people, and containing within it is everything you might need on the volcanic slopes.

Combining four sharply pointed pyramidal shapes, the resulting triangular gables resemble a classic tent, but also echo the shape frequently used in the roof structures of traditional Icelandic cabins. The large triple-gazed windows benefit from the triangular shape to maximize strength and durability. The cabin comprises two shells, the inner made from wood and the outer shell made from steel. The space between provides a place to dry clothes and also for a compost toilet.

The sloping roof is designed to deal with high amounts of snowfall, while the structure itself is mounted on a systems of plinths, minimizing any impact on Iceland's fragile landscape. The doors are located so as to be always protected from the wind. The interior includes four activity areas: two for rest and sleeping, one for cooking, mending, and communication, and one for eating and storing emergency supplies. Rainwater is collected from the roof into self-draining containers, supplying the cabin with water for washing and, once purified, drinking. The cabin has solar power and a battery, and a hand-crank generator for emergencies.

The outer shell's steel construction is painted a bright blue (made from Swedish rapeseed oil, and highly resistant to corrosion) that not only renders it highly visible in the landscape but also is reminiscent of colorful urban housing in Reykjavik.

Skýli is designed to be transported to remote locations. Once assembled, the structure is very strong, durable, and stable. This brilliantly blue and beautiful shelter will provide a welcome sight for weary trekkers.

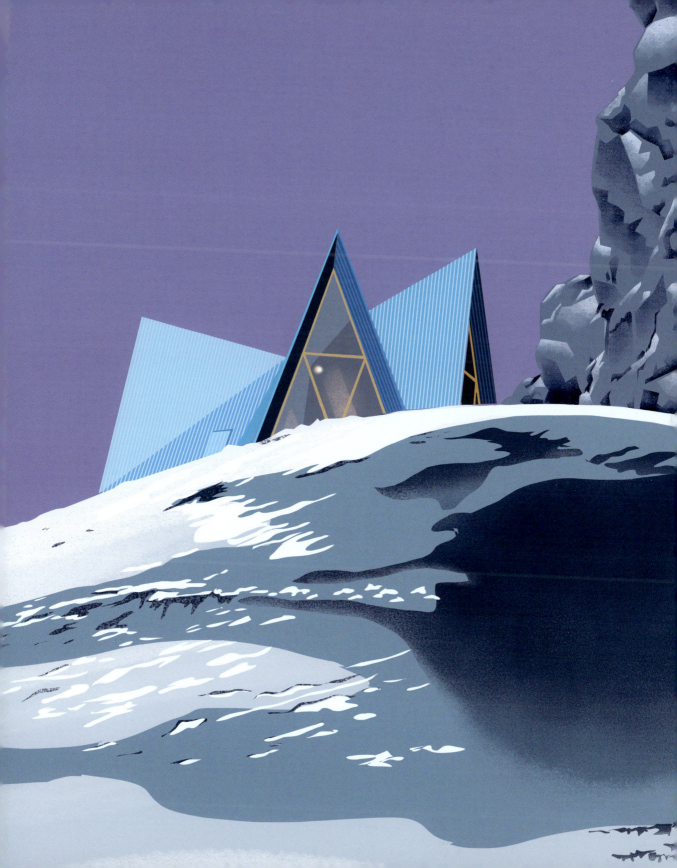

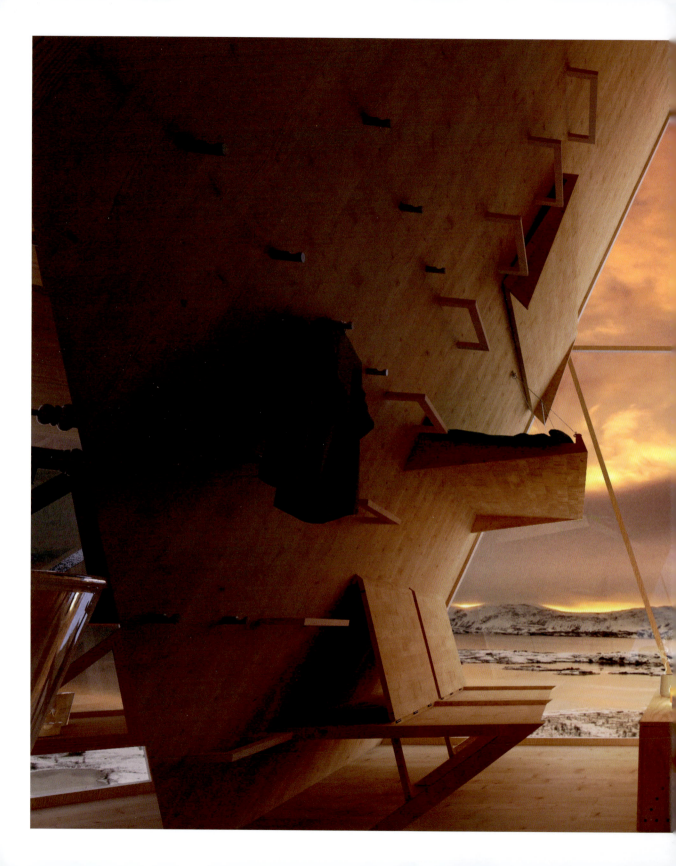

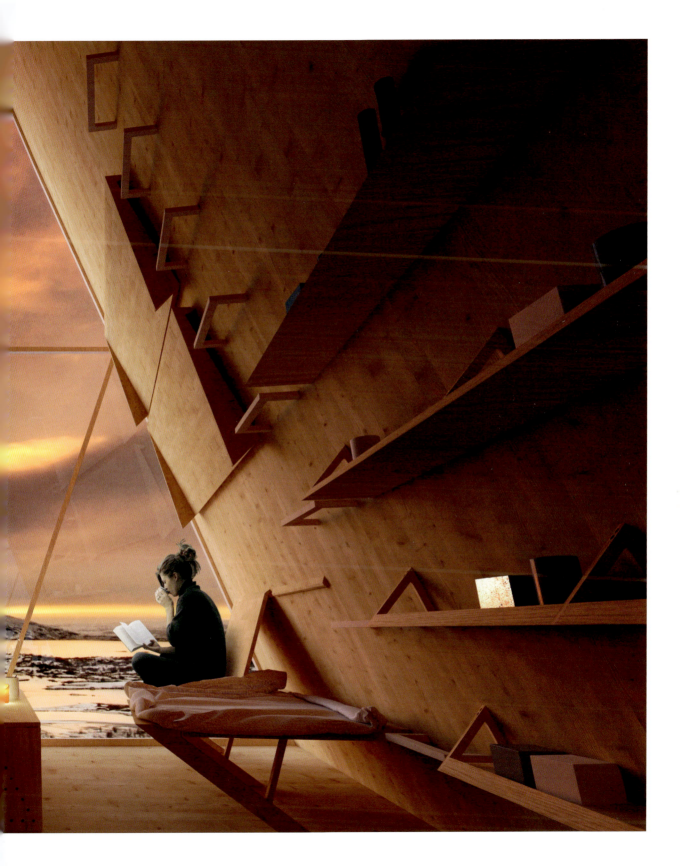

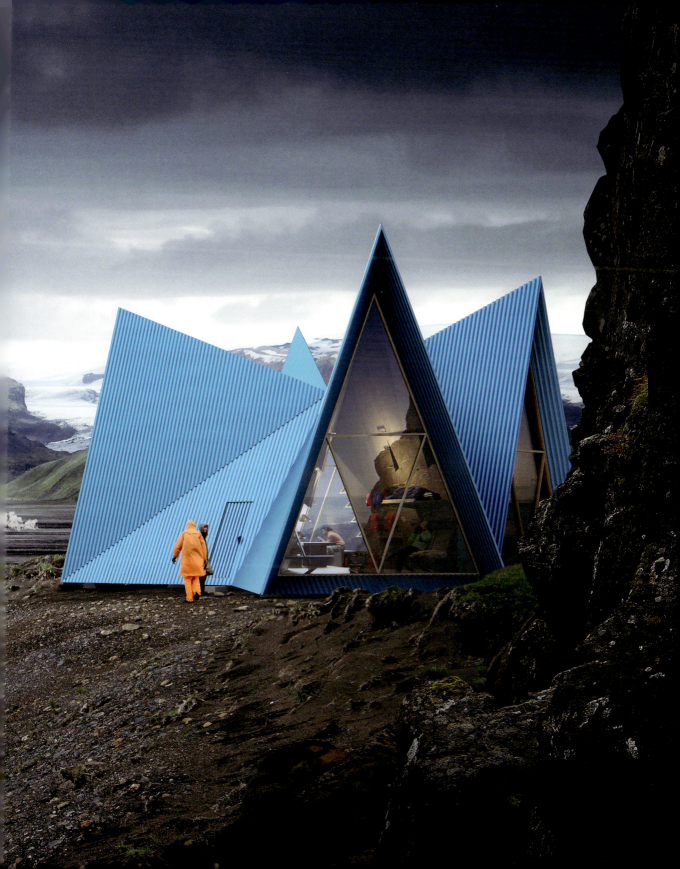

PROJECT CREDITS

All floor plans and such diagrams are supplied courtesy of the architects.
All color illustrations are by Kátia Schittine Nascimento Carvalho.

HOMES

⅓ HOUSE 10–17
Rever & Drage Architects || reverdrage.no
Location Øksendal, Norway
Photography Tom Auger

ACUTE HOUSE 18–25
OOF! architecture || oof.net.au
Location Melbourne, Australia
Photography Nic Granleese
Interiors OOF! architecture in collaboration with JPILD

BUMPERS OAST HOUSE 26–31
ACME || acme.ac
Location Kent, United Kingdom
Photography Jim Stephenson

CABIN AT TROLLS PEAK 32–41
Rever & Drage Architects || reverdrage.no
Location Trolltind, Norway
Photography Tom Auger

CARROLL HOUSE 42–51
LOT-EK || lot-ek.com
Location New York, United States
Photography Danny Bright

CASA 3000 52–59
Rebelo Andrade Studio || rebelodeandrade.com
Location Alcácer do Sal, Portugal
Photography João Guimarães–JG Photography,
Carlos Cezanne, Tiago Rebelo de Andrade

COCOON HOUSE 60–71
nea studio || neastudio.com
Location Long Island, United States
Photography Caylon Hackwith

CONNECTED HOUSE 72–79
Jacob + Macfarlane || jacobmacfarlane.com
Location Paris, France
Photography Roland Halbe

CORK HOUSE 80–87
Matthew Barnett Howland with Dido Milne and Oliver Wilton || cskarchitects.co.uk
Location Berkshire, United Kingdom
Photography David Grandorge, Magnus Dennis

CROFT LODGE 88–97
Kate Darby Architects and David Connor Design || katedarby.com | davidconnordesign.co.uk
Location Herefordshire, United Kingdom
Photography James Morris, Jim Stephenson

DOMIC HOUSE 98–105
Noel Robinson Architects || nracolab.com | domicnoosa.com
Location Noosa, Australia
Photography Scott Burrows Photographer

GREEN LINE HOUSE 106–11
Mobius Architects || mobius.pl
Location Warmia, Poland
Photography Paweł Ulatowski

HOUSE IN HOKUSETSU 112–19
Tato Architects || tat-o.com
Location Osaka, Japan
Photography Shinkenchiku-Sha

HOUSE IN TAKATSUKI 120–27
Tato Architects || tat-o.com
Location Osaka, Japan
Photography Shinkenchiku-Sha

HOUSE IN USUKI 128–35
Atelier Kenta Eto Architects || eto-atl.com
Location Usuki, Japan
Photography Toshiyuki Yano

HOUSE ON AN ISLAND 136–43
Atelier Oslo Architects || atelieroslo.no
Location Skåtøy Island, Norway
Photography Ivar Kvaal, Charlotte Thiis-Evensen, Nils Vik/D2

LOVE² HOUSE 144–49
Takeshi Hosaka Architects || hosakatakeshi.com
Location Tokyo, Japan
Photography Toreal Koji Fujii

MONTEBAR VILLA 150–53
JM Architecture || jma.it
Location Medeglia, Switzerland
Photography Jacopo Mascheroni

PARCHMENT WORKS HOUSE 154–61
Will Gamble Architects || willgamblearchitects.com
Location Northamptonshire, United Kingdom
Photography Johan Delin

QUADRANT HOUSE 162–69
Robert Konieczny KWK Promes || kwkpromes.pl
Location Near Warsaw, Poland
Photography Juliusz Sokołowski, Jarosław Syrek

RODE HOUSE 170–75
Pezo von Ellrichshausen || pezo.cl
Location Chiloe Island, Chile
Photography Pezo von Ellrichshausen

SHKRUB 176–83
MAKHNO Studio || makhnostudio.com
Location Kyiv, Ukraine
Photography Serhii Kadulin

SUSTAINABLE HOUSE 184–89
Gustavo Penna Architect & Associates || gustavopenna.com.br
Location Ouro Branco, Minas Gerais, Brazil
Photography Jomar Bragança

TRI HOUSE 190–97
Urban Agency || urban-agency.com
Location Dublin, Ireland
Photography Paul Tierney Photography

VILLA F 198–203
Christoph Hesse Architects || christophehesse.eu
Location Medebach, Germany
Photography Deimel + Wittmar, Thomas Baron, Christoph Hesse

VILLA YPSILON 204–13
LASSA Architects || lassa-architects.com
Location Peloponnese, Greece
Photography NAARO

DREAMS

CLIFF RETREAT 214–19
Alex Hogrefe || visualizingarchitecture.com
Location Selárdalur, Iceland
CGI Photography Visualizing Architecture

DUNE HOUSE 220–25
Studio Vural || studiovural.com
Location Cape Cod, United States
CGI Photography Studio Vural

HOUSE CYLINDER 226–31
Cyril Lancelin/town and concrete || townandconcrete.com
Location Lyon, France
CGI Photography town and concrete

SKÝLI CABIN 232–37
Utopia Arkitekter || utopia.se
Location Iceland
CGI Photography MIR.no

Published in Australia in 2024 by
The Images Publishing Group Pty Ltd
ABN 89 059 734 431

Offices

Melbourne
Waterman Business Centre
Suite 64, Level 2 UL40
1341 Dandenong Road
Chadstone, Victoria 3148
Australia
Tel: +61 3 8564 8122

New York
6 West 18th Street 4B
New York, NY 10011
United States
Tel: +1 212 645 1111

Shanghai
6F, Building C, 838 Guangji Road
Hongkou District, Shanghai 200434
China
Tel: +86 021 31260822

books@imagespublishing.com
www.imagespublishing.com

Copyright © The Images Publishing Group and the photographers as indicated 2024
The Images Publishing Group Reference Number: 1549

All photography is attributed in the Project Credits on pages 238-39, unless otherwise noted. All floor plans and such diagrams are supplied courtesy of the architects. Color illustrations © Kátia Schittine Nascimento Carvalho (2024).
Cover illustration: Connected House (Jacob + Macfarlane, pages 72-79).

All rights reserved. Apart from any fair dealing for the purposes of private study, research, criticism or review as permitted under the Copyright Act, no part of this publication may be reproduced, stored in a retrieval system or transmitted in any form by any means, electronic, mechanical, photocopying, recording or otherwise, without the written permission of the publisher.

A catalogue record for this book is available from the National Library of Australia

Title: Radical Living: Homes at the Edge of Architecture
ISBN: 9781864708646

This title was commissioned in IMAGES' Melbourne office and produced as follows:
Editorial Georgia (Gina) Tsarouhas, Jeanette Wall, *Art direction/production* Nicole Boehringer,
Layout Thais Ometto.

Printed on 157gsm Chinese OJI matt art paper (FSC®) in China by Artron Art Group

IMAGES has included on its website a page for special notices in relation to this and its other publications.
Please visit www.imagespublishing.com

Every effort has been made to trace the original source of copyright material contained in this book.
The publishers would be pleased to hear from copyright holders to rectify any errors or omissions.
The information and illustrations in this publication have been prepared and supplied by the author and the contributors.
While all reasonable efforts have been made to ensure accuracy, the publishers do not, under any circumstances, accept responsibility for errors, omissions and representations, express or implied.